AYMERI
OF
NARBONNE

AYMERI
OF
NARBONNE

A FRENCH EPIC ROMANCE

FIRST ENGLISH TRANSLATION

BY

MICHAEL A. H. NEWTH

ITALICA PRESS
NEW YORK
2005

Copyright © 2005 by Italica Press

ITALICA PRESS, INC.
595 Main Street, Suite 605
New York, New York 10044

Library of Congress Cataloging-in-Publication Data

Aimeri de Narbonne. English.
Aymeri of Narbonne : a French epic romance / first English
translation by Michael A.H. Newth.
p. cm.
Summary: "First English translation of the medieval French
romance of Aymeri of Narbonne, the son of one of Charlemagne's
paladins, who accepts the emperor's challenge to reconquer Narbonne
in Languedoc from the Saracens"--Provided by publisher.
Includes bibliographical references.
ISBN 978-0-934977-67-8 (pbk. : alk. paper)
ISBN 978-1-59910-161-3 (e-book)

I. Newth, Michael A. II. Title.
PQ1417.A36 2005
841'.1--dc22
 2005006470

Cover Photo: Detail from Table 29, Manessa Codex, Heidelberg.

FOR A COMPLETE LIST OF TITLES IN
MEDIEVAL AND RENAISSANCE LITERATURE
VISIT OUR WEB SITE AT
WWW.ITALICAPRESS.COM

CONTENTS

For John O. Ward

Tantes proeces sont issues de lui
Que nel diroie en un mois aconpli
Aymeri de Narbonne, ll. 34–35

INTRODUCTION

GENRE

This volume contains the first English translation of *Aymeri de Narbonne,* one of the finest epic poems of medieval France. The original work belonged to a form of public entertainment known generically as *chanson de geste* (literally 'Song of Deeds'), of which some ninety examples still exist in their manuscript copies today.

These surviving song-tales are themselves the literary culmination of a long tradition of "heroic chanting" in France, inspired originally by the historical deeds and legendary exploits of the great Frankish king and Western emperor Charlemagne (742–814) in his role as Defender of the Christian Faith. Orally composed, the first epic chants evolved a narrative construction which was heavily reliant upon mnemonic techniques and devices. Stereotyped themes, episodes and motifs were interwoven in strictly accented lines made up largely of formulaic expressions, and strung together in a ballad-like structure of verses monorhymed by assonance.

Received enthusiastically by the Frankish barons, whose delight in combat they reflected, these early chants were also welcomed, accommodated and nourished by the Church, which fostered their development along the pilgrimage routes to important shrines, such as that of St. James at Compostela in northwestern Spain. Reworkings of the old chants and original songs were subsequently written down by *trouvères* (poets, usually of good birth and education) and presented

by *jongleurs* (itinerant musicians), who sang or recited them to the accompaniment of a *vièle*, a forerunner of the viol, in private halls, public places and even within the precincts of the Church. In this way the chanson de geste genre came to provide the chief means of cultural and imaginative expression in the French language from the eleventh up to the middle of the twelfth century.

It remains unknown whether the original epic chants surrounding Charlemagne, well-documented as being sung among the people in the ninth, tenth and eleventh centuries, began, as has been variously suggested, as soldiers' songs, bardic laments, ecclesiastical chronicles or actual poems of hagiographical or epic nature, in Latin or in the vernacular. What is clear, however, is that the masterly level of sustained epic diction achieved in the *Chanson de Roland,* the earliest written chanson de geste that we possess today, reflects and consummates a long legacy of prior oral composition within the genre.

The *Chanson de Roland,* the first masterpiece of French vernacular literature, is thought to have been composed in its present form towards the end of the eleventh century, at a time when the interests of both *imperium* and *sacerdotium* were united and galvanized into violent action against a common enemy by the preaching of the First Crusade in 1095.[1] The song's narrative tells of the betrayal and defeat of Count Roland of Brittany, presented as Charlemagne's own nephew, at the Pass of Roncesvalles (French: *Roncevaux*) in the Pyrenees. Against a background of religious zeal and feudal loyalty, scenes of personal conflict and national combat are skillfully sustained upon a high level of emotional intensity by the poet's mastery of the genre's rhetorical devices. Despite its highly fictionalized rendering of a well-documented historical event (the ambush and slaughter of the emperor's rear-guard by non-Christian Basques in August 778), the enormous influence of this one epic tale upon the whole

social and artistic consciousness of medieval France is hard to overestimate. Its tone matched so exactly the contemporary fervor aroused by Pope Urban II's crusading rhetoric and its content so movingly established and celebrated the enduring ideal of French leadership, valor, and martyrdom in battle against the infidel enemies of Christendom.[2] Few of the chansons de geste that survive today do not owe something to the *Chanson de Roland.* Well over half of them deal directly with the life and deeds of Charlemagne or of those with whom he travelled to and from Roncesvalles. Several deal directly with the adventures of the emperor's knights specifically before or after the doom of that day, drawing to a greater or lesser extent upon the episodes, characters and themes of the *Roland* and describing them with an identical poetic art.

The deeds of the crusading knights subsequently inspired and continued to be inspired by a succession of chansons de geste, some celebrating contemporary heroes, such as Godfrey of Bouillon, his brother Baldwin and Tancred of Sicily (e.g., the *Chanson d'Antioche, Chanson de Jérusalem, Les Chétifs,* and *Le Chevalier au Cygne*). One of the finest of the later, so-called, secondary epics, known today as the *Chanson d'Aspremont,* was written in Sicily or Calabria during the preparations for the Third Crusade, which set out from Messina in 1191.

The religious sentiment which pervaded the majority of the earliest chansons de geste, providing the moral fulcrum on which the drama and humour of their narratives turned, is expressed most succinctly in the *Roland* itself:

Pagans are wrong and Christians are right (l. 1015)

The Pagan foe, known indiscriminately as Saracens, Arabs, Africans, Turks, Persians and Slavs, were defined in the first generation of written epics only in terms of their un- or anti-Christianity, and their narrative function was to bear the physical and moral discomfort and discomfiture thereof. The early trouvères endowed their epic heroes'

opponents with names, physical features, religious practices and a general deportment both on and off the battlefield that parodied both the Christian and the chivalric ideals. Collectively, the Moslems were portrayed as exotic "evil others," who worshipped Mahomet as the foremost deity in a hierarchy of deities that were replaceable both on and off the battlefield by graven images. The pagan rank and file were lampooned for their cowardice, their general light-headedness, their brittle obedience to their leaders and fickle adherence to their religious faith. The Moslem leaders were shown to lack little in terms of bravery, but, lacking the True Faith, their exaggerated boasts and taunts were there to be punished by the noble and righteous French with curt or elaborate schadenfreude.[3]

The written chanson de geste genre flourished in France for approximately two hundred years (c.1100–1300). Performed across the country before audiences of differing and changing tastes, its content and tone were altered accordingly. In addition to the deeds of Charlemagne, those of regional heroes like Girart of Vienne, William of Orange and Aymeri of Narbonne were also exploited. As active Crusader, pilgrim and trader contact with the Moslems increased, so the depiction of the "Saracen other" in the tales became more complex, more individualized and, sometimes, more sympathetic, with the introduction of stock-characters, such as the Christian convert, the skilful physician, and the amorous princess. Episodes of romance were included in response to the growing popularity of the tales of courtly love, of Breton lay and Arthurian legend, which the more literate and literary aristocracy wished increasingly to read privately, not hear publicly. Feminine characters in general began to participate to a greater extent in the intrigue of the plots, advancing the narratives by their craftiness, wit or wisdom. The character of the Saracen princess in particular, smitten with love for a Christian knight and fired with the zeal of the newly converted, added a new dimension

of sensuality and humor to the works – the sensuality inherent in the princess's foreign origin and exotic beauty, the comedy apparent in the aggressive energy she was shown to bring to all tasks, some of them traditionally masculine to Christian eyes and ears, and in the invective she loosed and the plots she hatched against the Saracen enemy, her own kith and kin, in pursuit of her romantic goals.

The tastes of popular audiences were increasingly accommodated by the introduction of comic elements in the form of social, racial and even religious satire. To begin with, a slapstick kitchen humor became embodied in the creation of a stock-character who may be called a churl-hero. This figure, possessing inordinate physical strength, extreme fondness for food and drink, and an obsessive attachment to an unconventional weapon and way of fighting, stood in obvious burlesque of the noble knights. In extension of the disdain accorded the 'Pagan other' in the earliest chansons de geste, any non-French warriors became targets of raillery and ridicule. Saxons, Danes, Germans and especially Lombards were lampooned for their ugliness, dress and manners, obesity, miserliness and, above all, cowardice. Priests and monks were derided for their verbosity, selfishness, treachery, niggardliness and again cowardice.

The profusion of these comic elements in the thirteenth and fourteenth century 'epic' compositions attests not only to an extensive vogue for this kind of humour among both popular and aristocratic audiences but also to the aesthetic influence on the genre of the contemporary rise into social prominence of the bourgeoisie.

Successful songs were continued either backwards or forwards in time and new tales containing the youthful exploits or last days of particular heroes or the deeds of their ancestors or descendants were added to the jongleurs' repertoires. At their height of their popularity, at the turn of the thirteenth century, all the epic tales were grouped

by the performers themselves into three main cycles, each named after the one legendary figure who united them in some way – Charlemagne (the cycle of the King), Garin de Monglane and Doon de Mayence. The Garin de Monglane cycle — also known as the William of Orange cycle or the cycle of the Aymerides — is a group of twenty-four surviving chansons de geste dealing with the exploits of an illustrious family, each generation of which is driven from home by its father to seek fiefs and glory in the south of France and in Spain. The Doon de Mayence cycle is also known as the cycle of rebellious barons, a small group of otherwise unrelated songs that detail the bellicose exploits of regional Carolingian barons, not in conflict with the Infidels but with their own central monarch or with each other.

During the thirteenth century the twelve-syllabled Alexandrine line ousted the ten-syllabled line and consonance replaced assonance in the monorhymed verses. The stanzas (or *laisses*) themselves, seeking descriptive rather than dramatic effects, became more chapter-like in length and purpose, and the old mnemonically-inspired epic formulas lost their syntactic flexibility, emotional function and narrative pulse. Great cyclic manuscripts, however, containing up to seventeen chansons de geste, continued to preserve and rehandle the subject matter of the earliest and most successful poems. Historical compilations, in verse, such as the *Chronique rimée* of Philippe Mousket in 1260, began to collect and codify the Charlemagne legends contained in the epic tales. Prose compilations and adaptations of the best of them began in the middle of the fourteenth century (e.g., the *Myreur des Histors* of Jean d'Outremeuse, 1340) and continued through to the mid-fifteenth (e.g., *Les Croniques et Conquestes de Charlemaine* of David Aubert, 1458), and into the early decades of the age of printing.

The influence of the chansons de geste upon the literature of other countries was widespread, significant and enduring.

INTRODUCTION

Adaptations, imitations and translations of many of the Old French epic tales survive extensively in Danish, English, German, Italian, Norwegian and Welsh manuscripts. The Norwegian prose compilation called *Karlamagnús Saga* (1230–50) contains many of the songs whose French originals are either lost today or preserved only in much later copies. Chanson de geste plots, in fragment or in entirety, and some of their main characters, in reputation or in action, appear in the works of such everlasting poets as Wolfram von Eschenbach, Dante, Chaucer and Shakespeare.

The Franco-Italian adaptations of the songs of deeds — works written in a hybrid language corresponding to no linguistic reality but catering to the burgeoning popularity of the French epic legends across the Alps — are significant not only by their considerable number. Some, like the fourteenth-century version of *Aliscans* and *Aspremonte*, dated 1509, both currently in the possession of the Biblioteca Nazionale Marciana in Venice, are virtual copies of their French originals and bear witness not only to the enduring popularity of certain Old French epics and their legends but to the survival of the genre itself in Italy. Others, such as *L'Entreé d'Espagne* (c.1300), its continuation the *Prise de Pampelune* (1328) and *La Spagna* (c. 1365), are original poems by Italian authors and link the last epic poetry in France to the first epics of the Italian Renaissance and beyond. In addition, the derivative prose works of Andrea da Barberino (1370–1431), in particular his *I Reali di Francia,* a large compilation of Charlemagne legends, were the major source for the *Orlando Enamorato* of Boiardo in the fifteenth century and the *Orlando Furioso* of Ariosto in the sixteenth. In their own right da Barberino's tales were read extensively up to the nineteenth century, which itself saw a revival of interest among scholars and poets of the Romantic school in medieval literature in general and in the legends surrounding Charlemagne in particular.

The surviving Old French chansons de geste form a vital and varied but comparatively neglected body of verse, the literary achievements of which have been represented almost exclusively to general readers by the *Chanson de Roland*. It is hoped that this verse translation of *Aymeri de Narbonne*, prepared for both the general and the more specialized reader, will help to provide a wider view of the excitement, pathos, humour and wisdom to be found within this poetic corpus, and to preserve an echo of its enthralling, atavistic art form of epic chant.

AUTHORSHIP

The text of *Aymeri de Narbonne* is preserved in five manuscript copies, each of them part of large cyclic compilations, which date from the middle of the thirteenth to the middle of the fourteenth centuries. The original poem itself is now thought to have been composed at some time during the early years of the thirteenth century, and is one of the twenty-four surviving chansons de geste of the William of Orange song cycle. With *Girart de Vienne* and *Les Narbonnais,* which flank it in four of the five extant copies, it constitutes a sub-cycle of its own, centred around the figure of Aymeri himself, his capture of the town of Narbonne, and the youthful exploits of his seven famous sons, in particular those of his second son, William.

The author of the first two poems in this *geste de Narbonne,* and of the first half of the third, known formerly as the *Département des enfants d'Aymeri,* is thought by most scholars to be Bertrand de Bar-sur-Aube, who names himself in *Girart de Vienne,* but further identifies himself only as a "gentis clers," (a noble clerk). Little remembered today, it appears that this Champenois poet was a trouvère of some considerable celebrity at the turn of the thirteenth century. The poet of a contemporaneous epic tale called *Doon de*

Nanteuil, for example, can best praise another jongleur in his verses by stating that "he learnt more in a single year than Bertrand de Bar knew in all his life." Although all biographical details concerning him remain conjectural, certain historical and artistic details observable in *Girart de Vienne* suggest that Bertrand may have enjoyed the patronage of the court of Champagne under Henry the Liberal and the Countess Marie at the time of that poem's composition (c. 1190–1200).

The frequency, accuracy and variety of the topographical references to the Midi region of France, which are made in his works, suggest that he must also have travelled widely in the south of France, and indeed his fame is attested in surviving documents from Gascony and Provence. The surviving works attributed to Bertrand de Bar-sur-Aube, which, apart from the *geste de Narbonne,* include one version of a popular epic tale called *Beuve de Hantone,* certainly exhibit a level of narrative skill, grace and humor that is rarely exceeded in the remaining chanson de geste corpus. Moreover, it was Bertrand himself, in his prologue to *Girart de Vienne,* who codified the three major heroic song cycles of his time, that same composition introducing a narrative cohesion among them which was respected by all subsequent poets (and scholars) of the genre.

The legendary hero of the present tale, although well known to the medieval French public as the famous father of the even more famous William of Orange, cannot now be identified with one single historical prototype. From the eleventh century onwards some nine viscounts of that name ruled in Narbonne, and baptismal records reveal the local popularity of that name from one hundred years earlier still. The *Annals* of Einhard for the year 810 mention an *"Haimericum comitem olim a Sarracenis captum"* (Count Aimeric was once captured by Saracens), and indeed this Aymeri may well have been one of the early ninth-century viscounts of Narbonne. Einhard's reference to his

imprisonment by the Saracens is a biographical detail that is certainly matched by episodes in the narratives of two later poems featuring the epic count (*La Mort d'Aymeri* and *Guibert d'Andrenas*). Of greater significance, perhaps, for the artistic treatment of the Aymeri legend in the epic poems is, however, the fact that the Castilian royal house of Lara inherited the viscounty of Narbonne in 1168. The heroic history of that household itself contains the legend of *"los infantes de Lara,"* which details the exploits of seven brothers and their love for Saracen princesses – a narrative construct that matches strongly that of Aymeri's family as preserved in the chansons de geste.

Narbonne itself, exposed by its location to the first Saracen invasions of southern France, was in the hands of the Moors for forty years during the eighth century, until it was retaken by Charlemagne's father, Pépin le Bref. In 719, El-Samah, governor of Spain under the caliphate of Omer II, took control of the town and led its women and children away prisoner. Advancing into Septimania as far as Toulouse, he was defeated there by Eudes, duke of Aquitaine, and his army withdrew under the leadership of Abd-er-Rahmân. Charles Martel besieged the town in 737, but after defeating reinforcements sent by sea, he returned to France, which itself had been threatened by Saxon and Frisian forces. His son, Pépin, returned to deliver the town in 751. In 793, Abd-el-Mélek, emir of Cordova, led an invasion of Septimania and his force set fire to the outskirts of the town. William, duke of Aquitaine, later to be immortalized in the epic tales as William Hooknose, Aymeri's most famous son, met and turned this force back at the river Orbieu, near Villedaigne. It is probable that the two sieges led by Charles Martel and Pépin le Bref left behind the heaviest traces in the popular imagination, especially the latter, which led to the definitive Christian conquest of the town. It is of interest to note that the name Desramed (Abd-er-Rahmân), borne by one of the

Pagan rulers of Narbonne in Bertrand's poem, was indeed the name of two Moorish governors of the town during that turbulent century of its history.

As stated above, the specific association of one historical Count Aymeri with one deliverance of Narbonne, if it ever existed, is lost to us now among the centuries bridging the historical deeds of the eighth with the legendary narratives of the twelfth, in which the deeds and family relationships of Aymeri of Narbonne appear as well-established bardic facts. The epic poems *Chançun de Willame, Coronemenz Loois, Charroi de Nîmes, Pèlerinage de Charlemagne, Girart de Roussillon* and *Aliscans* all speak of Aymeri of Narbonne and already know him as the father of William *Courb Nez* or *Court Nez* of Orange. The name and fame of Pépin's son, Charlemagne, have also, during this time, taken over the credit for the deliverance of Narbonne from Saracen hands, both in the poems and in the histories alike. At the beginning of the twelfth century, for example, the *Historia Ecclesiastica* of Hughes de Fleury refers to a conquest of Narbonne shortly after the defeat at Roncesvalles in 778: *"Post haec autem, dominus Karolus rex, subjugatis Narbonensibus, in Franciam est reversus"* (After this, King Charles, having subjugated Narbonne, returned to France). In 1187 the Catalan troubadour Guilhem de Berguedan's verses mention *"N'Aimeric de Narbona / a cui Charles det capdoil"* (Aymeri of Narbonne, to whom Charles gave a crown). More significant, perhaps, for the actual composition of the present poem by Bertrand de Bar-sur-Aube, is that the capture of Narbonne by Charlemagne's forces is alluded to twice in the *Chanson de Roland* itself. On one occasion, speaking of Charlemagne's horse, Tencendur, the *Roland* poet says:

Il le cunquist es guez desuz Marsune,
Si.n getat mort Malpalin de Nerbone (ll. 2994–95)

(He won it at the ford below Marsonne, flinging dead from it Malpalin of Narbonne).

Then, more significantly, the *Roland* narrative states, as does Bertrand in *Aymeri*, that Narbonne was passed on Charlemagne's return to France from Roncesvalles:

Passent Nerbone par force e par vigur (l. 3683)

(They pass Narbonne with every show of strength)

Indeed it seems quite likely that Bertrand, who in his earlier composition of *Girart de Vienne* had sought to relate the two major song cycles of the king and of William by making Girart the uncle of both Roland's companion Oliver and of his brother Hernaut's son, Aymeri, while writing in that poem a prequel to the most famous French epic of all, sought then in *Aymeri de Narbonne* to write its sequel, deriving poetic inspiration, in part, from the above-quoted lines.

Inspiration for the poem may also have come, however, from a much more direct and personal knowledge of Narbonne and of its heroic rulers. The detailed and accurate geographical references to the city in *Aymeri de Narbonne* may well indicate that Bertrand enjoyed for some time the patronage of Ermengard (d. 1197), daughter of Aymeri II, Vicount of Narbonne (d. 1134), whose brilliant court was famous for its reception of both troubadours and trouvères.[4] Not only had her father and her grandfather (Aymeri I d. 1105) led and fought in enough campaigns against the Saracens to be equally deserving of the legend's patronymic, but she herself, in 1148, had ridden at the head of her troops, to the aid of Count Raymond Bérenger IV of Barcelona, during the siege of Tortosa. The portrait of the wise, spirited and courageous Hermenjart, wife of Aymeri of Narbonne, as she appears not only in Bertrand's poem but in several other contemporaneous chansons de geste (most notably *Aliscans*, ll. 2709–28), may well have been inspired by this imposing matron of the Narbonne dynasty. In *Aymeri of Narbonne* the hero's bride is presented as the sister of King Boniface the Regent and the daughter of King Didier of Lombardy.

While no historical prototype has been found for the former character, the latter, who features in many an Old French epic, can be identified with the historical King Desiderius, who ruled in Lombardy from 757 to 774. Charlemagne himself married Desiderius' daughter in 770.

ARTISTIC ACHIEVEMENT

Since its first and only complete edition in 1887 *Aymeri de Narbonne* has been generally recognized as one of the finest extant Old French epic poems. As in its older and more famous brother, *Girart de Vienne,* Bertrand de Bar has created in the present poem an interesting range of psychologically credible characters whose relations are depicted with considerable dramatic and comic skill. His narrative is well-crafted, varied in style and content, energetic yet graceful, combining epic action with historical anecdote, satiric humour with romantic intrigue to form a sustained tale that is both aesthetically satisfying and generically cohesive.

The portrait of its hero Aymeri is particularly successful. No longer the young hot-head of the earlier poem, he still has the strength and independence of character that brought him into such violent conflict with Charlemagne in *Girart de Vienne* — a virtue not lost on the Emperor even now:

"By all God's Saints, is this then Aymeri?
Young Aymeri, by blessed St. Denis,
Do you wish now to be my friend indeed?
You have dismissed the day and hour, it seems,
When at Vienne I held Girart in siege,
And hunted pigs beneath his woodland trees?
Girart the duke surprised me in the deed
And you yourself were with him, sword unsheathed!
Your hatred then towards me was so deep
I would have died if he had paid you heed!
If I was spared, it wasn't on your plea!"

"In faith, my lord," replied young Aymeri,
"My mood is such and such will always be —
I'll never love or spare my enemies!
But you know well you acted wrongfully
When you attacked my uncle's land and lease.
In faith, my lord and king of visage fierce,
If you so wish, you have a friend in me;
But if you don't, by blessed St. Denis,
Then once again our friendship's bond shall cease...."
<div align="right">(ll. 716–35)</div>

With a subtlety unusual for the genre Bertrand presents a protagonist matured, in part by the suffering at Roncesvalles, into the ideal liegeman, a new Roland who is daring but not reckless, who is loved and feared by all. His noble character is carefully and consistently maintained with deft allusion and open illustration throughout the entire poem and is the yardstick against which the qualities of all the other male characters come to be measured. Among the few whose reputations do not suffer thereby are the two Girarts — Girart de Roussillon and Girart de Vienne. Considered by most scholars as two literary manifestations of the same historical personage, Count Gerardus of Vienne (819–77), they are nonetheless two distinct characters in *Aymeri de Narbonne.* The former, as one of Aymeri's ambassadors to Pavia, displays a wisdom, deference and diplomacy in all his actions, which are conspicuously absent from his behavior in the surviving chanson de geste that bears his name. The latter's impeccable behavior continues the poetic rehabilitation of this historically rebellious figure's maligned character, begun by Bertrand de Bar himself in *Girart de Vienne,* where Count Gerardus first appears as Aymeri's uncle. It is Girart de Vienne's support, not that promised by Charlemagne at the start of the poem, which rescues his nephew from the final pagan invasion. The ageing emperor himself is portrayed with a sympathetic realism not found in either the earliest or the later chansons de geste,



where he is idealized and satirized respectively. Still revered here as the great patriarch and the defender of the Faith, he is nonetheless upbraided by the younger, landless hero and unheeded by his barons both before and after the assault on Narbonne. His personal grief for the victims of Roncesvalles, his Christian anger at his barons' lack of zeal, tempered by the love, praise and generosity that he bestows upon them notwithstanding, are presented in sharp contrast to the selfish, contemptuous petulance displayed by his Lombard, German and Pagan counterparts in the poem.

The outstanding character-creation in the poem is, however, that of Hermenjart, the princess of Pavia and Aymeri's eventual wife. Her spirited speeches in criticism of her previous suitors' unsuitability, her brother Boniface's meanness and her Lombard countrymen's cowardice, are the verbal highlights of the work, adding a human and often humorous depth to the heroic surface of the tale:

"My brother dear," the slender maid replied,
"For love of God, Who governs all and guides,
Do not let wealth dictate your will or mine!
You've wealth enough, in coin and other kind.
Have you grown tired of me here by your side?
This makes me fret and so upsets my mind
That I'll not think of leaving you a while!
Spoleto's lord, last year, came here alike
To seek my hand with all his band of knights:
Othon the king, whose wealth alike was high;
And then there was old Savaris, the white-
Haired German lord, who must have lost his mind –
For I'd as soon be buried still alive
Than waste my love as such an old man's wife!
And then Duke Ace, the lord of Venice, tried
For twelve long months to win me as his bride,
As did André, who rules the Magyar tribes;
He's rich enough, this much I don't deny —

Beneath his writ ten towns and cities lie —
But he shall not have me to lie beside!
For he is old and all his beard is white,
His head is red, his skin all loose and lined!
By all the faith I owe blest Mary's child,
I'll not wed him, though I should lose my life.
I'd rather burn upon a flaming pyre
Than lie in bed by that slack-belly's side!
So help me God, Who governs all and guides,
I'll never wed a dotard." (ll. 2454–81)

In these outbursts and in several other tirades and actions, she exhibits many of the qualities traditionally invested in the genre's stock-character of the Saracen princess, first embodied in Lady Guibourc, the wife of William Hooknose. Like her literary progenitor in the *Chançun de Willame*, Hermenjart is possessed of an exotic beauty, an equal courage and moral strength to that of her French hero, and a greater charisma and enterprise to muster men, in small or large supply, to her and his support.[5]

Discomfiture and derision of pagan adversaries, the original sources of comedy in the chansons de geste, play a secondary role to the mockery of fellow-Christian German and Lombard warriors in *Aymeri de Narbonne*. Aymeri's rival for Hermenjart's hand, Lord Savaris, is humorously depicted as an old lecher and a coward, and his German army as an ill-clothed, ill-armed and ill-mounted rabble. Their individual and collective embarrassment forms a major component of the narrative and is treated with drawn-out relish. Similarly, King Boniface of Pavia and his Lombard knights, although desiring to show themselves as refined, clever and generous equals of the French, are depicted rather as pompous, calculating and mercenary cowards in comparison with Aymeri's envoys, whose sojourn in the north Italian city constitutes one of the funniest episodes in the entire genre as it exists today.

Bertrand de Bar's greatest artistic talent, it is generally agreed, lies in his dramatic ability to present clashes of will and feeling with an almost Cornelian intensity. Conflict through dialogue is a major narrative technique of the earliest and best chansons de geste, and there is little in all of medieval literature to rival the dramatic opening scenes of this poem, where in twelve successive, so-called parallel laisses, the refusal of each of Charlemagne's peers to attack Narbonne brings the emperor to the brink of despair. The smooth ebb and flow of this section's sombre tensions reveal the poet's skilful control of certain rhetorical devices, which contributed considerably to the genre's epic diction. At the heart of this art in the Old French poems lie the syntactically flexible four- or six- syllable verbal formulas. These stereotyped expressions are used as the emotional building-blocks of the narrative to sketch a person, object or scene, and to repeat, sustain or embellish an action or an emotion. A semantic amplification is achieved through syntactic combinations that tend to intensify rather than qualify the phrase. These formulas, which also, no doubt, served a mnemonic function, occur sometimes as noun + noun and verb + verb constructs in the text, either in half- or whole-line blocks:

> With strain and pain they all are overborne (l. 228)

> Its folk are full of pride and self-esteem (l. 309)

> In fealty and homage to himself (l. 327)

> All seasons through, both in the heat and cold (l. 412)

> You should be loved and cherished well by all men
> (l. 334)

> Whom you've so worn and overborne with pain
> (l. 244)

Most frequently employed in the hemistich are the adjective + adjective and particularly, the adjective + noun formulas, e.g.:

If I were not so old and white of head (l. 649)

To make us rich and wealthy all our days (l. 854)

To make the Moors and pagans leave their gates
 (l. 850)

Young Aymeri spurred his fast destrier (l. 893)

On seeing this, the hardy knights sped forth (l. 1128)

And felled the Moors with his well-burnished sword
 (l. 1174)

Another, particularly effective form of in-built repetition using formulaic expressions is where an affirmation is followed by a refutation of its opposite, in whole-line or even double-line constructs:

The counts are dead and never shall revive (l. 145)

I'm old and weak. I can no longer fight (l. 565)

They turned in flight, they neither stopped
 nor stayed (l. 916)

He must come here to see me from now on —
From nowhere else shall he gain a response
 (ll. 624–25)

The frequent and cumulative employment of these stylized combinations of formulaic expressions has a mesmeric effect upon the modern reader, much as it must have had upon the original audiences of the poem:

"Strike noble blows, knights worthy to be praised,
So that our deeds earn no reproof this day!"
His knights replied: "Well spoken, lord, in faith."
When this was said they readied for the fray.
Young Aymeri spurred his fast destrier
And raised his spear of sharpened iron well-shaped.
He spoke no more, to preach nor yet to pray,

But struck the first who stumbled in his way
And split his shield and slit the hauberk's chain;
One lance's length he flung him to his grave
(ll. 889–98)

It is, however, the unique syntactic flexibility of the Old French epic formulas that gives them their greatest narrative strength. When used in short verse-blocks with the changing assonance or rhyme of successive laisses, the affective powers of this formal adaptability in laments, and in the ritualized descriptions of duel and death, are quite extraordinary. As can be clearly seen in the first, more dramatic half of *Aymeri de Narbonne,* the chanson de geste poets' skilful handling of these emotive properties allowed them to build up tension and sentiment, and to arrest the narrative in so-called parallel verses of enormous intensity.

In the second, more narrative half of *Aymeri de Narbonne,* although the verses lengthen and the rhyme-change plays little emotional role, the poet's ability to present this traditionally epic skill of formula-manipulation within a more courtly framework is still evident in speeches of personal anecdote and in tender exchanges of pity and love. Other, more standard features of *roman courtois* composition, which are treated with considerable originality in this section of the poem, include the heightened importance, participation, description and analysis of female characters in the plot, the elaboration of travel sequences — where the Champenois poet reveals an accurate and detailed knowledge not only of southern France but of northern Italy — the reflection of courtly lifestyle itself, the detailed description of luxurious and exotic objects — for example, the fascinating description of the emir of Babylon's singing tree — and the illustration of correct and incorrect modes of behavior.

Aymeri de Narbonne, more colorfully than the majority of chansons de geste written down at the turn of the thirteenth century, displays the literary flowering of stylistic features

firmly rooted in an oral-based artistic tradition. The old composer–performer is still and always present in the written text as the omniscient narrator, who controls the attention and emotions of his audience by frequent interjections of humour, horror and homespun philosophy. He establishes a lasting rapport with his listeners by communicating his own enthusiasm for the tale through praise or scorn of its protagonists. Bertrand de Bar enhances the traditional discomfiture of non-French combatants, for example, with ironic comments of more sophisticated verbal wit. When the Saracen stronghold is being attacked by Aymeri's men, the poet humorously likens the assault to an admirable feat of carpentry:

> Some twenty clutched great axes in their claws
> And wondrous feats of carpentry performed
>
> (ll. 1155–56)

When one of Narbonne's pagan defenders is felled by Aymeri's blow, the poet adds facetiously that it was:

> So fierce a blow he knocked the villain straight
> Down in the moat, his thirsty throat well slaked!
>
> (ll. 926–27)

This traditional discomfiture motif is further extended by Bertrand de Bar, however, from the pagan adversary to one of Aymeri's own sons, forming part of a gentle, witty, personal satire quite alien to the original chansons de geste:

> For once he said before his band of knights
> That he'd not wed or bed a red-haired wife!
> But then he did, not long beyond that time,
> And in his town there was no uglier bride.
> She had a limp, and in one eye was blind,
> And she was red — and he was red alike!
> Then after that he bragged a second time
> That he would not be run from any fight,
> But then he was — the heathen Antichrists

For four whole leagues pursued him till he dived
Across a ford where he was forced to hide!
Before he'd reached the other bank and side
The flow had reached his jeweled helmet's height!
(ll. 4550–62)

A similar literary growth can be observed in the development of the simile in *Aymeri de Narbonne*. Quite traditionally, the poet, in a single line of formulaic composition and emotive intent, compares a warrior's anger to that of a wild boar (ll. 234 and 4085), his valor to that of a lion (l. 2770), and his imprisonment to that of bird trapped in a cage (ll. 538 and 3666). It is, however, an art of different inspiration, intent and scope, that produces a single line simile such as,

He lopped his leg just like a stalk of hemlock (l. 1806)

and the lovely three-line image that begins the work:

A hidden truth, I say, make no mistake,
Is like a fire on which the ash is raked —
It burns beneath but cannot give a flame (ll. 6–8)

As with its companion-piece, *Girart de Vienne,* the poet of *Aymeri de Narbonne* is undoubtedly creating his narrative truth by embroidering a popular legend, its protagonists well known to his public and to his peers through older epic tales, some lost to us now. Whatever his narrative sources, however, it is clear from the evidence of later poetic and historical compositions, that it was the present author's recreation of these tales that not only became the standard version of their plots, but also provided the definitive delineation of their characters.

SOURCES AND INFLUENCES

It seems clear that despite the breadth of invention displayed by the author of *Aymeri de Narbonne,* his poem is a composite work, incorporating elements of earlier epic Aymeri material

preserved in folk imagination or in actual chant with certain anecdotes from non-related historical sources.

The existence of earlier chansons de geste, now lost, which detailed Charlemagne's arrival before Narbonne and Aymeri's recapture of the town, can hardly be doubted. In his own prologue to *Aymeri*, Bertrand de Bar hints at the popularity of such earlier tales:

> You all have heard of Aymeri's renown (l. 36)

He also states at the start of his earlier work, *Girart de Vienne*:

> So many times you've heard the stories told
> Of Duke Girart, brave Vienne's lord of old,
> And Hermenjart and Aymeri the bold (ll. 81–83)

In earlier works of the William cycle itself, for example the *Chançun de Willame*, the *Prise d'Orange* and *Aliscans*, Aymeri's brave deeds are certainly lauded, although never listed. It is also possible that the poet of the *Chanson de Roland* was aware of an old poetic tradition detailing Charlemagne's capture of Narbonne on his return from the Roncesvalles defeat — certainly some scholars have read as much into one line of the famous poem:

> They pass Narbonne with every show of strength
> (l. 3683)

It has also been suggested that the archaic style of Bertrand's opening verses, so different in their stark simplicity from any other passages in the poem, could indicate his imitation of an early, oral epic chant, a *Siège de Narbonne*, which has otherwise not been preserved. On the other hand, it is perhaps inevitable that in a poem written as a conscious sequel to the *Chanson de Roland* there should be heard at least some stylistic and narrative echoes of such a resounding model — the poem starts with Charlemagne still in a grieving mood, and reminds its audience several times why this should be so (for example, ll. 77–79, 84–91, 107–24, 1273–87), while the great king's grief

is re-expressed in language that is almost identical to that used in Turoldus' masterpiece (for example, ll. 134–47).

The earlier works of the William cycle mentioned above already contain certain details of the family relationships, marriages and adventures of Aymeri's offspring, which are, for the first time, brought together and concisely summarized at the end of Bertrand's poem. This final section of *Aymeri de Narbonne* also alludes to the highlights of other epic compositions, such as *La Prise de Nobles*, *La Siège de Gironde* and *Aïmer le Chétif*, whose originals are lost to us today, but whose narratives have been preserved in summary form in later verse and prose compilations. The allusion in ll. 719–26 of the present poem to an earlier, much more hostile relationship between Aymeri and Charlemagne, which plays such an important role in *Girart de Vienne,* offers not only one example of the companion nature of both poems in a conceptual sense, but may also indicate that these two chansons de geste were indeed often recited together, as the final lines of *Girart de Vienne* would have us believe:

> But let us leave those heroes and their fate,
> And leave Girart, for I have told his tale,
> And Hernaut of Biaulande, well-bred and brave;
> Of Hernaut's son I'll tell you now, whose name
> Was Aymeri, of worth and valor great,
> The liege-lord of Narbonne. (ll. 6924–29)

One or two of the most vivid scenes in the narrative, where neither Aymeri nor Narbonne are in the limelight, appear to have been based upon anecdotes taken from historical sources or contemporary events, or upon excerpts from earlier but generically unrelated chansons de geste themselves. The humorously written episode of the French envoys' sojourn in Pavia where, deprived of wood for their fire, Aymeri's ambassadors raise a roaring fire with wooden goblets and nut-husks purchased from the townsfolk, replicates the deeds of Robert I, Duke of Normandy, and his entourage at

Constantinople, as recorded by Wace of Jersey in his *Geste des Normanz* (*Roman de Rou*, 1162–75). The whole relationship between the proud envoys and Boniface, the fearful king of Lombardy, recalls much of the mutual distrust between the Latins and the Greeks that was recorded by chroniclers such as Villehardouin and Robert de Clari during the Fourth Crusade. A parallel has been seen, for example, between the humiliating visit made by Boniface to placate the French envoys in their private lodging (ll. 2269–2409) and that made by Emperor Isaac to the Crusaders camped before Constantinople in 1203. The humorous discomfiture of Lombards plays such a significant role in *Aymeri de Narbonne* and in its continuation, *Les Narbonnais*, however, that its inspiration may equally have come from the contemporary business rivalry, jealousy and general antipathy of the French, and of the southern French in particular, towards the rising power and wealth of the Italian cities.[6] By the turn of the thirteenth century Lombard merchants, money changers, bankers and usurers had already established themselves in Montpellier and Narbonne to the general dislike of the populace and to the envious scorn of the nobles, for whom even their north Italian counterparts were more bourgeois than true nobility. The less extensive, but equally memorable description of the marvellous singing tree at the emir's palace in Babylon (ll. 3505–28) may likewise have been inspired by the description of similar mechanical marvels that can be found in several Latin texts prior to 1150, in the reports of French palmers' visits to Byzantium, or indeed in an earlier chanson de geste such as the *Pèlerinage de Charlemagne* (composed in its surviving form between 1150 and 1155), where the singing statues at King Hugo's residence in Constantinople make such an impression upon Charlemagne's knights.[7]

Several of the narrative additions to the legend of Aymeri and to the capture of Narbonne that are made in the present poem reappear in later historical compilations as established

facts. One Aubri de Trois-Fontaines, for example, states in his chronicle of 1232 that "in 799 Hernaut de Biaulande requested Charlemagne to offer Narbonne to his son Aymeri" (*Aymeri de Narbonne*, ll. 632–39 and 653–58). In 1242, the chronicle of Waulsort Abbey states that "Count Eilbert was a descendant of Aymeri of Narbonne and Countess Hermenjart, sister of Boniface of Pavia." *Philomena*, a romance written in the middle of the thirteenth century at, and to the glory of, the abbey of Grasse, was long held as an authoritative historical documentation of the events that it recorded — and it records not only the family relationships within the William cycle as they are re-invented in *Aymeri de Narbonne,* but also specifies that Narbonne was given to the son of Hernaut de Biaulande at his father's request; moreover, it describes Aymeri's assault upon the town in identical language to that of Bertrand's poem.

In the cyclic manuscripts of the thirteenth and fourteenth centuries *Aymeri de Narbonne* is followed by the long continuation called, nowadays, *Les Narbonnais.* The first half of this poem, known formerly as *Le Département des enfants d'Aymeri,* is also thought to have been written by Bertrand de Bar-sur-Aube, and contains an account of the youthful deeds of Aymeri's seven sons, as heralded in the last lines of the present work. This long *enfances* narrative seems to have enjoyed a particular popularity in the Middle Ages and beyond, to judge by the many allusions to it in later chansons de geste compositions and prose compilations. *Aymeri de Narbonne* itself seems to have been incorporated by later jongleurs in France and their imitators in Italy into their extended versions of the *Chanson de Roland.* The fourteenth-century manuscript of Turoldus' poem held in the Biblioteca Nazionale Marciana in Venice is the best-known example of this intercalation today, where the copyist interrupts his faithful transcription at l. 3683 of the great poem (*Passent Nerbune par force e par vigur*) to detail Aymeri's capture of the town. Outside of the cyclic tradition there are library records

indicating the existence of single manuscript copies of *Aymeri de Narbonne,* now lost, which were held in private collections across two centuries: 1306, Bordesley Abbey, one copy; 1373, the Louvre, two copies; 1407, François I of Gonzago, one copy; the duke of Burgundy, two copies; 1533, Henry II, king of Navarre, one copy.

The continuing popularity of *Aymeri de Narbonne,* both in France and further afield, is demonstrated by the considerable number of verse and prose compilations that have survived in which the events of the poem are featured. In France, two *Guerin de Montglave* incunabula of the fifteenth and sixteenth centuries, held at the Bibliothèque nationale and the Bibliothèque de l'Arsenal respectively, re-tell Aymeri's deeds along with those of many others of William's geste. The quasi-historical *Croniques et conquestes de Charlemaine* by David Aubert, completed in 1458 and later revised at the behest of Philippe the Good of Burgundy, inserts the story-line of *Aymeri de Narbonne* between its description of the disaster of Roncesvalles and the punishment of its instigator Ganelon — just as the copyist of the Venice manuscript of the *Roland* does. The Italian verse poem *Spagna* (c.1350–80), Andrea da Barberino's vast prose compilation *I Reali di Francia* (c.1380–1420) and his later romance *Le storie Nerbonesi* bear witness not only to the popularity of Aymeri's legend, and to that of other chansons de geste heroes, but also to the survival of the genre itself outside of France during the fourteenth and fifteenth centuries. In Germany, Wolfram von Eschenbach's *Willehalm* (1200) makes mention of Heimrîch von Naribon, but his continuator, Ulrich von dem Türlin, in his poem *Arabellens Entführung* directly alludes to the key innovations of Bertand de Bar's treatment of the Aymeri legend, namely his hero's personal capture of the southern city and his subsequent marriage to Iremenschart von Pavie. Two Old Castile romances of the thirteenth and fourteenth centuries conserve the name of the poem's hero in its Provençal forms

of Almenique and Benalmenique; the latter of these romances preserves also Bertrand's description of a besieged Narbonne and of the courageous role played by the hero's wife in its deliverance, leaving little doubt that Aymeri's name and fame, as presented in the Old French chanson de geste, enjoyed a certain popularity on Spanish soil as well.

The nineteenth century saw a rebirth in the popularity of medieval epic heroes and their legends among both poets and literary scholars. In 1859, as part of his own epic cycle, *La Légende des Siècles*, Victor Hugo's *Aymerillot* offered a poetic précis of the opening scenes of Bertrand de Bar's original narrative, which Hugo had culled from a novel written in 1843 by Jubinal. In 1852, that great pioneer of medieval French studies, Paulin Paris, was the first to publish a major analysis of *Aymeri de Narbonne*, with extracts, in volume twenty-two of his monumental *Histoire littéraire de la France*. His son Gaston, who succeeded him in the chair of medieval French at the Collège de France, and held that position for forty years, called Bertrand's oeuvre "of all the imitations of our ancient poems, the one most worthy to rank with them." In 1878, Léon Gautier's *Epopées françaises* (vol. 3) included a full analysis of *Aymeri de Narbonne* and emphasized the beauty of certain extracts (notably the opening scenes). In 1887, the only complete edition of the poem hitherto, by Louis Demaison, was published by the Société des Anciens Textes Français, with an introductory analysis running to over three hundred pages.

In more recent times the writings of the American scholar William C. Calin in particular have led to a wider and deeper appreciation of the literary merits of *Aymeri de Narbonne*.

AYMERI OF NARBONNE

EDITORIAL POLICY

Il est très certain que ceux qui ont mis en prose les romans que nos anciens trouvères avoient composés en rythme, les ont entièrement corrompus, et ont ostés toutes les graces et causé la perte de la plus grande partie de leurs ouvrages.

(It is very certain that those who have put into prose the stories that our old poets had composed in rhythm, have corrupted them completely and have taken away from them all of their grace and caused the loss of the greatest part of their works.)[8]

This is the first English translation made of Bertrand de Bar's *Aymeri de Narbonne*. It is based thoroughly upon the Demaison edition mentioned above, which itself follows closely two of the three manuscripts containing the poem held currently at the British Library in London. I have occasionally translated the variant readings offered by the third London manuscript and the two Paris copies held at the Bibliothèque Nationale, when they seemed to me to make more direct narrative sense. I am heavily indebted to Demaison's extensive analysis and appreciation of the poem in what the incomparable Joseph Bédier himself called one "of the finest publications ever produced by the Société des Anciens Textes Français."

In this translation I have tried, above all, to preserve most of the formal properties of the original text. The chansons de geste of whatever period are still oral-based poems and the performance-driven qualities of such verse (the mesmeric effect of formulaic diction, the affective power of assonance, rhyme and rhythm) need to be recreated in verse and declaimed by the modern reader, if something of the fine and full effects of this fascinating art form are to be appreciated. Of necessity, such an approach to translation is

taken at the sacrifice of some literal accuracy, but I would ask those scholars who find this version of *Aymeri de Narbonne* too free, to consider whether a prose translation of any piece of verse is, in essence, a stricter translation at all. Like most chansons de geste, *Aymeri de Narbonne* is written in ten-syllabled lines, grouped together in laisses of irregular length. The final syllables of all the lines in a single Old French epic laisse were originally assonanced together, but in later poems like *Aymeri de Narbonne* they were fully rhymed. This full rhyme, which is easy to achieve in French, is impossible to copy in English and so I have used the traditional assonance patterning — which does not, of course, preclude the occasional fortuitous rhyme. The assonance (or rhyme) changes with each laisse and is commonly masculine but occasionally feminine. A feminine ending is one in which the stressed syllable that carries the assonance (or rhyme) is followed in the original by an unaccented **e**: (e.g. baronn**ie**, fol**ie**); a masculine ending is one in which it is not so followed: (e.g. bar**on**, donj**on**). This additional unstressed syllable does not count in the scansion of the line. Thus, in the translation, not only do words like *brave* and *jail* assonate, but so do *barons* and *madness*. The line itself is strictly decasyllabic with strong internal accent. There is a break in the line after the fourth syllable (or occasionally after the sixth), and the final syllable before this caesura may once again be either masculine or feminine and may vary from line to line. I have preserved also the *vers orphelin*, the curtailed, six-syllabled line which terminates each laisse and does not rhyme with it. In the hands of skilled poets like Bertrand de Bar-sur-Aube it is used cleverly to summarize or ironically counterpoint the contents of each episodic stanza.

While preserving the medieval verse structure as much as possible, I have also tried to accommodate the needs and expectations of the modern readers of this poem. I have maintained a uniform past tense in narration, which does

ON

not reflect the indiscriminate mixture of tenses used in the original. Although the heavy end-stopping of individual lines found in the earliest Old French epics is much less evident in later poems like *Aymeri de Narbonne,* in the interests of fluency I have created even more run-on lines. I have also, again for the ease of modern reading, divided the text artificially into Gestes and Chants, to signify Parts and Chapters which are discernible but not distinguished thus in the original work.

This translation is primarily intended for general readers, for scholars and students of history or of comparative literature, and for readers of modern French who may not often venture beyond the formidable frontiers of the Renaissance writers. The select bibliography intends also to be of service primarily to the needs and interests of these groups. Given the limited availability of the only edition of *Aymeri de Narbonne,* even in its reprint by the Johnson Reprint Company in 1968, it is also hoped, however, that this volume, with extended extracts from the original poem included in its Appendix, will be useful to scholars and students of Old French itself, for classroom or individual purposes.

I am grateful to the Société des Anciens Textes Français for the formal permission to translate and to quote extensively from its unique edition of *Aymeri de Narbonne.* My warm thanks also go to my colleagues Gary Heap and Margarita Wilson for their assistance in preparing, respectively, the map and the glossary. As always, I am indebted most of all to my wife Sue, for her unfailing moral and practical support.

NOTES:
1. On the relationship between the Crusades and chansons de geste, see the Select Bibliography below, particularly for works by Peter Haidu, Anouar Hatem, Geraldine Heng, and D. A. Trotter.
2. As Friedrich Heer states: "The same basic themes recur in the *Chanson de Roland,* in the writings of Suger of St. Denis and in the political propaganda of the French kings which, starting in the late twelfth century, kept roughly to the same line for the next two hun-

XXXVI

dred years: the French nation is culturally superior to all others, it is the only nation of true believers and the lawful heir of Charlemagne, the French nation fights God's battles for Him on earth, all its wars are Crusades. The *Chanson de Roland,* when recited by a jongleur to the troops on the field of Bouvines had the same stirring effect as the *Marsellaise." The Medieval World* (New York: Mentor, 1963), p. 357.

3. The portrayal of Moslems in the literature of the West has been the subject of study for several decades. See Select Bibliography below particularly for works by David R. Blanks, and Michael Frassetto, William W. Comfort, Norman Daniel, Jacqueline De Weever, George F. Jones, Mohja Kahf, R. I. Moore, David Nirenberg, Lynn T. Ramey, Debra Higgs Strickland, and John V. Tolan.

4. Frederic L. Cheyette, *Ermengard of Narbonne and the World of the Troubadours* (Ithaca, NY: Cornell University Press, 2001).

5. For recent work on gender roles in medieval literature, see Select Bibliography below, particularly for works by E. Jane Burns, Kathy M. Krause, Roberta J. Krueger, and Karen J. Taylor.

6. For documentation of the business rivalries between the French and Italians during the twelfth and thirteenth centuries, see G. Schilperoort, *Le Commerçant dans la littérature française du moyen âge* (Gröningen: J. B. Wolters, 1933).

7. The detailed descriptions of "magical" automatons that enliven several chanson de geste narratives are almost certainly derived from eye-witness reports of contemporary Constantinople. See Gaston Paris, "La Chanson du *Pèlerinage de Charlemagne,"* in *Romania* 9 (1880):1–50; and Margaret Schlauch, "The Palace of Hugon de Constantinople," *Speculum* 7 (1932): 500–514. For the medieval habit of attributing marvelous qualities to certain inanimate objects, see Charles Bertram Lewis, *Classsical Mythology and Arthurian Romance* (London: Oxford University Press, 1932).

8. Marginal note written on to a thirteenth-century manuscript copy of the chanson de geste called *Beuve de Hantone* by an unknown seventeenth-century hand.

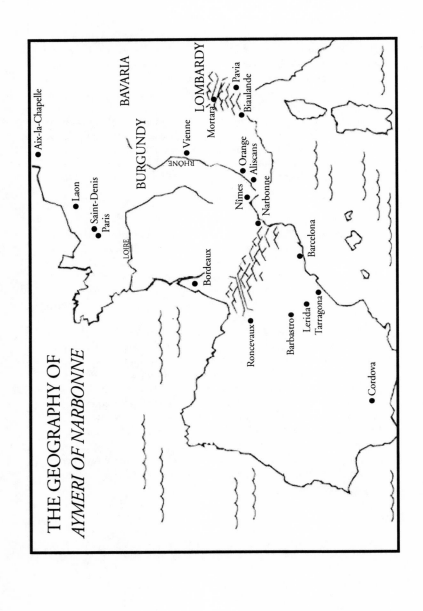

THE GEOGRAPHY OF
AYMERI OF NARBONNE

AYMERI
OF
NARBONNE

PROLOGUE

It's my delight to tell you all a tale
Wherein much wit and wisdom are contained;
And I would share my knowledge in this way,
For it's a fault in anyone, I'd say,
To know the truth and not to teach the same.
A hidden truth, I say, make no mistake,
Is like a fire on which the ash is raked —
It burns beneath but cannot give a flame;
So I shall speak without delay to praise
The finest man since Alexander's day. 10
Both high and low know very well his name:
So heed this song, whose honor only gains
 From its old, noble history.

This worthy song that I would sing you now
Relates the life of that most gallant count
Called Aymeri Brave-Heart of Narbonne town,
Who all his days with pain and strain endowed
In mighty fights against the pagan crowd.
He cherished God and championed His crown.
Each hour he lived, we know without a doubt, 20
There was no Moor or Saracen he found
Who did not come before him bowed and cowed.
Both everywhere and often you've heard how,
Since God ordained and made this world of ours,
No lineage from any lord came down
 To match the sons of Aymeri the Count.

1

Know this in truth: no line so fine or proud
Was like this lord's whom my song is about.
God bless the womb that carried such a count,
For by his deeds he blessed the lands around, 30
And every church and chapel, hall and house
Where God is served and all His saints avowed.
For such a man blest be the birth and hour!
In one whole month I never could recount
The flow of deeds of which he was the fount.
You all have heard of Aymeri's renown.
From when the king first gave him Narbonne town,
I do believe, until death struck him down,
He did not pass in peace one full year round.
And God's reward was of no mean account, 40
For in the end he earned His love unbound:
 A high and holy treasure.

In truth I say that in this song, good people,
You all may find much wisdom and sound reason,
For in old days Count Aymeri was a hero
Who of his life made such a fine achievement
That all his deeds should be well heard and heeded —
But not by cowards or any who are evil,
Or good-for-nothing or churlish or deceitful,
For shame alone is all that comes from these folk! 50
Barons and knights are people fit to hear it,
And counts and kings, and men of fame and breeding,
And worthy folk of noble mind and feeling.
In abbeys and in halls of prayer and preaching
This song of Aymeri should be repeated.
No prudent man should try to ban it either.
At any time folk should be glad to hear it,
Both during Lent or any festive season,
As only good can follow from its hearing;
And of the sons that Aymeri bequeathed us 60

No ill-repute was ever heard or meanness.
The truth is this — in written texts we read it —
That Aymeri and Charles, the fierce of feature,
Should have their names in history set clearly.
We know it well and truly that between them
The Christian faith, in all its realms and reaches,
Was saved from death by the prowess of these two.
If not for them, we know this most sincerely,
The Christian faith and law that we believe in
Would have been lost and totally defeated, 70
With no man left to worship our Lord Jesus;
But in his life King Charles was such a hero,
His name and fame so powerful and sweeping,
That seven kings were vassal–lords beneath him,
Who ruled their lands all owing him their fealty
And serving him as fast as spur could speed them.
You've heard in song so many times, good people,
How many keeps, how many forts and regions,
To Charlemagne's great will and skill all yielded;
How many Moors and wicked-working heathens 80
He brought to heel and wrought a fierce defeat on!
On any day no blighted pagan creature
Could fight for long against him and his legions —
Until that day when Roland, their brave leader,
And Oliver, the man he loved most dearly,
Were lost to Charles through treachery and treason,
When Ganelon, with spiteful heart and scheming,
Sold both of them to heathen King Marsile,
With twenty thousand French, the chanson teaches.
They all were slain by that great act of evil 90
 Wrought in the land of Spain.

THE FIRST GESTE

THE CAPTURE OF NARBONNE

⚘ CHANT 1 ⚘

HOW CHARLEMAGNE RETURNED FROM SPAIN
DISTRAUGHT AT ROLAND'S DEATH

White-bearded Charles was a most noble knight
For whom Lord God did wonders all his life,
As you have heard in songs time after time.
No mortal man, however great his pride,
No Moor emir or pagan king he'd find
Who brought him war or rivalry or strife,
Escaped his wrath or gained the least respite.
He slew them all upon the field of fight.
No ancient keep or fort could help them hide! 100
God showed His strength for Charlemagne in kind
When he set off for Spain with all his knights
And levied troops from every shore and shire,
So many men of courage hard and high!
They took Nobles and Barbastro alike
And then they won Lerida town besides.
Charles would have done all that his heart desired
And would have held in his own hand in time
The whole of Spain and all of Persia's might,
He would have ruled it all, this is no lie, 110
Had it not been for Ganelon, whose wiles
Robbed gallant-visaged Roland of his brave life,

And Oliver and all the rest who died
At Roncevaux through Ganelon's great spite.
White-bearded Charles, on hearing of the crime,
Was filled with woe that no man could describe,
But afterwards three days did not go by
Ere he avenged his worthy Frenchmen's lives
By leading troops against Marsile's might.
So many men they slew who knew not Christ 120
That all the land was strewn with fallen knights
For one good league and more both left and right,
And they pursued with very fierce desire
The routed king and his confounded tribe.
Then Charlemagne turned back towards the shires
Of wealthy France, with heavy heart and mind.
The French returned, each filled with grief and spite,
And each worn out with sorrow, strain and strife.
Their ranks were formed, but Charles was sat astride
A Syrian mule and rode along behind. 130
For Roland and his Peers his face was white,
And for their souls he prayed to Jesus Christ
That they might rest in everlasting life:
"May God preserve your soul, my nephew fine,
And garlands crown your brow in paradise!
In noble France what am I to reply
To all the knights and barons I shall find
At St. Denis' great abbey when they cry
And question me about those many knights
I led to Spain by will of my design? 140
What can I say, sweet blessed Mary mild,
Save that in Spain in Spanish soil they lie?"
Duke Naimon said, "Don't speak so wildly, sire,
For all your grief cannot bring back their lives.
The counts are dead and never shall revive.
Count Ganelon's to blame, God curse his life!"
"He has betrayed all France," the king replied:

"Four hundred years and more after I've died
Songs shall recount how I avenged the crime!"
When this was said the king and all his knights 150
 Pursued their course in silence.

<center>❦ CHANT 2 ❦</center>

HOW CHARLEMAGNE WAS CHEERED BY THE SIGHT OF
NARBONNE AND HOW HE FORMED A GREAT RESOLVE

Brave Charlemagne was coming home from Spain
With all the knights and soldiers he retained;
How heavy was the grief and great dismay
Shown by them all, as you have heard me say.
Our emperor was riding down a dale,
And as he rode back up the slope again
Towards the right he turned and fixed his gaze.
Between two cliffs and set along a bay
Upon a ridge he saw a city raised 160
By Saracens born in a former age.
The town was girt by walls and colonnades
More strongly built than any ever made;
Viburnum trees, grown in a grove for shade,
And yews they saw, which in the breezes swayed.
You could not see a sweeter sight than they.
Some twenty towers the shining town displayed,
And in their midst stood one of greatest praise.
No man alive, although his skills were great,
Would take less time than one whole summer's day 170
To tell of all the skill those pagans gave
To building this majestic tower I've named.
The crenels were all sealed with leaden frames,
Though any bolt would barely reach their range;
The dome that crowned its highest floor was made
Of shining gold, the best the East contained;

Set in it was a garnet-stone which blazed
Its luster forth and shed as bright a ray
As does the sun when dawn lights up the day.
In darkest night, this is no lie or tale, 180
Its glow would show from four full leagues away.
On one side lay the shoreline and the waves;
The other side the Aude's swift waters raced,
Which brought the folk whatever goods they craved.
Great barges which they summoned there conveyed
Rich merchants bringing goods and wealth to trade.
The city folk were so well served this way
That there was nothing that you could contemplate
Which this town lacked to honor man's estate.
King Charles observed the town and straightaway 190
His heart was fired to own so fine a place.
His closest friend was Naimon, whom he hailed:
"My noble lord," said fearless Charlemagne,
"I'd know at once, so do not hide it, pray:
Who owns this town so worthy of our praise?
Whoever does may boast and not be blamed
That in the world it has no peer, I'd say,
Nor any near whom it need fear to face!
But by the saint we praise, I tell you straight,
These men of mine who seek their French domains, 200
Shall do so first by passing through its gates!
I promise you, in truth, make no mistake,
That I intend to conquer this fine place
 Before I reach my homeland."

☙ CHANT 3 ☙

HOW DUKE NAIMON COUNSELED
AGAINST THE KING'S RESOLVE TO NO AVAIL

When Naimon heard King Charlemagne, whose talk
Had filled the knights with dread and fresh remorse,
He said to him in goodwill, but withdrawn,
"By God, your speech amazes me, my lord!
I never knew a will as wild as yours.
By all the faith I owe you, rest assured 210
That if you wish to take this town by storm,
You'll not have paid so dear a price before!
No town's as strong from here to Val Martroy;
It fears no siege or engine of assault,
And he who owns this town has in its walls
One thousand score of proud and haughty Moors,
Each one with arms and armor there galore!
They fear no siege of ours one Basel coin!
In faith, our men are so worn out with war
That three of them have not one woman's force. 220
No count or king, no prince or knight of yours
Desires to fight or to attack this fort.
They have no steed, no mule or saddle-horse
Which in this need would be of use at all —
For they've had naught to eat but grass and straw;
And not one man is left, I think, my lord,
With strength to bear his arms or armor forth.
With strain and pain they all are overborne.
True emperor, as for myself, I'm sure
I owe you faith, but my desire is more 230
 To be back in Bavaria!"

When Charlemagne heard Naimon speak this way
His senses reeled with rancor and dismay.

As angry as a savage boar he railed:
"Naimon, fine lord, not one more word, I say!
By glorious God I swear with all my faith
That I shall not return to France again
Till I have won this city with my blade!
Be gone, my lord, if you've no wish to stay!
But by the faith I owe St. Honoré, 240
Whoever goes, be certain I'll remain!"
Said Naimon, "Show some mercy, for God's sake!
Have pity on your knights and baronage
Whom you've so worn and overborne with pain!
Pass by this town in peace, fine Charlemagne!
You will not win its fortress all your days,
Unless God shows His strength here by His grace.
I'll tell you why I truly think this way:
The pagans have forestalled you in this place —
Beneath the ground they've dug a safe escape 250
Which, if they wish to take it, leads them straight
To Saragossa town with every haste;
And there's a metaled road which they have laid
To rich Toulouse and fierce Orange the same,
Which very soon will bring them massive aid,
If you besiege the city walls and wait."
On hearing this, Charles filled again with rage.
He called the duke and asked him, still unswayed:
"Naimon, fine lord, what is this city's name?"
The duke replied, "I'll not conceal the same — 260
It is Narbonne, in truth, for I have made
A careful search concerning this domain.
In all the world no fortress is as safe.
Its moat is more than twenty fathoms great
In width and dug in depth the same again,
And through the moat the tide flows from the bay,
And truly, sire, the great Aude River makes
A circle all around its walls — this way

10

The great iron-sheeted barges and galleys draped
With costly goods arrive with all their trade, 270
From which the wealth of this fine town is gained.
When all the bolts have barred the city gates
And those on guard have raised the drawbridge chains,
Its folk may rest assured that they are safe.
No mortal man could make them feel afraid —
All Christendom might storm the town in vain!"
On hearing this, the king laughed in his face
And in a voice of fearless strength exclaimed,
"So help me God, how glad I am we came!
Is this Narbonne, which I have heard so praised, 280
Which in its pride surmounts the whole of Spain?
When I took Nobles and held its King Forré,
I sent a guard with Roland to this place
To take the fort and man it in my name."
Said Naimon, "Sire, you speak the truth, in faith,
But all the Moors did then was lie in wait,
And when they saw your nephew ride away
The faithless fiends assembled in great haste
And then attacked the town and fort again,
Assaulting it from every side and way. 290
Those heathen dogs brought to its walls and aimed
So many catapults with rocks so great
They took the town in less than thirty days.
Our garrison was torn apart and slain.
Since then the Moors have worked so hard that they
Have built again the walls their siege laid waste.
And all around the moat has been remade
At greater depth, with ramparts greatly raised."
On hearing this, the king's expression changed:
"Who holds it now, this fortress, in their sway?" 300
"In God's name, sire, I will not hide their names:
King Agolant and strong King Desramé,
With Drumanz called Longbeard and Baufumez,

And twenty thousand Moors armed for the fray,
Who have no faith in God and neither pray
 To His most blessed mother."

Said Charlemagne, "Will you rule here for me?"
The duke replied, "My lord, I'll not indeed!
Its folk are full of pride and self-esteem,
And do not prize your honor in the least. 310
By all my faith, you will be here a year
Before you'll take this town, that's my belief!"
"Good friend," said Charles, "by God, my mighty Liege,
I'll so assault this town before I leave,
No wall or work shall save them from the siege.
Ere I return to France, where I must be,
I'll settle here the Christian law and creed.
I shall install, I think, one of my Peers,
 To render service for it."

<p style="text-align:center">❧ CHANT 4 ❧</p>

<p style="text-align:center">HOW CHARLEMAGNE OFFERED NARBONNE
IN FIEF TO EACH OF HIS TWELVE PEERS</p>

King Charlemagne was very bravely bred. 320
He saw the town and its old fortress held
By twenty thousand Moors and Saracens,
And planned at once a fine piece of prowess:
One of his Peers of great renown and strength
Would have the town and its fine residence
And guard its shires and shoreline in his stead,
In fealty and homage to himself.
And so he called a count of high noblesse
And wise repute, whose name was Count Dreues.
When fierce-eyed Charles beheld him standing there, 330
 He hailed him very nobly.

"Dreues of Mondidier, fine Peer, come forward!
You are the son of a most noble forebear.
You should be loved and cherished well by all men.
Receive Narbonne, which I shall make you lord of!
This wealthy land shall lie beneath your orders,
Each shire and shore to good Montpellier's borders!"
Dreues heard this and bridled in annoyance:
"My lord," he said, "I have not asked you for it!
The living fiend can take it and destroy it! 340
Within a month, in all faith I assure you,
I want to be in my own land and fortress,
Where I may bathe and heal the wounds I've borne here.
I am worn out; I can do little more, sire.
I need to rest; in truth I am exhausted.
Fine emperor, the truth of it is also
That I've no steed, no saddle-horse or palfrey
With strength enough to stride or struggle forward.
As for myself, for one whole year or almost
I have not slept three nights without my hauberk, 350
And spent each day in riding or in warfare,
With pain and strain for my companions always;
And now you'd give Narbonne to me in wardship,
Which still is held by twenty thousand Moors here!
My fierce-eyed lord, to someone else award it —
 I do not want Narbonne."

Again spoke Charlemagne, the white of beard:
"Come forward you, Richard of Normandy!
You are a duke of very high degree
Whose heart is full of highest bravery. 360
Receive Narbonne and rule it as a fief!
You shall control this wealthy land for me.
I swear to you, while I still live and breathe
You shall not lose one jot of what it yields."
On hearing this, Duke Richard groaned and grieved:

"My lord," he said, "your words are rash indeed!
Within this hated land so long I've been
That all my flesh is bruised with injuries.
Since I have been among the pagan breed
I have not shed my byrnie for one week, 370
But by the saint that pilgrims sue and seek,
If I were back in Normandy, my seat,
There's naught in Spain that I would want to keep,
Nor would I care to rule Narbonne as liege.
Choose someone else, for I want it the least!
 May hell-fire burn the city!"

The emperor stood there with downcast eye
For these fine counts of proud and fearsome line
Who each refused to rule Narbonne outright.
He called Hoel of Cotentin this time, 380
A palace-count, a brave and well-bred knight:
"Come forward, count of birth and breeding fine!
Receive Narbonne's rich hall of marble white!
One thousand knights will serve you as you like.
So please the Lord, Who made the water wine,
It shall no more be ruled by pagankind."
On hearing this, Hoel bowed and replied,
"St. Martin be my witness, noble sire,
I'll never live in Narbonne or nearby!
For I have worn my double-hauberk's iron 390
From early morn until the dead of night,
My flesh all bruised beneath this fur of mine;
And now to me you offer Narbonne's rights,
Which twenty thousand Moors still hold inside,
Who do not fear your name one mote or mite!
Though I received all Pépin's treasure, I
 Would not rule Narbonne city!"

King Charlemagne was very vexed and wroth
To hear his counts and barons fail him so.
He called upon Girart of Roussillon: 400
"My noble lord well-bred," he said, "approach!
Receive Narbonne, which freely I bestow.
The land around you'll hold from me alone."
On hearing this, Girart's old chin dropped low,
Then with goodwill he answered, nothing loath,
"True emperor, you speak in vain! All know
That we came here more than a year ago
To save this realm and fight its heathen host;
I've scarcely slept since then in hall or home,
But in my tent upon the fields and slopes. 410
And always dressed in my bright hauberk-coat
All seasons through, both in the heat and cold,
I've served you here as fast as spur can goad,
Till all my flesh is bruised as black as coal;
And now to me you tend Narbonne's control,
Which twenty thousand Saracens still own,
Who do not fear your name one mite or mote!
Give someone else Narbonne to have and hold —
I'll not stay here for all Solomon's gold!
 I have enough land elsewhere." 420

King Charlemagne the fierce was full of wrath
When all refused to take the town Narbonne.
He summoned next the noble Duke Heudon:
"Come forward, duke of Burgundy the strong!
I'll give to you the city of Narbonne."
"My lord," said he, "do not, for love of God!
For if you do, you show you love me not!
I have a land, a lovely land, now locked
In war against a count beyond the Saône.
He has attacked my lovely land and robbed 430
More wealth than all the worth of Tarragone.

Just yesterday word came to me therefrom.
Without delay, my lord, I must be off
 To rescue my own borders."

King Charlemagne was filled with deepest rage
When all his lords refused him in this way.
He summoned next in speech Ogier the Dane:
"Come forward, duke," said fierce-eyed Charlemagne:
"Receive Narbonne, which I'll bestow this day!
It could not go to any lord more brave. 440
Hold all this land and rule it in my name!"
On hearing this, the blood left Ogier's face.
He said, "My lord, I want it least, I'd say.
I've land enough which I would not exchange.
I seek repose from all my pain and strain
In Denmark's realm, when I am home again.
I do not seek to rule Narbonne's domains.
Bestow this town on someone it will grace,
 For I cannot accept it."

King Charles's mind was filled with wrath and woe 450
To hear each knight refuse what he'd bestow.
He summoned next the Marquis Salemon:
"Come forward, knight of breeding brave and bold!
Accept Narbonne, its fort and golden dome,
And all the land around from me you'll hold!"
On hearing this, he hung his head down low
And then replied with anger in his tone:
"True emperor, by St. Denis' own bones,
The Judgment Day itself may come and go
Before I'll stay and govern Narbonne so! 460
My only wish is to return back home
And take with me the noble knights I own —
But very few are left to me, God's oath,
And how I grieve for those slain by the foe.

16

May paradise receive their valiant souls,
For they are lost to me, like it or no;
But this one thing, King Charles, I'd have you know:
I'll not rule here for two whole weeks alone!
Fine emperor, lay somewhere else this yoke,
 For I shall never bear it!" 470

With fiercest rage King Charles's face was livid
When his best men refused to do his bidding.
He summoned Gondelbuef, king of the Frisians:
 "Come forward, knight of brave and worthy kinsmen!
Receive Narbonne, which with this glove I'll give you!"
The German heard but did not feel like singing!
With ringing voice he answered very swiftly,
"True emperor, your words leave me bewildered!
For one whole year and more, in my opinion,
I have not seen my wife or my own children. 480
My heart's desire is to return to Frisia,
For here in Spain I've borne with much affliction
And too much pain and strain to further linger.
Of all my men I scarcely have still living
One third of them, and I am filled with pity.
The Saracen and Persian hordes have killed them;
And I've no steed or saddle-horse still living
Which is not spent of all its speed and vigor.
Now you would give to me this city's riches,
Of which you hold at this time less than little! 490
But by the saint besought of every sinner,
I'll not agree for one day or one minute!
Find someone else — the devil take this city,
 For I shall never have it!"

"Duke Naimon of Bavaria, come forward!"
Said Charlemagne, whose courage never faltered:
"Your flag is first in battle to support me

At any time and I esteem you for it;
You never yet have failed or served me falsely.
Receive Narbonne, its land and all its shoreline! 500
Its mighty tower and all the town in wardship
You'll hold from me to great *Gate-on-the-Water,*
So please the Lord, this faithless race shall forfeit
Their ill-won wealth, down to the smallest straw-stalk!"
On hearing this, the duke fiercely retorted:
"True emperor, no more of this exhorting!
I want to go to my own land and fortress.
Since I came here from my Bavarian borders
I have not slept one month without my hauberk
And sword-blade girt, and laced up in my coif-cap! 510
And all my men, whom I loved well, are slaughtered.
Of fifteen score my flag of war had brought here
There are not five whose deaths I am not mourning.
The wretched Moors have slain them all in warfare.
You offer me this great town to reward me,
But I tell you, without a doubt and surely,
I'll not accept, whoever asks or orders.
Bestow it, sire, on one more suited for it.
 It never shall be mine."

"Come forward, Anseis of Carthage, pray! 520
Receive Narbonne and rule its hall of state.
You are a knight who always has been brave.
Defend this port and keep this shoreline safe
From the attacks of heathendom's foul race;
And if the Moors besiege you in this place,
Or come to fight or lay your land to waste,
Then send for me by envoy straightaway.
No wind or storm shall stop me or delay
Me bringing here my noble barons' aid."
On hearing this, Anseis boiled with rage: 530
"True King, I've not the least desire or aim

18

To tarry here in this harsh, hostile place!
I would be mad, I swear to you in faith,
To leave my home, my land and my estates,
Where there is none who challenges my name;
With every cause they'd say I was insane!
If I stayed here, enclosed in this enclave,
I would be like a bird trapped in a cage.
 Accursed be such a country!"

Our emperor grew wilder in regret 540
And once again lamented Roland's death
And all those lords he'd loved so long and well:
"My nephew fine, alas that you are dead!
No more again shall I find such a friend
Nor ever know whom I may trust in hence!
The proof of this my present need attests!"
Thus spoke the King with anger in his breast.
Then he began to ask his Peers again,
Sir Doon first, lord of Valcler, and then
Old Duke Girart, the brave lord of Vienne; 550
But no one there was willing to accept,
So much they feared the Eastern pagans' threat.
Charles grieved anew when all refused the pledge,
For he knew none to turn to now — except
Hernaut the count, much praised for his prowess,
Lord of Biaulande, upon the sea itself.
Charles looked for him and, bidding him attend,
 He offered him Narbonne.

☙ CHANT 5 ☙

HOW HERNAUT OF BIAULANDE WAS MOVED TO SPEAK

"Hernaut, fine lord," said Charles the fierce of eye,
"Receive Narbonne by will of my design, 560

19

And with such terms as I shall now describe:
In war or siege against the antichrists
I'll stand by you with many of my knights."
"In God's name, sire," the brave Hernaut replied,
"I'm old and weak. I can no longer fight
Or bear my arms or mount a horse to ride!
I have no wish for further war or strife,
Nor dare to bear a burden of this size!
Whoever has Narbonne to guard and guide
Will have to meet with courage countless times 570
Assaults within and battles waged outside.
You should confide this wealthy city, sire,
To someone young, who is both strong and lithe,
And fit to bear the fighting he must bide
To beat the Moors right back across the tide
And conquer them with steel and iron's might.
Sire, such a man should rule this city's pride —
Unless one does, I will not try to hide,
Who is both strong and from a fearsome line,
 He will not keep the country." 580

On hearing all his knights refuse and fail
To do his will and rule Narbonne this day,
How Charles bewailed his nephew Roland's fate,
And Oliver his friend, who was so brave,
And all the lords whom Ganelon betrayed!
"Fine youth," he said, "may God, Who never fails,
Receive your soul with pity and with grace,
And all of those who died for His love's sake!
If you still lived, I know as sure as faith,
Narbonne would not be spurned or spared this way; 590
But since it seems that my true friends are slain,
The Christian faith henceforth is desolate!
But by the Virgin's Son, I swear again
I shall not leave this siege that I shall lay

While pagan law still holds in thrall this place.
Good nobles who have served me well in Spain,
Turn back your steeds, heed truly what I say,
Towards those realms where you were born and raised!
For by the Lord, Who never lies or fails,
Since you refuse my will and disobey, 600
Go one, go all, but know that I shall stay
 And take again this city!"

"My worthy lords," King Charlemagne said on,
"Burgundians and Frenchmen all, ride off!
Knights of Aval, of Flanders and Hainaut,
And of Anjou, of Poitou and of Mans,
Of Brittany, Lorraine and Hurepoix,
You Berry men and all you Champenois,
And all of you who have no will to stop.
I'll keep no man against his will — be gone! 610
Lords, do not think I jest, for I do not!
I swear by St. Firmin of Amiens,
I shall remain in this realm of Narbonne
And have the town and its strong garrison!
For twenty months, in faith, I'll wait and watch
Till I may take this palace rich and strong;
And when you all return to Orléans
Within sweet France, and when you come to Laon,
And people ask where is your king — by God,
My lords of France, make sure that you respond 620
That you left him to lay siege to Narbonne!
I'll make my laws and judgments from this spot:
If any man has grievances or wrongs,
He must come here to see me from now on —
From nowhere else shall he gain a response!"
"God," said Hernaut, the good count of Biaulande:
"Most noble king, my lord, what shame and shock
I feel for you, to see you in such wrath!

I never knew you yet so woebegone!
My name and fame and honor would be lost 630
If I left now before I'd served your want.
I have, my lord, a brave and well-bred son,
Who has, indeed, not borne his sword-blade long:
In truth, two years and four months have not gone
Since Girart of Vienne first girt it on.
If he desired the wardship of Narbonne,
King Charlemagne could swear that he had none
In all his realm, from here to Vermandois,
 Who kept so well his borders."

Towards the king Hernaut of Biaulande stepped 640
And hailed him like a man of noble sense:
"True emperor, my lord, do not lament!
You should not show such anguish or distress.
Though you have met with loss and are bereft
Of all those lords slain by the Saracens,
You have, yourself, not met defeat or death;
And God the Lord is still your greatest strength,
Who will assist and aid you in your quests.
If I were not so old and white of head,
Then I would have and hold this realm myself, 650
And rule its shires and shoreline in your stead;
This long debate would soon have found an end!
But I've a son, both strong and fiercely bred,
Who is a knight of wisdom and prowess.
If by your deeds you make him your best friend,
By God above, I do believe that then
This city and this realm will be well held
And well secured against the pagan threat."
"God!" said the king, "Command him to attend!
 Such news was ne'er so welcome!" 660

HOW AYMERI APPEARED BEFORE CHARLEMAGNE:
HOW AN OLD QUARREL WAS REMEMBERED
AND A NEW COMMITMENT WAS SWORN

Hernaut the count was neither slack nor slow:
To Aymeri his son at once he strode
And hailed him thus — my friends, heed how he spoke —
"Son Aymeri, may God fulfill your hopes!
If our Lord God, from His majestic throne,
Exalts your name and lets your honor grow,
What happiness both you and yours will know!"
Said Aymeri, "Why have you spoken so?"
"In God's name, son, I'll tell you, nothing loath!
Our Emperor, so fierce of eye and bold, 670
Has summoned you, through me, and you should go!
In truth, my son, he wishes to bestow
Narbonne on you and all that it controls!
Fine son, by God, Who bore the Cross's woe,
If he does this, do not indeed say 'no.'
If you can take Narbonne with lusty blows,
You will be rich for evermore, I know!"
Said Aymeri, "All praise the Lord of Hosts!
My father fair, just lead me there, God's oath!
For by the saints whom God has loved the most, 680
I would not like another knight to own
This fief Narbonne for ten towns full of gold!
If God permits Narbonne to be my home,
Then Roland's death shall be most dearly sold,
The fearsome count whom heathen Moors laid low;
If I dwell here, their death-knell shall be tolled!
From here to Balaguer not one alone
Shall live unless he joins the Christian fold,
Or earns a truce through tribute I'll impose.

If I survive to sit on Narbonne's throne, 690
 All Spain shall pay the forfeit!"

Good Hernaut came once more before his liege
King Charlemagne, who still was much aggrieved.
Before them both stepped fearless Aymeri.
In fourteen lands his presence had no peer,
For he was tall and strong and fair indeed;
His look was fierce, his face was bright and clear;
Towards his friends his mood was mild and sweet,
But fierce and hard to all his enemies.
The knights and lords all stared when he appeared, 700
But Aymeri was wise and finely reared.
On seeing Charles, he showed no sign of fear.
Before the king had even moved to speak,
Young Aymeri hailed him most courteously:
"May God, Who dwells in paradise redeemed,
Protect and bless the king of Saint-Denis,
And all the men who sit before him here,
And send to death all of his enemies!
Fine emperor, my lord, attend my plea!
Give me Narbonne and its dependent fiefs, 710
Which marquises nor princes want, I hear,
Who fear too much the hated heathen breed!
Fine emperor, my lord, give it to me!"
On hearing this Girart laughed loud and deep.
Then Charles replied, so fierce of eye and cheek:
"By all God's saints, is this then Aymeri?
Young Aymeri, by blessed St. Denis,
Do you wish now to be my friend indeed?
You have dismissed the day and hour, it seems,
When at Vienne I held Girart in siege, 720
And hunted pigs beneath his woodland trees?
Girart the duke surprised me in the deed
And you yourself were with him, sword unsheathed!

Your hatred then towards me was so deep
I would have died if he had paid you heed!
If I was spared, it wasn't on your plea!"
"In faith, my lord," replied young Aymeri,
"My mood is such and such will always be —
I'll never love or spare my enemies!
But you know well you acted wrongfully 730
When you attacked my uncle's land and lease.
In faith, my lord and king of visage fierce,
If you so wish, you have a friend in me;
But if you don't, by blessed St. Denis,
Then once again our friendship's bond shall cease.
I have no land of value in the least,
But if God wills, then I shall soon receive
A wondrous wealth well purchased with my steel."
"In truth," said Charles, "your heart is high indeed.
In Jesu's name, Who bore the Cross's grief, 740
I give to you Narbonne and all its fiefs.
Accept them, friend, together with this plea:
That God, Who pardoned Longinus his deed,
Grant you success against your enemies!"
"God hear your words, my lord," said Aymeri,
 "And strengthen my own valor."

Said Charlemagne, "Now this has been put right,
I am much eased of my distress and spite.
Now Aymeri will govern and will guide
Narbonne in fief and its dependent shires, 750
I do believe with all my heart and mind
That evil times await all pagankind!
Sir Aymeri, your bravery is high,
But low indeed your wealth and your supplies.
Much shining gold and silver are required,
And hay and oats, and meat and wheat and wine,
And many steeds, and arms and armor bright,

By any lord who rules a land as fine
As does the lord who governs Narbonne's pride!"
"You fill me with dismay, God help me, sire! 760
But by St. Clement's bones," the youth replied,
"Does God no more dwell in His heaven high,
Who governs all with everlasting might?
With all my soul I trust in Jesus Christ,
And He, I think, will help me in good time!
Sire, I am still a young, aspiring knight;
So help me God, Who never fails or lies,
Whatever wealth the pagans have acquired,
I am quite sure will soon be yours and mine!"
When Charlemagne heard such a fine reply, 770
 It filled him with rejoicing.

"Sir Aymeri," said Charles the fierce of visage,
"My noble knight, be of good cheer and spirits:
What help I can, I shall not fail to give you.
Before I must return to my French kingdom
I shall ensure one thousand knights stay with you.
Each one shall have a steed and good equipment,
And in your need these knights will aid you swiftly
To wage campaigns against the Moors and win them.
Whatever wealth you gain from any victory, 780
In land or property, in gold or silver,
I shall not wish to have one little bit of!"
"Much thanks, my lord," said Aymeri, "God willing,
Who, big or small, holds all in His dominion,
No evil news of us shall be delivered!"
At Charles's feet he knelt down in submission,
And did not rise until the king had bidden;
Charles said to him, as all his barons listened:
"Sir Aymeri, I shall not leave it hidden:
From this time forth I'll love you like a kinsman! 790
My noble lords and soldiers," he continued,

26

"Of Berry shire and France, I bid you listen!
I should not hide from you what I am thinking:
For many a day no mirth has dwelt within me.
Since Roland died and Oliver, and with them
Those hardy lords whose arms gave me assistance,
I've had no joy in eating or in drinking;
But now, good men, be sure this mood has finished!
Behold this youth, for he deserves the tribute!
I feel that he displays such fighting spirit 800
That much indeed of my great grief has lifted.
Now I would like, if you yourselves are willing,
To have prepared a jousting pole, a quintain,
Raised just outside the walls of Narbonne city.
Let our young knights ride out and strive to hit it,
And our young men earn fame through competition!
If Aymeri will lead the way to signal
His love for me, I'll cherish him more richly.
If we can start a tourney with our tilting
That tempts the Moors to ride out of their city 810
To challenge us as we attempt the quintain,
By God, the Judge of all, I truly think that
Whoever wants may profit from the issue!"
Said Aymeri, "We'll do as you have bidden.
Seize forth your arms, knights lithe of limb and nimble!
By St. Denis, we'll all ride forth this instant
 To strike those quintain-posts!"

☙ CHANT 7 ☙

HOW AYMERI DISPLAYED HIS MOOD TOWARDS THE PAGANS

When Charles's wish and counsel were proclaimed,
For love indeed of Aymeri the brave,
Some quintain-posts were placed down on the plain, 820
Beside the moat and near the city's gates —

27

Too near indeed for cowards or for knaves!
The youngest knights were armed without delay,
Those newly raised to knighthood's high estate,
Who by their deeds of daring sought more fame.
How many steeds were saddled up and reined!
How many gold and silver shields were raised,
How many spears and solid pikes ornate
With pennants and with flapping flags they waved,
All well-equipped for jousting on that day! 830
King Charlemagne called Aymeri and hailed
Good Hernaut's son in ringing tones this way:
"Sir Aymeri, I have a wish to make!
If you agree, be first to strike and lay
The quintain low, for me and my love's sake,
So that my lords may see your valor's rate!"
"My lord," he said, "your will I will obey."
He said these words but thought another way:
Within his heart a silent vow he prayed,
That his proud line should never bear the shame 840
That he chose empty shields to fight against!
He called to him five hundred youths, and they
Were all his friends, companions of his age,
And of his geste, for whom his love was great,
Young knights of worth and prowess to be praised:
"My lords," he said, "be armed as best you may,
And by my side ride forth in ranks arranged;
Towards the town we'll ride and lie in wait.
If God resolves, in His majestic way,
To make the Moors and pagans leave their gates, 850
Then make quite sure that you are unafraid!
If we can meet and beat them with our blades,
We all may win such plunder straightaway
To make us rich and wealthy all our days!"
They all replied: "Your will we will obey.
Though limb or life be lost, we shall not fail!"

So all of them, well armed, without delay
Left in a group the host of Charlemagne,
Without one word to any it contained,
So much they feared the emperor's fierce rage; 860
They rode along, not slackening their pace,
And lay in wait beside an ancient drain,
Not far removed from Narbonne's city gates.
Then all those knights back in the host made haste
Towards the posts and struck them straightaway
To please the king and frolic as he bade.
How many spears they split apart that day
And iron shafts they shattered in that game!
But Aymeri, who saw it all take place,
He and his men moved not one inch away 870
To strike the shields those quintain-posts displayed!
When time had passed a little in this way,
God's hand re-shaped their fortunes and their fate.
For they beheld one hundred Moors who'd strayed
Outside the town to comment and to gaze
Upon the French — for they had seen them raise
Those quintain-posts upon their grassy plain!
They saw the French, but not the French who lay
Beside that drain and ditch in ambuscade!
If they'd seen them, in truth they'd not have strayed 880
For all the gold a hogshead could contain!
Count Aymeri observed them well and hailed
His men this way: "My worthy knights and brave!
The grace of God has blessed us all this day.
What I sought most has brought itself my way:
The pagan foe I've wanted so to face!
Now all will see whose prowess will prevail,
Whose blood will rise with valor in his veins!
Strike noble blows, knights worthy to be praised,
So that our deeds earn no reproof this day!" 890
His knights replied, "Well spoken, lord, in faith."

When this was said they readied for the fray.
Young Aymeri spurred his fast destrier
And raised his spear of sharpened iron well-shaped.
He spoke no more, to preach nor yet to pray,
But struck the first who stumbled in his way
And split his shield and slit the hauberk's chain.
One lance's length he flung him to his grave.
He called aloud King Charles's battle-gage:
"Now strike the rest with courage unallayed! 900
The first of them stands no more in our way!"
And so they did, without a stop or stay.
With all their heart they struck those heathen knaves!
How fierce a fight, how wild a battle raged
When French prowess with pagan pride engaged!
How many shields were splintered through the grain,
How many coats were cleft and reft of mail,
How many helms of green crushed clean away,
How many Moors unhorsed, how many laid
Upon the ground, some wounded, others slain, 910
While others fled or floundered to escape!
The dead fell dumb, the wounded wept and wailed:
"Mahomet, lord, take pity on our pain,
For we have met with devils in this place!
The blest alone will live to tell the tale!"
They turned in flight, they neither stopped nor stayed,
But Aymeri held high his shining blade.
The man he struck had spent his span of days.
How well the count displayed his valor's rate!
He struck the Moors so much with spear and blade 920
That of five score not forty Moors escaped
And fled towards their mighty castle's gate;
But Aymeri, of strength and temper great,
Pursued them all, his graven sword upraised.
Upon the bridge he met with one and rained
So fierce a blow he knocked the villain straight

Down in the moat, his thirsty throat well slaked!
The rest of them rushed back inside the gates,
Which quickly shut to keep those wretches safe.
Still Aymeri rode on, his sword upraised, 930
And struck the gates with all his heart and hate:
"Narbonne," he cried, "now you are mine to take!
You sons of whores, you blighted, heathen knaves,
Give up your towers! Surrender all your gates!
This town is mine, a gift from Charlemagne!
If you refuse, with life and limb you'll pay!
I'll have you hung or flung among the flames:
 For I shall have this city!"

When all the Moors were vanquished or were dead,
Who'd ridden from Narbonne to spy the French, 940
Count Aymeri rode back with all his friends.
King Charlemagne had seen from his own tent
How Aymeri had fought the infidels.
He saw and knew that Aymeri, instead
Of tilting at the quintain with the rest,
Had ridden straight to strike the Saracens.
The emperor was filled with high content
To see those youths acquit themselves so well.
Now as his knights rode forth to meet with them,
The king stepped forth, not waiting to be met. 950
He saw the youth and, greeting him, he said,
"Sir Aymeri, what happened to your pledge?
I saw you fight with Saracens instead!
You paid small heed to what I told my men,
And did not do as promised or as pledged.
Not one blow at those quintain-posts you sent!"
"Sire, pardon me," Count Aymeri said then,
"By all my faith I meant no disrespect;
But I would have been shamed and blamed myself
If I had struck a shield and nothing else! 960

It was more fit that I should test my strength
Against those Moors who dared to show their heads!
So help me God, Who bore the Cross we bless,
I'll never love, as long as I draw breath,
 An infidel or heathen!"

☙ CHANT 8 ☙

HOW AYMERI TOOK THE CITY OF NARBONNE

When Charlemagne heard Aymeri's bold speech,
He laughed aloud and willingly indeed.
The worthy knights disarmed themselves and each
Had water brought, then all sat down to eat.
I will not say what food made up their meal, 970
But every man well satisfied his need.
As for the Moors — the shock they had received
Inside Narbonne was plain for all to see.
The town's four kings in counsel were convened —
All brothers they, or so I learnt at least —
King Baufumez was one, it seems to me,
With Agolant, a brave and well-bred liege,
And Desramé and Drumanz, fierce of mien.
Each said to each, "King Charles has set a siege!
Mahomet help us all, look there and see! 980
He rides from Spain back home to Saint-Denis,
In fearsome rage against us and our breed!
By good Mahom, if we are taken here,
We'll pay the price for all his slaughtered Peers!"
Said Agolant, the oldest and most fierce,
"I counsel this, my lords, if you will hear —
We all are kings of honor and esteem —
If you will do as I advise, then heed!
First, two of us should go to the emir
In Babylon, whose power is supreme; 990

You can be sure he'll come to our relief.
The other two, meanwhile, should tarry here
To guard the fort from capture and defeat."
"We quite agree," replied the other three,
"Let us proceed as you have said, indeed."
Their counsel done, and everything agreed,
King Desramé at once prepared to leave
With Baufumez; they left immediately,
Escaping through a tunnel known to each,
Then spurring on with every haste and speed 1000
 To seek aid and assistance.

The envoys left; with no delay at all
They rode beneath Narbonne along a vault.
All day and night they rode without a halt
And left the tunneled road before Orange,
Which was their town, like Nîmes, which lay before.
So much for them! The devil curse their course!
I'll tell of Charles the mighty emperor
And Aymeri, the worthy count, once more,
Whose hearts were full of hate for every Moor! 1010
Soon after that, one morning with the dawn,
The emperor bade heralds sound his horns
And all his knights and soldiers armed for war —
For the assault, which all had waited for.
They stormed Narbonne, behind it and before,
While those inside defended with all force.
Within the town both high and humble-born
Were called to fight and fortify the walls.
Great stones they cast, God curse them one and all,
And sticks and staves they hurled with sharpened
 points, 1020
Which sent to death each wretch they struck or gored.
On seeing this, King Charles was angered sore,
And in God's name he cursed them all and called:

33

"God damn you all, foul Saracens and Moors!
You took from me Roland and Oliver,
And my Twelve Peers, who were my pride and joy!
But by the saint of sinners all besought,
Before I turn to worthy France once more
I'll sell you dear my anger and remorse!"
He called to him his engineers, Morant 1030
And Savari and his brother Jordant:
"Make straightaway a siege-tower strong and tall,
As great in height as Narbonne's city walls,
So we may take at once their shining hall!
I'll pay you each so much in goods and coin
That you'll be rich and wealthy evermore."
All three replied, "Just as you wish, my lord."
And they began at once to size and saw.
They worked all day till dusk, without a pause,
And then all night by lantern and by torch. 1040
Their carpenters so labored at their toil
That Charles's tower was standing by the dawn.
Towards the walls their workers dragged it forth,
Then fighting men and archers climbed the boards.
When this was seen by all those heathen Moors,
Each said to each, "These French are most adroit!
What mighty piece of magic brought this forth?
We all are slain — defeated and outfought!
Our messengers have ridden hard for naught:
Ere the emir can bring us his support, 1050
 We shall have lost this city."

The mighty tower was raised to its full height
And dragged in place to face the ramparts' height.
Then catapults were brought on and aligned
To cast against Narbonne and those inside.
Then Charles addressed Duke Naimon, standing by:
"Fine lord, if you approve and think it wise,

Then send the word along my soldiers' lines
For all to arm, not wasting any time.
Make sure there is no soldier or young knight 1060
Nor any man with strength to wield and strike,
Who doesn't now prepare himself to fight —
In this assault not one shall stay behind!"
"I grant this well, my lord," Naimon replied.
So through the ranks those horns and trumpets cried
Their call to arms and every knight complied —
No duke there was or count, no peer or squire,
No serving-man or young, aspiring knight,
Who failed to arm for the assault and fight.
Then Charles himself harangued them all and cried, 1070
"My worthy lords, now you must risk your lives
To earn the love of our Lord Jesus Christ!
Today the brave must prove their valor's might.
Raise war-machines against the wall and climb —
And he who does and penetrates inside,
I'll give that man as much gold coin of mine
As he himself could ever dare desire!"
On hearing Charles address them in this wise,
They left their tents, not wasting any time,
Not halting once until they reached the site 1080
And rolled machines against the city's side.
Then their most bold began to climb and rise.
The Saracens and Moors looked on in fright,
 Afraid that day of dying.

When this began how bleak the struggle was!
King Charles's men were brave and full of pluck
And fierce intent as they attacked them thus.
On seeing this, the hated infidels,
Though fearing death, each man and every one
Rushed up to save the city's battlements. 1090
They cast great stones, God curse them all, which struck

So many men and stove in countless skulls —
Pavian helms were cracked in half or crushed.
The French looked on, lamenting loud and much,
But nonetheless did not relent or run
But strove again and fiercer still to come!
They felled the trees that lined the city's front
One arrow's range in full circumference,
And in great rage they filled the ditches up,
And charged the walls all round in one great rush. 1100
With picks in hand and some with axes clutched,
They struck the walls in one united thrust.
A mighty swathe they would have cleft and cut,
When Charles upon a Syrian mule rode up.
He saw them strike and called to all of them:
"Don't smite the stones, my worthy lords well-loved!
For all the gold that gleams in Syria,
I do not want this ancient city touched,
Its fortress felled or any ruin done.
With Jesu's help, our blessed Mary's Son, 1110
We'll take the town exactly as it was!
And by the saint whom pilgrims seek in trust,
For seven years we'll stay here if we must.
If you need help, then I shall send at once
To bring reserves from noble France to us.
The hated infidels shall pay with blood
 Until Narbonne surrenders."

When every knight and man heard Charles's voice,
Forbidding them to break or breach the walls
But come to grips and grapple with the Moors, 1120
They all were filled once more with deep remorse.
Each said to each, "This bodes ill for us all,
For we may never reach fair France henceforth,
Nor see our wives or children any more!"
When this was said the noble youngsters paused

And soldiers stopped, both turning to withdraw,
Not daring more to strike or breach the walls.
On seeing this, the hardy knights sped forth
To arm themselves in hauberk-coats of war,
Then in their rage began a fresh assault. 1130
They raised some fourteen ladders against the walls,
All tall enough to reach up and be caught
Within the crenellations and secured.
Then Charlemagne, the fierce-eyed emperor,
Drew up the tower against the very walls.
Foot-soldiers now and archers climbed in force;
Crossbowmen raised their crossbows to the fore,
Took aim and let their cutting bolts fly forth.
The archers too shot arrows at the Moors
Whom they could see in lines and relays formed 1140
To hurl down stones without one moment's pause.
A lot were hit and staggered back to fall
Upon the ground behind their city doors!
If you had heard those pagans howl and roar
And hail Mahom with sundry cries and calls!
One league away folk heard the awful noise.
The French themselves were in no mood to halt
But struck again at every side and point
To give the Moors no chance or choice at all.
Young Aymeri, whose deeds deserved reward 1150
Above the rest, this fact I know for sure,
Strove fearlessly to drive on the assault.
One hundred men by whom he was adored
Attacked the gates with every haste and force;
Some twenty clutched great axes in their claws
And wondrous feats of carpentry performed:
Now right, now left, they cut so well and sawed
That, breaking through the city gates' stout boards,
They burst the beam, which fastened both its doors!
The Moors inside were helpless then to halt 1160

Our worthy knights, who rushed in by the score!
I do not know who entered last of all,
But Aymeri the count was first, I'm sure!
If you had seen how they cut down the Moors,
Whose self-defense grew hopeless more and more
As dead on dead were flung upon the floor!
Some turned in flight towards their mighty hall.
With ringing voice they cried aloud and called,
"Deliver us, Mahomet, mighty lord!"
They sought retreat inside the palace–fort, 1170
But ere those rogues and wretches reached its doors,
Our Frenchmen slew at least some fifty score!
My friends, if you had seen how Aymeri fought
And felled the Moors with his well-burnished sword:
How heads and arms and feet and fists were shorn
Each time he struck, you'd praise him too, I'm sure!
He struck so hard, behind him and before,
With all those knights who lent him their support,
That on they surged inside the mighty hall.
He had his flag flown from the highest floor 1180
And in the wind the banner billowed forth!
The king was first to see it raised and called
Upon the duke, his wisest counselor:
"Naimon, behold!" said Charles the emperor:
"Thank God above, Who judges each and all,
Count Aymeri is lord of Narbonne's hall!
Upon the wind his banner billows forth!
I swear by all my faith in God the Lord,
 He's earned the land around it!"

Within the hall, upon its floor most high, 1190
Stood Aymeri, the fearless-hearted knight.
He bade his horn blown lustily, whereby
His men could know that he was lodged inside.
The king heard too and made at once to ride

38

Inside the town, not wasting any time,
With all his lords in entourage behind.
They found such gold and silver there in piles
That no emir or peer had more or like.
Whoever sought a steed or stallion fine,
A coat of mail, a helm or shining pike, 1200
Could make his choice and take what he desired.
God! How much wealth of wheat and bread and wine
And salted meat and fresh meat met their eyes!
King Agolant, who ruled with greatest pride,
His brothers too, who all were kings alike,
Had kept the town well stocked with rich supplies.
The two of them, I'd say, who least were wise,
Were those who stayed when Charlemagne arrived!
Count Aymeri, the fearless-hearted knight,
With all his men, took both of them alive — 1210
When hope was gone, they both gave up the fight;
But Aymeri, without the least respite,
Put both in cells, with no redress or rights,
Where both remained until the day they died.
The other pair, with all their main and might,
Could seek for help as much as they might like,
But Charlemagne, whose hair was silver–white,
And Aymeri, so brave of mood and mind,
Would take their rest in Narbonne's hall that night,
 With all their lords and nobles. 1220

When Charlemagne the brave had won the day
Within Narbonne of such renown and fame,
You can be sure his Christian joy was great.
From all its shrines he stripped Mahom away
And broke to bits their gold and silver plate;
He gave it all to those who would remain
Within Narbonne to guard and keep it safe.
The Frenchmen built a lovely church and nave,

Then sanctified its altar to Christ's faith;
Then they installed and placed there straightaway 1230
An archbishop to honor and maintain
The Lord's command and serve His holy name.
Charles gave the church in offering and praise
St. Paul's own head, this is no lie or tale,
Which he had brought back home with him from Spain.
The King displayed his noble birth and grace:
Before he left Narbonne and its domains
A Mass was sung within the church he'd raised
And wealthy gifts and offerings he made;
And all his Peers, his counts and barons, came 1240
To each present rich offerings the same:
A golden bezant or silver mark they gave.
When Mass was sung, without the least delay,
The king prepared his mighty baggage-train.
They packed the hacks and saddled destriers
And harnessed them and set and rigged their reins.
Be certain, friends, that they were not dismayed
At setting off, at last, for France again!
King Charles himself was keen to be away,
But called aloud, while riding forth, and hailed 1250
 The new lord of Narbonne:

"Sir Aymeri, you own now and possess
A mighty town and palace of great wealth.
Within your hall and walls of ancient strength
You should live both in joy and great content.
You have supplies for countless days ahead,
And many steeds of worth and birth the best,
Good weapons too, of many colors blent,
And floral-painted shields, hauberks and helms.
You should not fear the heathens or their threats, 1260
But if you need my help, I'll not forget!"
Thus spoke the king, of courage fierce and dread.

"Much thanks, my lord, for your love's great largesse,"
Replied the count of such pride and prowess:
"So help me God, the Father of all men,
I shall be yours as long as I draw breath.
And never fear in all the years ahead
That any Moor shall have one moment's rest!
While I've a horse I never shall relent.
Each day I live I shall pursue their deaths, 1270
And never shall my hate for them grow less
But greater still to deal them more distress,
For Roland's sake, the fighter I loved best,
And Oliver, the count so nobly bred,
And all those Peers whose courage was their crest,
And who were doomed at Roncevaux to death
By Ganelon, the traitor foul and fell,
May God the Lord pour shame upon his head!
True emperor, for Lord God's sake, I beg
That when you're back in France among the French, 1280
You do not hesitate to wreak revenge
On Ganelon as on a traitorous wretch,
So lands and men, the greater and less,
From France to India, may know his end.
All traitors then may fill with fear and dread
To plot or plan so great a crime again
Against their lord and violate their pledge."
King Charles replied, "By God, the guide of men,
Well spoken, count! May God increase your strength!
Strive hard to guard and keep your wealthy realm!" 1290
Said Aymeri, "My lord, fear not, I shall!
Please God above, the Maker of all men,
I shall not lose to any Saracen
 One half a foot or fistful!"

THE SECOND GESTE

THE EMBASSY TO PAVIA

❦ CHANT 1 ❦

HOW AYMERI PROSPERED AND RESOLVED TO WED

King Charlemagne, not wasting any time,
Rode back to France, the highly praised and prized,
With all his men, his barons and his knights.
To Aymeri he gave the city's rights
And in the land around he left behind
One thousand knights, whose name and fame were high, 1300
To guard the town and help the count alike
In its defense against the Pagan tribes.
God willing, they would guard it with all pride,
Since gaining it gave others such a fright.
To thirteen lords, before, the king had tried
To offer it and all refused outright!
Good luck to him whose pluck did not decline,
Count Aymeri, whose face was brave and bright!
How many wars, how many bitter fights
Against the Moors, those evil Antichrists, 1310
He had to wage henceforth, can't be denied;
And he upheld so strongly all his shires
That not one mile was lost nor half a mile.
Instead he made such increase to his might
That everywhere his fame spread far and wide:
From Gate of Spain to where the seas turn ice

43

His flag was feared wherever it might fly.
Yet, after this, but little time expired
When tidings came, which much aggrieved his mind:
Inside Narbonne the sad report arrived 1320
That Count Hernaut, his father, had just died,
His mother too, the countess fair and fine.
On hearing this, his grief was hard and high,
Although he knew that naught was gained thereby.
He built a church in honor of their lives,
Where many a Mass was sung in aftertimes;
They left behind no heirs, this is no lie,
Save Aymeri, whose face was brave and bright.
Thus all was his of what was left behind
By Count Hernaut of fearsome mood and mind. 1330
How strong and rich, how very well-supplied
The count was now with land and fearsome knights!
 A wife alone was lacking!

The high and low advised him, one and all,
"Lord Aymeri, for God's sake, noble lord,
Delay no more but take a wife henceforth,
From whom, fine lord, a child may soon be born
Who, after you, may rule this land of yours;
Without an heir of yours, the only joy
Would then be felt by Saracens and Moors!" 1340
Said Aymeri, "By St. Amant, I'm sure
That there's no maid I know of, south or north,
Whom I am not related to, therefore
Whom I may wed by any chance or choice!
So help me God, the One Almighty Lord,
If there is none whose beauty is not small,
None who is wise and nobly bred of yore,
 Then I'll not wed another!"

Said Aymeri, "My noble lords and liegemen,
I know of none in France or Berry either, 1350
From here to Rome, this is the truth I'm speaking,
Whom I am not related to, believe me!"
"My lord," said Hugh, of high prowess and feeling,
"By God our Lord, I am amazed to hear this!
I know of one, I swear this most sincerely,
Who is more fair than any I have seen yet,
Of slender limb and tender, winsome features.
But, on my faith, this maid does not live near us.
This princess that I praise comes from Pavia.
Fair Hermenjart's her name, and she is peerless — 1360
The daughter of a king whom you've heard speak of:
King Didier the brave has bred and reared her;
Her brother's called King Boniface the Regent.
I say again, this maid dwells in Pavia —
Which both heirs will inherit in due season.
High lords have wooed and sued for many years now
This lovely maid, believe me, I beseech you,
But there's not one whose suit she will agree to.
A pilgrimage in penance I'd completed
To those two saints who were beloved of Jesus: 1370
I'd prayed for grace to St. Paul and St. Peter,
And in that town as I returned one evening
I saw an arch and, sitting there beneath it,
With fifteen maids on each side of her seated,
Was Hermenjart, so fair of form and feature.
She asked me then what land I had been reared in,
And I replied, "In Aymeri's great region."
Because of you she cherished and esteemed me,
And honored me and served me very sweetly;
For she'd heard much about you that had pleased her." 1380
The count replied, "All grace to her, indeed Hugh!
By good St. Rémy's bones, I love her dearly!

You speak of her so highly and sincerely
That I swear God, if I don't have this creature,
One thousand men shall die who come between me
 And my love for this maid!"

"In God's name, Hugh, you've praised this maiden so,
And for some time I've heard her name extolled,
That now I swear, by God the Lord of Hope,
And by the faith that I have sworn to hold 1390
With Charles of France, whose beard is white as snow,
That if I fail to make this maid my own,
Those Lombards will have war before they know!
I'll make them pay with towers toppled low
And towns ablaze and razed with fire and smoke,
And bodies cleft and left bereft of souls,
Unless I gain this princess nothing loath!
For I shall come with Charles's standard flown,
Right to Pavia, so strong and praised of old.
If this fair maid is willingly bestowed, 1400
She'll be obeyed in every land I own,
But if they all refuse me and say "no,"
Then they will pay indeed before I go!
 I tell you this most truly!"

"My lord," said Hugh the noble and the wise,
From Barcelona town, a much-feared knight:
"Do not proceed this way, I urge you, sire!
Put trust in me and do as I advise,
For I shall give more tried and true advice!
This plan, my lord, is what I have in mind: 1410
Place in my charge some sixty men astride
Good, rapid steeds, well armed with weapons bright.
Let each be dressed as best befits our pride
And let each man be brave and strong alike,

The highest born and bred that you can find
In lands you own and others far and wide,
A count or prince or sheriff of a shire.
In all these realms there is no lord so high
Who will not come to you if you desire,
Although he owes no fealty or tithe. 1420
You are so feared by princes on all sides
That they will come to serve you when you like.
When they arrive in Narbonne and unite,
We'll ride at once to meet Pavia's sire;
Whatever winds, whatever storms arise,
We shall be there before two weeks are by.
If Boniface is there when we arrive,
We shall ensure he knows your thoughts and mind.
We'll seek at first, in friendly, loving wise,
This maiden's hand, who is so fair and fine; 1430
Then if he dares so much as to decline,
We'll bring her back, whatever his despite,
Whatever shields are shattered through the splice,
And hauberks wrecked and ripped apart with iron,
And Lombards robbed of limb, if not of life!"
When Aymeri heard this, he laughed outright:
"Sir Hugh," he said, "your words are good and wise.
If you can do this plan you have described,
I'll cherish you until the day I die
And give to you two castles side by side 1440
To honor you and serve you and your line."
"Five hundred thanks, my lord," Sir Hugh replied:
"In Narbonne's hall, before two months are by,
 I swear you'll have the lady."

❦ CHANT 2 ❦

HOW AN EMBASSY TO PAVIA WAS ASSEMBLED

Count Aymeri was keen to make all speed.
Throughout his lands rode messengers to seek
The noblest men of most praiseworthy deeds.
On his behalf they bade those lords to leave
And go to him, as each one held him dear
And hoped henceforth for his support in need. 1450
They all obeyed, delaying not the least.
Some sixty peers, all bred of bravest breed,
Within a month rode forth to Aymeri.
The fearsome count lodged twenty out of these
Within his hall of noble walls, where each
Drank all he drank and ate his every meal
And looked to him as their true lord and liege —
For every one held lands from him and fiefs.
When all those lords, all sixty, were convened,
Count Aymeri addressed them thus in speech: 1460
"My worthy lords, I tell you, frank and free,
I have a mind to wed a wife indeed!
But first I wish to hear from you brave peers,
As men of might whom I should hold most dear,
And whom I wish to thank most heartily
For riding from your lands to help me here:
My knights and lords all praise a maid to me —
The daughter of King Didier is she,
Sister of Boniface, the much-esteemed.
There's many a man has sought her hand, it seems, 1470
But I have heard she spurns their every plea,
Refuting each, refusing all of these.
In faith, my lords, I'll not hide how I feel:
I'll have this maid or I'll have none this year!"
The nobles said, "Send forth an embassy!

On your behalf let sixty envoys leave,
But none of mood and manner weak or meek,
But all high-born, of strength and temper fierce,
Men who can speak your message loud and clear,
Then, if need be, defend themselves with zeal! 1480
We'll thank the Lord, if Lombardy accedes,
But should it not, they'll pay a heavy fee:
We'll take apart Pavia piece by piece,
Lay waste its realm and devastate its fiefs,
And treat its king like any common thief."
Said Aymeri, "I readily agree."
His men replied, "Then pray let us proceed!
Without delay select from all you see
The messengers who will enforce your plea."
The count replied, "Most willingly, indeed. 1490
Sir Hugh shall go, and Garin Lancingspear,
Sir Fulk of Fors and Achart of Rivier,
The fifth Bernart, the sixth shall be Gontier,
Raoul the seventh, the eighth shall be Braier,
Herchanbaut ninth, the tenth Count Engelier,
Girart eleventh, the twelfth Count Berengier,
Huon thirteenth, the fourteenth brave Braier,
Milon fifteenth and sixteenth wise Renier;
The seventeenth shall be Buevon the fierce,
And Duke Garnier I'll have as the eighteenth; 1500
This score, with Fouchier and Tierri,
 Form one third of the party."

One score he named, all brave and nobly-bred;
William of Blois was twenty-first, and then
The twenty-second was Jociaume, blond of head;
The twenty-third was young Guion, and next
Maudit the Spaniard made up two dozen men.
The twenty-fifth was Orléans' Ensel,
And Lohier was the twenty-sixth, from Gênes.

Girart from Avalgaw was twenty-seventh, 1510
Count Gaufroi twenty-eighth, so says the geste.
Bernart the Albigeois was chosen next
And brave Duke Godfrey made one score and ten
 Who'd journey to Pavia.

The men I've named were thirty noble peers,
All fit to fetch a wife back for their liege.
The thirty-first was called Count Savari,
Gaydon was thirty-second, of bravest breed.
The thirty-third he chose was Esmauri,
And thirty-fourth to join them was Count Gui, 1520
The thirty-fifth the castellan Henri,
And thirty-sixth was Geoffrey of Ponti.
The thirty-seventh the seneschal Guerri,
And thirty-eighth the Lorraine Tierri.
The thirty-ninth was fearless Count Ferri,
Who held Béziers and Tarragone in fief
To Aymeri, in love and loyalty.
The fortieth he chose was Alori,
Who held Etampes and governed Montlhéry.
Those forty lords, and I have named them each, 1530
 Would go to gain the lady.

Those forty lords, and I have named the lot,
Would leave in haste to bring back to Narbonne
Fair Hermenjart, whose face with beauty shone;
And twenty more, of bravest, highest stock,
Rode with them too, whose names are in the song:
A noble lord indeed led this score off —
His town Montpensier, his name Guion;
And Chartres' lord, whose name was Aliaume,
Rode in the front and bore the gonfalon. 1540
Then Walter Mans rode with Garin of Laon
And good Sanses, the famed, of Orléans,

And Count Guimarz and Ors of Vaubeton,
And that well-bred Galician knight Aymon.
Geoffrey Anjou and Brittany's Hunault,
Hernaut of Metz and Landris of Mâcon,
Spoleto's lord Othon and Jocerain
Rode with Sir Fulk, the lord of Morillon,
Rotrox the count and Basin of Dijon.
And with all these was Fouques of Monjeucon, 1550
Together with Gibers of Tarragone,
And, twentieth, Girart of Roussillon.
The king's own realm these twenty peers came from,
Who with the rest whom I have told you of,
Made up in sum those envoys sixty strong,
All dukes and counts or barons every one,
Or castellans or peers whose fame was long.
This band would ride, though woe betide or not,
To seek the maid whose face with beauty shone
 Within strong-walled Pavia. 1560

<p align="center">🜊 CHANT 3 🜊</p>

<p align="center">HOW THE ENVOYS DEPARTED IN RICH ARRAY</p>

The messengers whom I have named as envoys,
Were sixty lords of Aymeri's selection,
All princes, dukes or counts who were his tenants.
They stayed no more but made themselves all ready
Then asked for leave and mounted horse together.
The count commended them to God's protection,
The glorious Lord, the Majesty of Heaven,
And bade Him guide and guard them from all peril.
When this was said they turned their reins and left there,
Yet not at all like lost or lonely beggars, 1570
But richly dressed and wealthily presented:
Their robes were silk and every one enveloped
In fur-trimmed cloaks attached by clasps of metal;

Their hose was made of golden cloth or sendal,
Their boots and shoes of good Cordovan leather.
Each rode a mule robust of limb and rested,
Or palfrey-beast whose saddles all were splendid.
The straps alone, of beaten gold and belting,
Were worth, I'd say, a city's gold or better!
Each noble lord had five squires to attend him, 1580
And each of them was well supplied with weapons.
The hand of one led forth their master's destrier,
The rest bore gold and silver coins in plenty,
And coats of mail and countless jeweled helmets,
And spears and shields with ornate bands and edges,
With which their lords could swiftly be invested,
If anything they saw met their displeasure:
For all were knights of bold prowess and temper;
Yet all were not of equal age, however:
They rode in groups, by age, in ranks of twenty. 1590
One score of them were old and all white-headed,
While twenty more were greater lords than lesser;
The other third were youths well-known for venture.
The score I've named, whose ranks composed the eldest,
Bore on their wrists mewed goshawks for their pleasure;
Those greater lords I named, without exception,
Bore on their fists fine falcons held by tethers,
While those young peers already feared by many,
Held sparrow-hawks to hunt with at their leisure.
But all were wise, well-taught in word and gesture. 1600
No court in Christendom, or any elsewhere,
Would not attend their words, if they addressed it.
If Boniface were not in his best senses,
And out of pride, or ill-advised, objected
To do their will in any way requested,
His town at once would be so fiercely threatened
That fifty men, then fifty more would perish
 For this fair maiden's love.

☿ CHANT 4 ☿

HOW THE ENVOYS MET A ROVING GERMAN WAR-BAND,
AND HOW A FIGHT ENSUED

The envoys left without the least delay,
And merry cheer they shared upon the way, 1610
Conversing much in joyful word and phrase.
They rode along with all their heart and haste
Till by a field and wood they drew their reins.
A river there lured forth abundant game,
And so they stopped to hunt both ducks and drakes.
Then, suddenly, they saw within a glade
A German lord of high renown and fame:
A dotard now, whose beard was white with age,
Lord Savaris had led out on that day
Three hundred knights, each one with visored face, 1620
Among the best of his own German race,
But all were dressed like folk bereft of brains!
Each wore a shirt too wide for any shape,
And then a gown of coarsest sheepskin made.
Their shoes were hooked, their hose tucked up the same,
And on their heads were hoods with hems upraised.
Each one was girt with an enormous blade,
Six feet in length, if measured tip to base,
And round their necks great rounded shields were draped.
They trotted on outlandishly conveyed — 1630
Some riding mares with shorn or shortened tails,
Some gangling steeds, their gawky heads unreined,
And when they came and saw our envoy-train
They cried aloud, like panic-stricken strays:
"Gott hilf uns nun!" with voices loudly raised.
But Savaris, whose beard was wide and gray,
Spoke Charles's French, from years in his domains.
Towards our lords he strained his stirrups' weight

And when up close, with ringing voice he railed:
"Mad runaways, it seems you've lost your way! 1640
Who is your lord, and of what land and race?
You look to me like Normans, I must say,
Who ride so proud, dressed in such pompous drapes!
Before you see Pavia's city gates,
Your clothing's price will be most dearly paid,
For you'll not wear one stitch of it away!"
But Geoffrey said, whose courage burned his face:
"If you did this, all France would feel the shame
That our prowess so much belied its name!
Because you dare to slander us this way, 1650
By God, Who makes the sky and dew the same,
You shall receive from us so fierce a wage
That never yet will you have felt such pain!
You sons of whores! You foolish jackanapes!
You little know the folk you've run against!
For have we not, each one of us, sharp blades
And other arms befitting knighthood's state,
And worthy steeds both strong and fast of pace?
By St. Denis, before the daylight fades,
That beard of yours will be so plucked away 1660
Your wool-shirt will be dyed blood-red with stains!"
"I thought as much!" old Savaris exclaimed.
"It is the truth, and truly did I say
This was a troop of Norman runaways!
 Your words alone betray you!"

When brave Girart of Roussillon arrived,
He heard the pride of Savaris and smiled
At him a while and then made this reply:
"In truth," he said, "this vassal is quite right!
Normans we are and Angevins alike, 1670
And our best men are French, without a lie,
And know this too — Pavia's where we ride,

For Boniface, its worthy lord, to plight
Fair Hermenjart as Aymeri's new bride,
His sister fair, whose fame has traveled wide.
If he agrees, then she may bless her life,
For there will be no better, blither wife;
If he does not, then he shall truly find
No greater cause for sorrow till he dies.
We shall defeat both him and all his knights, 1680
And he shall see his lands brought low alike,
And we shall take his sister in despite!"
"This vassal lies," old Savaris replied,
 "For this fair maid you speak of and describe
Was pledged to me these thirty months gone by.
I have paid more, in truth, to make her mine,
Than all the wealth Count Aymeri's acquired.
I tell you straight, if you take one more stride,
You'll all be caught and humbled ere you die!
 Turn round and ride back swiftly!" 1690

Said Savaris again, the German-born:
"You vassal-lords, ride on no further, for
This lovely maid is mine by pledges sworn!
If you ride on, your loss will not be small —
You shall not keep one hack or horse of war,
One shining helm, one hauberk or one sword!"
On hearing this the counts were filled with gall.
Count Gui called out and said with ringing voice:
"My noble lords, why do we stop and stall?
Do you not hear this wretched villain's scorn, 1700
Who does not prize our great prowess at all,
But blocks our way with menaces and taunts?
We all are knights of valor, land and laud,
And messengers of Aymeri, our lord,
The best of men alive, here or abroad!
If these low knaves hurl mocking insults forth,

Are we struck dead, or do we drop and fall?
Lords, arm yourselves at once to fell these boors
That block our way behind us and before!"
And so they did — they armed without a pause — 1710
And while both sides swapped challenges and vaunts,
Their serving-men and squires brought weapons forth,
Which straightaway were seized in hand and borne.
That German band, alike, girt up its loins.
When all were armed as suited each man's choice,
They swung astride their battle-steeds once more
And round their necks wound sturdy buckler-cords.
Then with their spurs they sped their mounts towards
 That warring-band of Germans.

The month was May, when roses flower sweetly, 1720
And woodland-leaves and meadow-grass grow greener,
When our good band across that land went speeding.
The German knights stood in their way and fiercely
They met upon the plains of Lombardia,
But all our men were sons of bravest breeding
And all were armed as men both fierce and fearsome.
They spurred towards those Germans, bold and eager,
Who were in sum three hundred strong between them.
Against three score the odds were most unequal,
Yet our brave counts, whose great prowess was peerless, 1730
Did not, for that, refuse to meet and greet them,
But stormed their lines with all their strength and feeling!
The German knights, in ranks, prepared to meet them:
"*Herrgott! Herrgott!*" they cried aloud to Jesus.
No battle, friends, was ever waged, believe me,
Which such wild zeal began and ran so freely!
They fought that day so ardently and keenly
For Hermenjart the maiden of Pavia
That when they stopped one hundred had stopped
 breathing.

But Savaris, the wizened and white-bearded, 1740
Who sought the maid, to have and hold her near him,
When he beheld our counts and their demeanor,
Which was so fierce, so fearsome and so fearless,
He lined his men so ours could never reach him!
He rode behind, not citing right nor reason
Why he should strike the first blows or should lead them!
In front of him he set his startled people
 In very fear of death.

Old Savaris was cowardly all right —
Among his own he rode, behind their lines, 1750
And laid no claim to leading off the fight.
He held a lance that wasn't willow-light,
While all around the fighting grew more wild.
Each count of ours held up his banner high
And spurred his mount whose stride was greyhound-like.
As both ranks met, each count of ours and knight
Set out to joust a German with such might
That through his shield the sturdy lance was plied
And flung him dead, then thirteen more alike.
No leather girths could save those Germans' lives. 1760
They needed biers and nothing else besides!
Then Savaris, who'd held back all this time,
Spurred forth at last his rapid mare to smite
The good Sir Hugh, whose face was brave and bright.
Old Savaris attacked him — from behind!
He cracked his lance, whose haft nor shaft survived,
But Hugh stood firm upon his stirrup-irons
Then turned his courser's double-reins to find
Old Savaris, and looked from left to right.
If he were there, he would have paid in kind; 1770
But he had gone — he'd taken fright and flight
 To save himself from slaughter.

How fierce it was, that fight upon the plain!
Upon both sides the battle-cries were raised.
Behold, for one, Goniot of Alemayn —
The German's nephew, by his sister germane —
He spurred ahead his barren mare against
Lord Aymer of Lausanne in deadly rage,
Among the best of all our men that day.
He split his shield and hauberk of Cerdagne 1780
And flung him dead from his good horse of Spain.
On seeing this, our envoys' grief was great
And all were filled with anger at his fate.
Girart of Roussillon, with no delay,
Unfurled his flag for vengeance straightaway.
He struck Goniot with all his heart and hate,
Whose buckler split just like a chestnut's case;
From German steed he flung him to his grave.
Lord Gui looked on and gladly grasped the reins
Of Goniot's steed, left roaming like a stray. 1790
His own one had been badly gored and maimed
And nevermore would run a slope or plain;
He leapt astride the German's mare in haste
 And very well it pleased him.

Our envoy band, may Jesus aid and bless them,
Maintained the fight with all their strength and temper.
Girart of Roussillon showed great endeavor:
He spurred his steed, which sped across the meadow,
And from its sheath he drew his blade well-tempered.
He smote a German, one called Hew, so deftly 1800
Upon his shield he split it through the center,
Then ripped apart the byrnie-mail's close meshing
And slit the gown the wretched clown was dressed in;
All down one side the blade, unchecked, descended
To strike his thigh, and all it met it severed.
He lopped his leg just like a stalk of hemlock,

58

Then turned the blade and tipped the villain headlong!
He sped his soul so swiftly off to heaven
The German had no time to say "God help me!"
When Savaris beheld his liegemen perish 1810
His cheeks turned white with anger at the Frenchmen.
He called his troops and when they were assembled
He urged them all to fight with fiercer effort!
On hearing this, they fell at once to yelling.
Their boldest men were so afraid and fretful
They almost blew their horns to leave already.
Our envoy band, each one, displayed such mettle
Within the press, and fought so well together
That on those plains of Lombardy there never
 Was seen so stout a stand. 1820

The German and his men were filled with dread
To see the French display such fearless strength.
There wasn't one whose lance was still uncleft
Nor sword undrawn, wherein their faith was set.
The men they struck were sent at once to death.
When Savaris beheld their fierce prowess,
He swore to God, on Whom all good depends,
That he was mad and very foolish when
He let his pride deride them with contempt.
Yet since his men had suffered so and bled, 1830
He swore to die if he could not avenge
The deaths of those he'd never see again.
He blew his horn and fighting recommenced.
His Germans struck as one upon our French,
With lances some, with naked blades the rest,
But our brave peers were fearless nonetheless
And rallied hard in sally and defense.
Lord Sanses struck one Gontart of Valence,
And Garin smote Guerri of Val Silenz,
While Gui attacked Maleffort of Bregenz; 1840

Whoever grieves or groans, they flung them dead.
Ill-starred they started fighting!

How very hard the fighting was that day!
The German feared to look upon the fray.
On every side his men had given way
And very soon he feared they'd all escape!
With ringing voice he cried his battle-gage
Till all of them had rallied round again.
Then one of them spurred forth in mighty haste,
A German lord of arrogant display, 1850
Helpin his name, the lord of Valsegrée.
Count Fulk, who held the land around Poitiers,
Attacked his shield without the least delay
And broke his lance till but a stump remained.
Before the rogue could turn his horse's reins
Fulk smote his banded shield so hard again
He broke its boards and cleft apart the chains
Of byrnie-mail and saffron overlay.
Upon the field he flung him to his grave.
The arms he'd borne and armor worn that day 1860
Sir Fulk gave to his squire, who straightaway
Equipped himself without the least delay:
He donned the coat of sturdy, close-meshed mail
And then the helm and then the burnished blade.
Sir Fulk's own blade then fell beside his face
And dubbed him knight on that auspicious day.
In days to come he'd earn undying fame.
Astride his steed, whose saddle's gold was great,
He grasped the shield, with painted wheels ornate,
Which Helpin's hand had brought there when he came. 1870
He raised a wide, well-sharpened pike and made
His stallion bound across the Lombard plain.
A German came to meet him in the fray
And our new knight attacked him, full of hate.

He split his shield and slit the hauberk's chains;
Right through his spine he thrust the pike's sharp blade
And flung him dead and drove his soul away.
The French looked on and their delight was plain:
"Mountjoy!" they cried with voices loudly raised:
"Well done, indeed, dear God, with Your good aid! 1880
Lord Aymer's loss to us has been regained,
That worthy knight whose life the Germans claimed.
His sister's son has made the culprit pay!
This lad deserves the lands and the estates
His uncle held, whose face with valor blazed!
A curse on him who'd steal one coin away
Of what is his by destiny and claim!
And now our band is what it was again:
 Our sum once more is sixty."

How very hard the fighting was and wild! 1890
Our counts rejoiced to see that squire astride
A warring-steed and newly dubbed a knight,
For evermore to bear the name and pride.
A worthy friend they had in him for life.
Three score they were once more, but nothing like
The German force against them, which, combined,
Made fifteen score drawn up in battle-lines.
One Gracien raced through the rest to fight.
A mighty mare this German spurred to strike
Girart the brave, of heart and honor high — 1900
Who did not think he'd hit him from behind.
With lance outstretched he flung him down to die.
On seeing this Sir Gui filled with despite:
"God's truth, you've pushed my grief too far!" he cried,
"The noble lord whom you have robbed of life
Most treacherously, gave me this horse to ride!
He was my liege, both kin and friend of mine.
My name means naught till I avenge the crime."

He spurred his steed, which tarried not, to smite
The German's shield with all his mood and might. 1910
Beneath the boss he split the buckler wide.
The hauberk's mail he ripped and rent awry
And through his ribs he rammed the cutting pike;
He flung him down, where, bleeding hard, he died.
Gui drew his sword, with hatred in his eyes,
And saw ahead another German knight;
With blade upraised he struck a blow so wild
The German's skull was split from side to side.
"Lay on, my lords!" with ringing voice he cried.
When this was said the battle grew more dire, 1920
But still the French were well outnumbered by
The fifteen score benighted German knights,
Although, in truth, five score no more survived!
But one thing more our men had on their side —
Three hundred men-at-arms and willing squires,
Who all were bold of manner and of mind,
And it was then they armed themselves to ride
With all their might to fight at their lords' side.
And so the blows grew greater all the time,
As fresh men came who could not wait to strike 1930
And slay all those in arm's length of their iron!
When Savaris beheld this force arrive,
With utmost speed he turned his steed to fly.
He told his men: "My lords, give up the fight!
I truly think that these are evil sprites!
If we were at Vercelli now, we'd find
Protection there and help, for there resides
Morant my brother, the bishop of that shire.
He'll wreak revenge upon this devilish tribe
 Who tread upon our heels here!" 1940

The Germans dared delay no more but fled there,
And all the French were keen to chase and check them!

Old Savaris was first to flee our envoys,
And then his men, none loath to leave the melee,
Cared not at all which road or route was better.
The last to go was first to know his peril,
For in pursuit our men were unrelenting
And from their steeds they thrust and threw down many
Who had no strength to rise again or ever!
Those worthy squires pursued as hard as any, 1950
And any youth who sought a steed or weapon
Could choose at will their pick of them from plenty;
And so they did, as suited best their pleasure,
And loaded wealth on sumpters' backs well-tethered.
The Germans fled, as fleet as steeds could fetch them,
Spurred on unchecked until they reached Vercelli.
They thought at last the town would give them shelter —
But those inside who saw their helter-skelter,
Closed all their gates to bar them any entry,
Lest their own town were battered down in frenzy! 1960
On seeing this, the German started yelling:
"Unlock the gates and make all haste, I beg you!
We are pursued by demons and by devils!"
But those inside manned all the walls and crenels
And hurled down rocks and blocks upon those wretches
Who, willingly or not, fell back, or perished.
Old Savaris himself found no protection.
A Lombard heaved a boulder at the fellow,
Which struck him hard upon his paneled helmet
And crushed it in, and where his naked neck was, 1970
Across the nape, it cut a bloody flesh-wound.
It flung him from his horse's back directly.
He felt his head and anger filled his senses!
He'd never met with such a sore reception
As in this town he thought would make him welcome!
The envoys' thoughts were somewhere else, however:
Not stopping once, they galloped on together
 Towards Pavia town.

♈ CHANT 5 ♈

HOW THE ENVOYS REACHED PAVIA
BUT CLASHED WITH BONIFACE THE KING

They galloped on, who had outshone their foe,
And headed straight along Pavia's road. 1980
Through Barzellino's ford the envoys rode,
Where on each side the fearsome waters flow.
They passed alike through Mortara and Gauz
And galloped on across the plains and slopes
Until they saw Pavia's mighty domes.
What happened next? Pay heed and then you'll know!
King Boniface was on that very road,
Returning home from seeking some repose
Spent on the river-bank with friends alone.
Towards his left he chanced to look and lo! 1990
A cloud of dust along the metaled road
Betrayed our men as swiftly they approached.
He called his lords: "Look there! I do not know
What hasty hooves upon our land encroach!
They are, perhaps, a pilgrim-band — if so,
On pilgrimage to seek the pope in Rome!
This very night Pavia will play host!
Attend them here and let us hear their hopes!"
"Just as you wish," his men replied, none loath.
Around their king they drew their palfreys close, 2000
But as they did, our noble ranks and rows
Loomed very large, their bearing brave and bold,
And when the king beheld their noble robes
And saw the glint, which from their weapons glowed,
And all their flags and sendal pennants flown,
And banded shields and many chain-mailed coats,
And all their spears and helms inset with stones,
He took such fright that all his blood ran cold!
He told his men: "What madness to suppose

That we had chanced on pious pilgrim-folk, 2010
For they are not, I swear upon God's oath;
They have no wish or will to go to Rome!
No pilgrims wield the weapons these men hold!
They've arms galore and plenty more in tow!
Their pilgrim-staves are long and iron-spoked!
They look prepared to strike an evil stroke.
Turin has men, this much indeed I know,
Who hate me much, and so does Barbastro:
Twelve months and more they've watched me come
 and go.
If captured here, my life's not worth a clove. 2020
I fear we may have stayed too long, although
I don't know if they mean me harm or no.
Let's hurry back to our good town and bolt
 The gates against their entry!

King Boniface took flight: he turned his horse
Towards Pavia town and spurred it forth,
And all his men were close behind their lord,
The fastest one the first inside the walls.
When all were in they grinned with greatest joy
As after them they closed the gates and doors 2030
And climbed upon their ramparts, gazing forth!
Our knights and men were much amazed, and all
Said each to each: "Our quest's ill-blest for sure!
At every step we meet ill-will or scorn!
See Boniface whom we so long have sought.
We find him here, at last, and wish therefore
To speak with him of our desire and cause —
And like a cur he turns back to his fort,
Then in our face he fastens all his doors!
Now we shall lodge outside in wind and storm. 2040
He welcomes us with anything but warmth!"
Girart of Roussillon raised up his voice:

"My worthy lords, do not be so distraught!
The king is here, in his own home and hall,
And he can do whatever suits his choice.
You cannot judge his prowess yet, my lords.
Perhaps he has not often seen before
So many men ride through his realm who bore
So many arms and brought so many more!
If he has barred his gates against our force, 2050
Perhaps he has no will or wish for war.
Let us proceed with wisdom and with thought.
I first shall go to meet with him and talk.
If we do this as wisely as we ought
And gain a place within his city's walls,
I swear to God, our never-failing Lord,
We need not fear the town's response henceforth.
We all may speak in safety, rest assured."
The counts replied: "Your plan we all applaud;
Let us proceed without one moment's pause. 2060
Speak as you ought, Girart, before his court,
 When asking for the maiden."

The French rode on, not wasting any time,
And reached the gates not slackening their stride.
They saw the king upon his ramparts high,
And Duke Girart was much to be admired,
Who in his speech was courtly and polite.
He saw the king and hailed him in this wise:
"May God the Lord, Who deigned to give us life,
And Whom we all should love and praise alike, 2070
Bless Boniface, the king so brave and fine!"
The king replied, "My friend, and may the Christ
Whom you have named both bless and let you thrive!
Whose men are you? Whose banner do you fly?
You're nobly bred and well can speak your mind."
Girart replied, "You shall not hear a lie.

We're envoys, sire, with nothing here to hide.
We've come in peace and love, with no desire
For making war on you or on your shires.
We ask instead for you to be so kind 2080
And find us all some lodging-place this night
Within Pavia until the morning light."
Said Boniface, "You shall not be denied."
At once he bade his gateways opened wide
And found each knight a good room to reside;
Then with goodwill he said to all our knights:
"My lords, will you obey one wish of mine?
For friendship's sake I ask that you comply:
Please eat with me at supper-time tonight,
And then again tomorrow when I dine! 2090
Reside with me as long as you would like —
You will be well and willingly supplied.
For nothing here shall you pay any price!"
"Much thanks for this, my lord," they all replied,
"But we cannot comply with your desire.
One hundred marks of gold won't change our minds,
For we are all rich barons, counts and knights,
And we have all that all of us require.
Since yesterday, be sure that this is right,
With God's good help we won such rich supplies 2100
That thirty mules cannot support the pile!
So much of this we shall dispense inside
Your town before we start our homeward ride,
That your most poor shall all be satisfied.
We'll not refuse whatever food we buy
To pilgrim-folk who enter at our side,
Nor any meal to any passer-by
Or vagabond who sings for our delight.
There's none we'll spurn and none we'll turn aside."
Said Boniface, "You are well-bred and kind. 2110
If your largesse be such as you describe,
 Then you indeed are wealthy."

✣ CHANT 6 ✣

HOW BONIFACE TRIED TO TEACH THE FRENCH A LESSON,
AND HOW HE LEARNT FROM HIS OWN MISTAKE

King Boniface was proud and fierce of race
And much aggrieved for our fine envoys' sake,
Who spurned the food and drink he bade them take.
He thought, indeed, that their affront was grave.
If they had shared his table with good grace
And honored him, their honor would have gained;
But they rode on, then left their destriers
And bade their squires seek lodgings where they may. 2120
King Boniface, meanwhile, went his own way.
Within his hall he summoned all who baked,
Or worked in iron, or sold the city's ale,
The candle-makers and fishmongers the same,
Those who supplied the city's wheat and hay,
And all its meat, the merchants small and great,
The shoe-makers and furriers all came,
Each citizen who plied the city's trades.
"My worthy men," said noble Boniface,
"Some sixty lords have passed inside our gates. 2130
I've never seen such noble knights as they,
For all are dukes or counts with rich estates.
Not one's without five servants in his train,
Whose right hands lead fine steeds and destriers
And sumpter-hacks whose backs with wealth are laid.
Their wrists bear hawks and falcons of the chase,
And hounds they have and hunting-dogs on chains.
I order you who ply this city's trades
To sell your wares so dearly that they pay
Two sous or twenty pence for one today! 2140
Before the sun tomorrow will have waned,
They'll dine with me, I'm sure, without complaint!"

They said, "My lord, by all of Poitier's saints,
This strict command is easy to obey!
If they intend to buy the goods we make,
We'll charge them all at such a costly rate
That even foreign pilgrims do not pay
 For all of their provisions!"

King Boniface withdrew inside his palace
As all the French took up their lodgings gladly, 2150
But then they bade their servants buy and carry
Great stores of food to where they all had gathered —
As if the price were of the smallest matter!
Whoever had a pike to sell, or salmon,
And did not weigh it out in coin, did badly.
Their fare could fetch whatever price they fancied!
A bear could fetch one hundred marks exactly,
And thirty pounds the season's stag well-fattened;
Their partridges they sold for one whole mangon,
Their hens and cocks for ten whole sous — imagine! 2160
No venison, however overvalued,
No foul or fish, no meat the traders had there,
Although the price they asked for them was madness,
Was quibbled at or questioned by our barons!
They bought so much of everything on hand there
That you would think they'd found it all abandoned
 By men as free as they!

Our barons made a fierce display abroad:
To seek for bread they sent their servants forth.
Whoever had white bread or cakes in store, 2170
Could choose what price he sold it to them for,
And be well-off for one whole year or more!
The French remained so rich and liberal
That there was naught so dearly priced at all
That they refused to buy, just as before,

As if they'd found it, and it had cost them naught!
That very day, with no delay or pause,
A townsman raced inside the king's fine hall
And faced King Boniface with this report:
"In God's name, sire, the orders of your court 2180
Have run amok in town, their purpose foiled!
This envoy-band to whom you've given board
Behave themselves with too much pride and scorn.
There is no meat to eat of any sort,
No fish or fowl they have not found and bought.
Your town is now so highly priced withal
That pilgrims here and citizens of yours
Can purchase naught for any sort of coin.
The French have bought so much there is no more!"
On hearing this, the king was most distraught. 2190
"In faith," he cried, "they've pared me to the core!"
Once more he bade, with more forbidding voice,
That no man now, however rich or poor,
Pavian citizen or foreign-born,
Should furnish wood at any price at all
To Frenchmen lodged within the city-walls.
On hearing this, our princes and our lords
Who'd all bought meat to eat at their own board,
Were not well pleased, of this you can be sure,
And met to hold a council, one and all. 2200
Gui of Montpensier was first to talk:
"My lords," he said, "we have been held to taunt
By Boniface, whose ban has been enforced.
We are not used to eating our meat raw,
And if we did, it would demean us all.
We should be shamed back in our homes and haunts.
In God's good name, by Whom the world was formed,
If you believe my words and heed my thoughts,
Then we should arm and seize our shining swords
To fight this king whose honor over-vaunts, 2210

Up there inside his over-ornate fort!
Let's slay him now, in view of all his court,
Then hale away his sister, fair of form,
Before their eyes, and devil take them all!"
Girart replied: "Men, cast aside such thoughts!
What good is it to run a reckless course?
Is he not still a king and noble lord?
Within his realm his will should be performed!
Since he has banned us wood for heat and warmth,
We'll purchase nuts with thickened husks and all 2220
The cups of close-grained wood that can be sought!
When these are thrown upon a fire, I'm sure
You'll not have seen so bright a blaze before!
We all are men of high noblesse, my lords,
Our kingdom's peers, of peerless sires before.
If we must pay one thousand marks or more,
It should not mean a shelled egg to us all,
As long as we have done all that accords
With Aymeri's high honor and his cause."
The counts agreed: "Well said indeed, my lord! 2230
We shall proceed just as you say we ought!"
And to his words each one gave pledges sworn,
Then through the town they had it cried and called
That they would buy all wooden goblets brought.
The townsfolk heard and very soon stirred forth!
Beneath their cloaks so many cups they clawed
That soon our men had raised a mighty tor!
Each trader gained the sum he asked them for,
In weight of gold and silver unalloyed.
What riches, friends, those citizens enjoyed! 2240
Then rustics came with many a laden horse,
And sumpter-mules piled high with nuts galore,
Which soon were sold at prices of their choice!
Upon their fire the Frenchmen cast them all:
With broken cups, chopped up by them and sawed,

And well-husked nuts, their fire began to roar
And raised a flame that cast its glow abroad.
The sparks flew up and reached the roof-supports
And nearly fired the building like a torch!
The Lombard folk were filled with fear and awe. 2250
Each said to each: "What curse is this to fall?
These lords of France are Satan's living spawn!
Our injury and loss will be the fault
Of Boniface, our foolish, feckless lord,
 Who let them in Pavia!"

<p style="text-align:center">ᛉ CHANT 7 ᛉ</p>

<p style="text-align:center">HOW KING BONIFACE ATTENDED THE ENVOYS' PLEASURE</p>

For one whole week our envoys lived this way,
And every day the meals they took remained
As rich and rare as anyone could make.
The deer they'd bought and bears alike were slain,
And when the meat was ready for their plates 2260
Then they themselves displayed a strict restraint
And shared it all or gave it all away
To any man or wanderer or waif.
Their food was free for any man to taste
And take away as much of as he craved.
The Lombard lords, whose greed each one was great,
Could not endure to see such lavish grace
And sent a man at once to Boniface:
"In God's name, sire, you made a grave mistake
When you allowed this envoy-band to stay! 2270
We've never seen such pride as they display
From king or count or prince or peer of state!
They've turned the town into so rich a place
That travelers cannot afford to stay
Or purchase food at prices they can pay!

Fine king, my lord, send all of them away!"
On hearing this, the king was filled with rage.
He said, "In truth, I grieve at what you say.
I'll summon them to meet me straightaway."
"A waste of words, my lord!" the Lombards wailed: 2280
"Two weeks might pass and still you'd sit and wait,
Before they'd deign to meet you here again.
You angered them too much, King Boniface,
When you denied them wood the other day.
 That was, it seems, a folly."

Said Boniface, "By Mary's Son Lord Jesus,
It was indeed a folly past all reason
For me to ban the sale of wood to these men,
For they are knights of noblest birth and breeding
And they care naught for anything that we do. 2290
Their recklessness could very soon turn evil
If they remain much longer in Pavia.
But first, before this town gets any dearer,
I will not rest till I have gone to meet them."
At once he grasped a Syrian mule to leave there,
Selecting first an entourage of liegemen,
Some thirty knights, all lords of Lombardia.
Before they left his hall of vaulted ceiling
He turned to them while they were still convening
And spoke with grace in warning and entreaty: 2300
"My lords," he said, "by Mary's Son Lord Jesus,
When you set eyes upon those knights, be heedful
Of what you say — I want no reckless speeches,
For all the French are proud and fearless people,
Full of prowess and bravery unequalled.
One haughty word to them or in their hearing
And with their sword they'll split your skulls to pieces!
They would not stay their hand for all Pavia!
And if they then attacked our local people,

Five score of ours would die out in the streets here 2310
Before we'd robbed one Frenchman of his freedom!"
"My lord," they said, "you have no need to fear us;
So please the Lord, we'll not speak out of season!
May God, the Guard of every living creature,
 Preserve us from assault!"

King Boniface, his friends and closest lords,
Were richly dressed and shod, each one and all.
Not wasting time, each one bestrode his horse
And rode to join our envoys at their board.
And when our men beheld them at their door 2320
They rose at once to meet and greet them all.
The king spoke first, most courteous of voice:
"May Jesus Christ, our rightful King and Lord,
Who ever was and is for evermore,
Preserve you all in honor and in laud!"
They all replied: "We welcome you, my lord,
And yet you wronged us, sire, and were at fault
When you banned wood from being sold or bought!
If we'd not found another means of warmth,
We would have had to eat our dinner raw!" 2330
"My lords," he said, "bear anger here no more.
I meant no harm, in God's name, rest assured!
But now I'd know the reason and the cause
That brought you here, if you will speak it forth.
Why have you come to me and to my court
 Out of your native country?"

Sir Hugh it was, the Barcelona knight,
Who spoke for all, in graceful speech and wise:
"Fine king, my lord," that worthy count replied,
"So help me God, the King of paradise, 2340
We all are dukes and counts and marquis-knights,
And each of us rules regions rich and wide.

We've journeyed here at Aymeri's desire,
The best of lords this day and age alive,
Count Hernaut's son, whose deeds will never die.
From Saint-Denis to here there's none so fine
As is the Count who's sent us to you, sire —
Save Charles himself, so fierce of face and eye:
We do not match our lord with Charles's might,
But after his, our captain's bears the prize, 2350
Who rules Narbonne and its surrounding shires,
Which no prince else or marquis dared acquire,
So much they feared the heathen Moorish tribes.
This noble Count, whose honor I've described,
Bids you, through us, fine king of noble line,
To let him have your sister as his wife,
Sweet Hermenjart of face and figure fine.
I pledge to you in faith, if you comply,
No maid alive could hope to rise so high,
And you would gain so many friends thereby 2360
That you need fear no other man alive.
But if you don't, then rest assured alike
That you will have an enemy for life
 In Aymeri of Narbonne."

Sir Hugh spoke on, the brave and nobly-bred:
"Fine King, my lord, heed well what I have said
And rest assured I do not speak in jest:
If you give us your sister to be wed
Within Narbonne's rich hall of such noblesse,
In thirty days she shall be its countess. 2370
But if you don't, by God, I tell you then
That pain and shame will fall upon your head,
For we'll return with such a force of men
That in one year we'll have her nonetheless.
Fine king, my lord, pursue this course instead:
Submit the maid so fair of hair and head,

And she shall have a dowry of much wealth,
Which I at once shall nominate myself:
She shall be Lady of Biaulande, as well
As of Belcaire and all of Narbonne's realm 2380
And of Marsanne as far as to Vienne."
On hearing this, the Lombards filled with dread.
Each said to each: "By God, Who rules all men,
No count or king gave such a dowry yet!
 This lord should have the lady!"

Said Boniface, "My lords, now hear me speak!
In one respect I thank you much indeed,
When out of love you come to me and seek
My sister's hand for much feared Aymeri.
And yet it seems great arrogance to me 2390
That you intend to force us, if need be!
My lords of France, know one thing truthfully:
That man's a fool and mad in the extreme,
Who takes a wife against her wish and plea,
For such a wife will never hold him dear
Or honor him or serve him in the least.
But so that none may blame my actions here,
I'll go to her, at once, if you agree.
If she accepts your offer, frank and free,
Then I'll comply and give her willingly." 2400
The Lombards said, "Thank God for this release!
Fine king, my lord, attend her with all speed!
Do you not hear the menace in their speech?
Their haughty threats have filled us all with fear.
These envoys are not mortal men but fiends!
For God's sake, go! Give up the maid, fine liege,
And rid this land at once of all of these!
If you do not, we'll all regret and grieve."
When this was said the king turned round to leave,
Not halting then until his hall was reached. 2410

He found her there, his sister fair to see,
And at her side her maidens were convened.
The king was wise and very skilled in speech.
He threw his arms around her neck to greet
And hail her thus, most lovingly indeed:
"My sister fair, here's news for you to heed!
If you consent, then you can wed in brief
The highest prince alive today — for he
 Has sent his men to seek you!"

<div align="center">

❦ CHANT 8 ❦

</div>

HOW HERMENJART DISCLOSED HER FEELINGS FOR AYMERI

Within a room of floral-painted walls 2420
Sat Boniface the king inside his hall,
By Hermenjart, so fair of face and form.
With grace and love he lifted up his voice:
"My sister fair, this day can render yours
So brave a count to be your wedded lord
He has no peer from here to India's shore.
Some sixty lords have come from France's soil,
All counts and dukes, to lead you to their lord.
Four days and nights they've spent here, far from poor:
They've spent so far five hundred marks in coin!" 2430
On hearing this, she said with loving voice:
"My brother dear, don't think me mad or coy,
But by the Lord our Maker I have sworn
That I'll not wed a man to be my lord,
If I can't have the bravest one of all —
Count Aymeri, the warrior whose sword
Commands Narbonne and all its borders broad,
Which high and low refused from Charles before,
So much they feared the Saracens and Moors!
He rules it now with such prowess and force 2440

Against the threats of all the heathen hordes
That he's not lost six inches of its soil!
Because there's none whom anyone fears more,
He has become the husband of my choice —
And I'll wed him or never wed at all,
So my own fame may rise with his henceforth!
Monflor's King Herchenbaus has paid me court,
But he is old and weakens more and more!
For all the wealth of Charles the Emperor
I'll have no more of him, by God the Lord, 2450
For we would share no peace and love at all,
But grief instead, dishonor and remorse —
 And shame would shortly follow."

"My brother dear," the slender maid replied,
"For love of God, Who governs all and guides,
Do not let wealth dictate your will or mine!
You've wealth enough, in coin and other kind.
Have you grown tired of me here by your side?
This makes me fret and so upsets my mind
That I'll not think of leaving you a while! 2460
Spoleto's lord, last year, came here alike
To seek my hand with all his band of knights:
Othon the king, whose wealth alike was high;
And then there was old Savaris, the white-
Haired German lord, who must have lost his mind —
For I'd as soon be buried still alive
Than waste my love as such an old man's wife!
And then Duke Ace, the lord of Venice, tried
For twelve long months to win me as his bride,
As did André, who rules the Magyar tribes; 2470
He's rich enough, this much I don't deny —
Beneath his writ ten towns and cities lie —
But he shall not have me to lie beside
For he is old and all his beard is white,

His head is red, his skin all lose and lined!
By all the faith I owe blest Mary's child,
I'll not wed him, though I should lose my life.
I'd rather burn upon a flaming pyre
Than lie in bed by that slack-belly's side!
So help me God, Who governs all and guides, 2480
 I'll never wed a dotard!"

Said Hermenjart the fair of form and face:
"Fine brother, Lord, I swear to you in faith
That I shall stay a spinster to the grave
If I can't wed Lord Aymeri the brave,
Count Hernaut's son, whose deeds shall never fade,
To whom King Charles gave all Narbonne's domains.
When all the rest refused in fear and failed
The king's request, which to them all he made,
That gallant youth, most gratefully, obeyed. 2490
Fine brother, Lord, I've made my feelings plain.
So help me God, Who never lies or fails,
I want no lord except the lord I've named."
Said Boniface, "May Jesus Christ be praised!
I offer you none other but this same!
He's sent to us some sixty peers and they
Are all high lords of courage grand and great.
They've been here in Pavia for four whole days!"
"May God be praised!" cried Hermenjart the maid:
"O happy hour of birth! O happy fate 2500
That brings to me Count Aymeri, the brave
 Liege-lord of Narbonne city!"

HOW THE LOMBARDS AND THE FRENCH REJOICED

When Boniface the king heard from his sister
That she would wed the count and be most willing,
How glad he was, as were his knights and kinsmen,
And all the folk within his city's limits,
For they were filled with fear and much misgiving
Of what the French would do if angered with them.
With every haste the first of them turned quickly
Towards the French, to meet and greet them swiftly, 2510
Who in their lodge were waiting all to witness
The answer which the lovely maid had given.
The Lombards rode with every haste to bring it,
All keen to tell fair Hermenjart's decision.
The Frenchmen asked the very first ones in there:
"What says the maid of comely face and figure?
Will she return to mighty Narbonne city
As bride-to-be of Aymeri fierce-visaged?"
The Lombards said, "She will indeed, most willing!
If only four of you were to assist her, 2520
She still would go, blithe-heartedly and blissful,
 To him who holds Narbonne."

When all had heard the word that willingly
Wise Hermenjart the maiden had agreed
To be the wife of fierce-faced Aymeri,
You can be sure our counts were greatly cheered;
And Boniface, with every haste and speed,
Then led them all to his paved hall to see
The throng of folk, inside and out, convened —
For news had sprung and spread to far and near 2530
That Hermenjart was soon to wed and leave —
And then it was the honored maid appeared!

She left her room most nobly dressed indeed,
In purple robes of silk with patterned wheels.
Throughout her hair a golden ribbon gleamed.
Her eyes were green, her face was bright and clear.
Lord God had made her beauty so complete
That no maid since has been as fair as she.
The barons gazed, held fast, as in a dream,
Then privately they whispered, each to each: 2540
"Once Aymeri has wed this maiden here,
Well might he claim and say most truthfully
That from Narbonne to where the seas all freeze,
No monarch has so fair a wife as he!"
The lovely maid, as one well-taught and reared,
Moved forward then to meet and greet our peers.
With wit and grace she hailed them thus in speech:
" May Lord our God, Who sinners' souls redeems,
Who made the sky, the earth and salty seas,
Protect you all and bless us as we meet! 2550
How fine a throng this day has gathered here!
How many robes there are all slashed and seamed
With miniver and vair and gray between!
Yet I am vexed, for I cannot perceive
The gallant face of brave Count Aymeri,
Lord of Narbonne, who is to marry me!
Step forth, I say, and stay no more concealed
But take my hand, if such you would receive!"
"Fair Maid," said Hugh, "you ask what cannot be!
By God, Who made the sky and dew, believe 2560
That when your wish may truly be achieved —
When he to be your husband and your liege
Will come for you within this kingdom here,
You'll know at once by his most noble mien,
His fearsome look and sturdy arm, that he
Will be the count whom you will wed in brief.
Around him then so many men will cleave

That this paved hall with all of them shall heave;
And all this town, in every lane and street,
Will feel the shock and shudder then with fear!" 2570
"My lord," replied the maiden wise in speech,
"Then praised be God and praised His mother sweet,
 For such a noble marriage!"

Our sixty peers, on hearing what was said,
Could see how well they had achieved their quest:
They'd heard the maid with all her heart assent
To be the wife brave Aymeri would wed.
Then each to each turned privately and said,
With lowered voice, unheard by all but them:
"By all God's saints, our search has met success! 2580
In beauty's ranks fair Hermenjart's the best!
May God, the Son of blessed Mary, let
Count Aymeri possess this fair princess
Within his town of such renown and wealth!
Let them be wed with solemn word and pledge
Within the law set down by God Himself,
Then let them lie in his fine palace-bed!
And then our liege may truthfully contend
No prince or king, however rich and dread,
Has such a wife, from here to Hungary's edge!" 2590
 Those very words they uttered.

❦ CHANT 10 ❦

HOW AYMERI WAS SUMMONED TO PAVIA
AND HOW SAVARIS ATTEMPTED HIS REVENGE

Within the hall our peers remained awhile —
So they unclasped their cloaks of gray and white
And spread them out to sit on and recline.
In happy mood they jested and they smiled

Among themselves and with the maid besides.
And then she rose and hailed them in this wise:
"My lords," she said, "hear what I have in mind!
Since we have met and matched in our desires
That Aymeri should take me for his wife, 2600
Then by my faith in Christ the crucified,
If you agree to act on my advice,
Some ten of you should ride to Narbonne shire
With utmost haste and with no waste of time,
And tell the brave Count Aymeri outright
To mount his horse and come and fetch his bride,
If he still wants the one you rode to find!
If he does not, by St. Denis, reply
That she will not be asked a second time!
If he will come, with comrades by his side, 2610
Then they must ride all day and through the night,
And not delay for any horse they ride,
Though lame it falls or hurt or even dies!
For every hack I'll give two steeds of mine!
For every death I'll render two alive!
But you must go — some ten or twelve combined,
Two score and ten remaining here behind
To guard my rooms, well-armed and dressed in iron.
If in this land, to seek my hand, meanwhile
Some duke or count or marquis should arrive, 2620
He's sure to bring such riches with his knights
That both would snare my brother by surprise.
Then those of you within my rooms would rise
And bring me aid, your burnished blades on high
To strike those who would take me!"

"My noble knights, good envoys, noble lords,"
Said Hermenjart of lovely face and form,
"Let ten of you ride off now and report
To Aymeri the fierce at Narbonne court,

That he should come with no delay or halt 2630
But with all speed, not sparing any horse.
If hacks are lost, I'll pay back steeds of war!"
"Fair Maid," they said, "your will we well applaud —
And any man who wouldn't is at fault!"
They stood and left their cloaks upon the floor,
Not deigning stoop where they had sat before.
The ten of them, selected to report
Back to Narbonne, prepared to journey forth
And all the rest escorted them in joy
Till they had left Pavia's palace-walls. 2640
The maid began to marvel in her thoughts
About these lords whose fearsome pride had scorned
To pick up cloaks that they had once let fall
And cursed the cur who thought he might at all!
But Hermenjart, so fit for love and laud,
Bade Garnier forth, who was her seneschal,
And with him too a lithe and likely boy,
A worthy squire, and then two servants more:
"Good men," she said, "pick up and carry forth
These costly cloaks to those departing lords. 2650
They've left them strewn about our royal hall,
Perhaps to try or trick us in some cause."
"Princess," they said, "your will we well applaud."
Each took some twelve or fifteen, running forth
Towards our men without delay or pause,
Who all, just then, had left the palace-doors
To set those ten on their appointed course,
Whose task it was to reach Narbonne once more.
The seneschal ran after them and called:
"Lords, wait for us! Fine warriors, pray halt! 2660
The maid returns these costly cloaks of yours,
Which all of you left lying on the floor!"
Gui of Montpensier said, "My lackey-lords,
You keep them all and they will keep you warm!

It ill befits a knight who's nobly born,
Or any duke or count with lands in law,
 To take the seat he'd sat on!"

The Marquis Gui called out: "My noble lackeys,
You keep them all, those gray and ermine mantles,
For we have more to suit our every fancy: 2670
Each one of us has five or six to match them.
There is no call, in our domain or manners,
For counts or dukes, for marquises or barons,
To take away the seats that they have sat on!"
The youths replied, "My lord, one thousand thank you's!
May God above, Whose love has made you lavish,
The King of paradise, protect your valor!
So help us God, Who suffered on the gallows,
King Boniface, whom we have served unflagging,
Not once before gave us such noble mantles." 2680
The Lombards looked and all were filled with panic.
The king himself was troubled and distracted:
He wondered much where such a wealth was gathered
That men like these could give away so grandly.
Within his heart he thought them fools and madmen,
For he himself was never so free-handed;
But Hermenjart, when she learnt of the matter,
Her spirits leapt with joyfulness and gladness.
They mounted up, those ten who were to travel,
Astride their mules and sought no more to tarry. 2690
Upon their way without delay they sallied
And left behind their fifty fine companions,
Just as the maid, well-bred and brave, had planned it!
She saw them leave with bold intent and manner
And called on God to guide them in their saddles —
But ere they saw Count Aymeri's fine palace,
Their bravest steed would shy with fear and stagger,
For that low wretch, the German Lord Savaris,

Whom, as I've said, had fled before their valor,
Had since that time pursued and sued and rallied 2700
His brother's help, who lived within the land there,
And gained from him one hundred well-armed vassals.
God help the counts, Who suffered on the gallows,
 For trouble lay in wait!

The ten set out, not wasting any time.
They took the road direct to Narbonne shire
With ten young squires, who led upon their right
The Magyar steeds belonging to each knight,
And bore their swords and all their armour bright,
Which they would need indeed before that night! 2710
They rode in rank at easy pace the while,
Their trust in God, Who governs all and guides;
But Savaris, whose beard with age was white,
Still bore the pain of his defeat in mind
And scanned the road, day in, day out, for signs
Of Hermenjart, the fair Pavian bride
For whom his grief was matched by his desire.
He'd brought with him his brother's men to fight:
One hundred knights — God curse them all — aligned
In ambush on an ancient pathway's sides. 2720
Our envoy-band, all unaware, arrived
Beside the spot, much smaller in their size.
Hugh spoke aloud, whose face was brave and bright,
The liege he was of Barcelona shire:
"My lords," he said, "I think it would be wise
For us to mount our Syrian steeds and tie
Our helmets tight, of bright Pavian iron,
And clutch in hand the sword-blades at our sides,
To ride on here without a fear or fright.
This passage seems an old, secluded climb. 2730
If there are folk who lie in wait, they'll find
 We offer stout resistance!"

"My worthy lords and brave," Sir Hugh exclaimed,
"Pay heed to me and mount your steeds in haste,
And by your sides clutch hard your cutting blades!
If we're attacked, a stout defense we'll make!"
They all replied: "With God's goodwill we may!"
So each man left at once his mule of Spain
To mount his steed without one moment's waste,
Then all rode on in fierce and free array 2740
Till reaching where those Germans lay in wait.
When Savaris— God curse him and his fate —
Beheld them come, the joy leapt to his face.
He told his men "Now heed the words I say!
The day has come of our revenge and gain!
Upon this track I see that envoy-train
That put to sword my German race and maimed
So many men whom I had led this way,
But now their sum is not at all the same:
I do not rate a fig those who remain! 2750
If we do not seek vengeance on this day
For all of those they slew in wrongful rage,
Then we shall have no honor left or fame.
Because of them our comrades lie in graves,
Which grieves me much and fills my heart with hate."
His men replied: "And why then do we wait?
Against our force how shall their few be saved?"
When this was said those rogues rushed forth and raced
Their steeds along to meet our men again.
The French looked up and fear shot through
 their veins. 2760
"My lords," said Hugh, whose valor never failed,
"From good advice good only can prevail.
Now you can see that in the speech I gave
My words were true and my advice well made.
It seems to me that wretched German knave
We put to flight in fight the other day

Has set a trap to catch us on this trail.
For love of God, my lords, and in His name,
Be sure to show that each of you is brave!
Be fierce as lions and valiant as they! 2770
If we are few, then truer be our aim!
You all can see that we have no escape
And have no hope of any other aid
From anywhere save God and our own faith.
And you know well that if we seem afraid
To face their might, then we shall fall and fail,
As does the dove become the falcon's prey.
Ah God! How much we few shall miss this day
Girart of Roussillon, so strong and brave,
Hernaut of Metz and Ors of Beton Vale, 2780
Garin of Laon and Walter Mans the same,
Hunault of Brittany and Gaufroi's blade,
And Jocerain and Gui of Montpensier,
And all the rest who stayed to guard the maid!
If all of them were with us in this place,
These blighted rogues would not survive, I'd say,
But they are not and this much being plain,
By God Who pardoned Longinus, I aim
To make them pay ere I am caught or slain!
My lords, I have no other words to say; 2790
I trust us all to God and to His grace.
I'm off to strike, whoever likes or hates!"
When this was said he spurred his destrier
And raised his flag all crimson in the air.
His horse sped off and ran one arrow's range
As Savaris flung forward at great pace
To meet head-on and cried along the way:
"You harlot's son, surrender now you knave!
For you to fight against our might is vain!
I'll haul you back inside a German jail 2800
And wreak revenge upon you for my pains!

Then if I please, in ransom make you pay!"
On hearing this, good Hugh was filled with rage.
Without a word he spurred his destrier.
The German too advanced with greater haste
And struck Hugh's shield with all his heart and hate.
His spear was split — its fragments flew away —
But Hugh struck too the wretched German knave
Upon his shield, a blow so strong and great
The boards weren't worth a fig — they split and gave, 2810
As did the chains of sleek and shining mail —
But underneath his acton kept him safe
And saved the wretch from death and from the grave.
Hugh struck him well, with all his heart and hate,
And, legs aloft, he landed on the plain.
Hugh drew the sword that hung upon his waist
And like a lion he sprang on him, enraged.
He would have swung his blade through neck and nape,
When help arrived to save the wretched knave,
One hundred strong companions of his race. 2820
"*Gott hilf uns nun!*" they cried time and again,
As on all sides they circled and assailed
The noble count with weapons that they waved.
Without God's help and His most holy aid,
Good Hugh would not have lived to tell the tale.
Those Germans hurled their spears time and again
Till they had slain his Spanish destrier
 And brought him down before them.

When Hugh beheld the slaughter of his steed
You may be sure he felt great rage indeed, 2830
As fearsomely he leapt up to his feet.
If you had seen how hard he grasped his shield
And fought them all with his bright sword of steel,
You would have praised the prowess he revealed.
He dealt such blows to those in front or rear

That all were doomed who dared to come too near.
From further off they hurled their cutting spears
And would, no doubt, have brought him to his knees,
When our brave knights spurred up to his relief,
His noble friends, responding to his lead, 2840
And with them those ten squires in company,
Who all were armed as worthy knights should be.
Without delay they struck the German breed
Where they could see brave Hugh still striking free,
Though he himself was in the greatest need.
They cried, "Narbonne!" with voices loud and clear,
And each one smote the first he chanced to meet
Upon the ground, whoever groaned or grieved.
If you had seen those German forces reel!
They fled the field before our Frenchmen's zeal, 2850
Till Hugh alone was left upon the field,
Without a horse, still swinging his brave steel!
On seeing this, his comrades were aggrieved
And, looking round, they saw the raw-boned steed
From which good Hugh had felled old Savaris —
Who had, as yet, not found the strength or means
To reach its rings and thus remount the beast.
So Hugh himself was raised with every speed
Upon the rogue's swift horse, which had no peer
From here to Montpellier, or so I hear. 2860
And Savaris had loved it so that he
Would fain have lost a limb than such a beast!
His blighted men, on one side of the field,
Raced off to raise their injured lord and liege
From where Sir Hugh had hurled him in a heap
With such a blow that all his senses reeled.
They raised him up upon another steed,
Which they had found still straying through the field.
He blew a horn to stop his men's retreat
And back they rode and rallied at his feet. 2870

He looked at them and then began to speak:
"My lords," he said, "I fill with spite and spleen
And pain untold caused by these vassals here!
They've cracked my limbs and my whole body feels
So badly hurt I fear I'll never heal.
And what is more, they've robbed me of my steed,
For which I grieve so much my senses heave!
I call on you to help me, as agreed!
If you can wreak revenge upon these fiends,
My coffers' draught I'll drain down to the lees! 2880
No copper coin I'll spare if you succeed.
So much pure gold and silver you'll receive
As any man could carry in his dreams!"
On hearing this, his liegemen filled with glee.
If you had seen them seize afresh their steel
And strike the spurs once more against their steeds
From every side to charge our envoy–peers!
On seeing this, the envoys filled with grief.
They called on God, the Judge of all and each,
 To save them all from slaughter. 2890

How fierce it was, that fighting, and more dread
Than any seen before with so few men!
Our noble counts put up a stout defense,
Their numbers mean but mighty their prowess.
Each swung aloft his blade, of colors blent.
No German there, however great his strength,
If struck upon his floral-painted helm,
Could live for long, the blow soon left him dead.
What use was that? There still were too few French
And far too large a foe to fight against! 2900
The grace of God was all they could expect!
Their ranks were cleft. They could not hold the press.
Those wretched rogues soon slaughtered every ten
Of their young squires, which broke their hearts as well.

Our noble counts took so much pain themselves
That all their limbs were steeped in blood and sweat.
On all their shields not one whole board was left,
And all their floral-painted helms were cleft,
And, all around, their hauberks ripped and wrecked.
They called upon their true Creator's help 2910
To save them on that day from shame and death.
No wonder, too, if they were in such dread,
For many there bore wounds that were immense:
The smallest ones, in truth, were gaping rents.
In loving tones Sir Hugh addressed them then:
"For Jesus, our true Savior's sake, my friends,
Let us not shirk the fight while we have breath,
Lest shame or blame should fall upon our heads!
I do believe I see a tower ahead,
Well-fortified upon each side and length. 2920
If we can gain enough respite and rest,
And if God's grace will favor us and let
Us get inside, we'd have no worry hence
Of being caught without great loss to them."
On hearing this, the French regained their strength.
Each one of them allowed his steed its head
And, turning off, they spurred with fierce intent.
God's loving grace attended them so well
That when they reached the tower they found its men
Out in the fields, their gates unbarred and left! 2930
With no delay our counts rode in — except
For Hugh alone, that fighter bravely bred.
He hatched a plan of bravery and sense,
Which was to ride to Aymeri for help,
Since he possessed a steed so swift of step
It had no peer from here to India's edge!
And so he turned and rode off from the rest.
Now all those lords, without delay or let,
Closed every gate and all the entrances.

Inside they found a vassal who'd been left 2940
With his good wife, of face both fair and fresh,
Who greeted them with willing friendliness;
But when our nine had all disarmed themselves
They looked around, this way and that, and when
They failed to see brave Hugh there anywhere,
They thought him caught or that he'd fought to death,
And each of them made such a wild lament
As for one man was never heard till then.
But they were wrong and had no need to fret.
That worthy lord, with spur and speed unchecked, 2950
Had turned his steed to Aymeri instead,
 With news of what had happened.

❦ CHANT 11 ❦

HOW AYMERI LEFT NARBONNE
TO RESCUE HIS ENVOYS AND TO PUNISH SAVARIS

Sir Hugh rode off without the least delay
To reach Narbonne upon his steed of Spain,
And Savaris, with Germans of his race,
Approached the tower outside upon the plain.
Their rage was high, as was their wrath, against
Our men inside its walls both tall and great.
Old Savaris dismounted by the gate
And swore to God and all the Breton saints 2960
That he would rather be run through with a stake
Than leave before he took our men in chains!
But if he were to wait till Aymeri came,
He'd suffer more before he left again!
And worthy Hugh was well upon his way,
 With news of what had happened!

Inside the tower our envoys were besieged,
While at the gate they lay in wait and schemed.
Their rage was high and their despite was deep
Against our men, who lay beyond their reach. 2970
Those wretched rogues strove hard to gain a breach,
But those inside were little moved to fear.
In self-defense they showed like noble peers:
They hurled great rocks about those German ears
And those they struck were sorely squashed and squeezed
And many died or took great injuries.
The vassal there lent strong support. Both he
And his good wife showed great goodwill indeed,
And all they had was theirs to drink and eat.
And so our peers were lodged in equal ease 2980
As if they lay in their own forts and fiefs!
I'll leave them there awhile, my friends, and speak
Of good Sir Hugh, that peer without a peer,
Who'd made such haste and ridden with such zeal
Through dawn and dusk upon his rapid steed
That now he saw the town he'd longed to see:
Through Narbonne's gate he rode and through its streets
Without delay, though drooping with fatigue,
One Sunday, just upon the midday meal.
Before the hall he stepped down from his steed 2990
And gave it to a squire to tend and feed.
He climbed the stairs inside on weary feet
To find the count and all his knights at ease
On noble seats at marble tables reared.
On seeing Hugh, they all let out a cheer
And welcomed him by leaping to their feet
To kiss his cheeks and hug and hold him near.
For pity's sake the count began to weep,
Then straightaway he urged the knight to speak.
"Good Hugh," he said, "how did your quest succeed? 3000
Where are they now, those counts of high esteem,

Those sixty lords I sent in embassy,
Since only you have come back here to me?
Where have you left your fifty-nine fine peers?"
On hearing this, Hugh sunk his chin and cheek,
But did not speak, his eyes o'errun with tears.
When Aymeri saw this his senses reeled.
He asked again, as his quick temper seethed:
"Count Hugh, do not withhold the news I need,
But tell me straight, how did your quest proceed?" 3010
Count Hugh replied, "My lord, hear well and heed,
 And I will tell you truly."

Said Aymeri: "Do not deny or hide,
But tell me straight, good Hugh, for love of Christ,
Where are they now, those counts of valor high,
Since only you have come back to my side?
You have endured, it seems, an evil time.
You are worn out; it seems you have been tried
To the extreme by battle's strain and strife.
This shield of yours, who gave it holes so wide? 3020
This coat of yours, who ripped it so awry?
And this green helm, who broke it with such spite?"
"I'll tell you all, my lord," good Hugh replied.
 "Our quest has fared so well, thanks be to Christ,
That willingly the maid will be your wife!
From here to Nero's field there's none her like.
High, landed lords have sought her countless times,
But she replied she would not be a bride
Except to you, whom she has long admired.
On hearing this, we did as she advised, 3030
And in her hall stripe-walled we left behind
Two score and ten of us, well armed to fight.
We other ten set out for Narbonne shire
And took with us ten valiant young squires,
To tell you how our quest had won its prize.

95

Before we'd gone one day upon our ride
We were attacked by Germans from all sides.
They were in sum more than one hundred knights
And we were forced to wage so fierce a fight
That all those squires were robbed of limb and life, 3040
And we ourselves were wounded countless times.
We ten would have been slain had we not spied
Upon our road a fortress tall and wide
Whose sturdy tower was built in times gone by.
Praised be the King of majesty, all nine
Of my companions escaped inside,
Where they are safe, I'd say, a little while.
I do believe that they can all survive
Until you come and save them from their plight;
But do not wait, fine count of noble line! 3050
Help those whose love may cost them yet their lives!
You'll bear the blame if those nine nobles die;
And when they're freed from those in siege outside,
We'll leave at once, without the least respite,
To meet and greet fair Hermenjart your bride."
Said Aymeri, "Good Hugh, your words are wise.
By all the faith I owe Lord God on high,
Within this town I'll lie but one more night
Before I free those noble counts of mine
From that same tower wherein they are confined! 3060
When this is done, if God permits, we'll ride
 To fetch the maid directly!"

On hearing thus that he could have the maid,
Count Aymeri would brook no more delay
As he prepared to leave in rich array;
Throughout his realm he sent off word in haste
To summon all those knights from his estates
Who'd stayed with him that day when Charlemagne
Left them behind as Narbonne was reclaimed.

What numbers came to Narbonne's hall of state — 3070
Five thousand strong they were, and more, I'd say,
Who pledged to him with life and limb their faith!
He lodged them all inside the city gates
Throughout the night until the light of day.
When dawn arrived they loaded up the drays
And other carts and wagons that conveyed
The goods and gear that they would need to take.
The men-at-arms and servants led the way.
Count Aymeri, all praise to him, retained
Four hundred knights to keep the city safe 3080
And left one thousand men to lend them aid.
And yet, before the count came home again,
Five thousand would have been of more avail!
So help me God, in Whom all hope remains,
When Aymeri returned to his domain
He nor his bride would find a place to stay
Before he had re-won it with his blade!
For Desramé and Baufumez, those knaves,
Those cunning kings, God curse them, who'd escaped
Through Narbonne's vault from Aymeri that day, 3090
Had told their liege of Narbonne's fate — and they
Would soon return with all their pagan race!
Before our count could come back home again,
They would besiege his conquest and his claim.
Not knowing this, he set out on his way.
How hard they rode, how keen they strove and strained!
I'll not spin out the journey that they made.
Across the land his gallant band made haste
Until they saw that tower tall and pale
Wherein his peers were forcibly detained, 3100
Those noble counts whose hearts were filled with rage
At Savaris, who held them thus enclaved.
Yet ere the sun shone once more on the face
Of all his rogues, they'd wish that they had stayed
 Back in their German homeland!

With every haste the host had left in strength.
How hard they rode until they spied at length
The mighty tower where all his men were held
By German siege in their imprisonment.
All round the walls the count beheld the tents 3110
Where Savaris and his fierce Germans dwelt.
On seeing this, Hugh filled with deep content
And called by name upon his liege and said,
"Lord Aymeri, hear what I recommend:
Behold the tower, which holds our noble friends;
But, thanks to God, Who pardoned Longinus,
Those German knaves still sit in siege of them.
If you agree, then we should arm ourselves,
For if we can surprise them in their tents,
I would not give a fig for their defense. 3120
They can be caught and slaughtered ransomless!"
Said Aymeri, "God bless what you have said!"
Dismounting then, with no delay or let,
His knights and men all armed themselves and then,
When all was clear on every side, they stepped
Astride their steeds of Spanish breed the best,
And spurred their flanks to drive their ranks ahead.
High in the tower, at its top window-ledge,
Our prisoners beheld the surging press.
So many coats of mail, so many helms 3130
Gleamed in the sun, and shields with lion-crests,
That every man among them filled with dread —
For they believed the army was not French
But all the host of Savaris, intent
On taking them by force of arms and men.
Each said to each, "My lords, what hope is left?
There's no escape, we all shall meet our end!
This German knave has far too many men!
May Jesus Christ forgive our souls in death!
Lord Aymeri, what loss is on your head: 3140

For love of you, fine lord, we all are dead!
Brave baron's son, ill-starred we ever met,
Or saw the maid so fair of face and fresh,
 For whom our lives are forfeit!"

Within the tower they all filled with dismay
And cursed the day the count sent them away —
And yet his men were speeding to their aid,
And he himself, with all his heart and haste,
Was at their head on his rich destrier,
Beside him Hugh, whose valor too was great: 3150
Well-armed, he rode on that fleet-footed bay
From which he'd flung old Savaris that day.
He raised his flag and then the Oriflamme.
Those in the tower, on seeing these, all raised
Such shouts of joy as none before had made.
They cast aside in brief their grief and pain
And called upon the Lord our God in praise.
Each said to each, "Let us no more delay,
But arm ourselves, fine lords and fighters brave,
And ride outside and challenge straightaway 3160
This Savaris, this faithless German knave!
The Lord our God, through His sweet, saving grace,
Has looked on us with such a loving face
That Aymeri has come here to our aid,
 And to effect our rescue."

That noble nine were filled with mighty cheer.
Inside the tower they armed themselves with speed,
And while they did, as fitted fighting peers,
Count Aymeri spurred up to their relief,
Beside him Hugh upon that noble steed. 3170
Five hundred men had followed them, and each
Was armed to match his temper and his need.
The German troops, on seeing them draw near,

Each one of them turned white with dread and fear.
"By mighty God, my lords," said Savaris,
"I know in truth that every one of these
Bears no goodwill to either you or me!
But now I'll know my true men by their deeds!
I ask no more than that you help me flee —
For riding here is none but Aymeri! 3180
And that fierce lord beside him there is he
Who stole my steed in combat on the field.
He rides it now in front of those he leads.
To think of that fills up my heart with grief.
Let's mount in haste, and let us turn and leave!
If we are caught, they'll slaughter us with glee!"
His men replied, "My lord, most willingly;
You shall not call in vain for us to flee.
We've no desire to stop and fight, indeed!"
So off they ran to find a mount for each, 3190
Content with hacks, not searching for their steeds.
Whatever beast they came across they seized —
A nag for those, a stallion for these,
A sumpter-horse or any mulish beast,
They did not care — not even Savaris:
Bare-backed he rode a horse he knew was fleet,
And turned in flight as swiftly as could be!
And in his tracks they all made their retreat,
The strongest there not waiting for the weak.
Hugh saw them all, as charging at great speed, 3200
He lunged and plunged among them with great leaps.
If Savaris escaped, then Hugh would feel
That all his life he'd hold his honor cheap!
He spurred his steed until his eyes could see
The German rogue upon the grass between
A narrow slope and edge of a ravine.
He cried to him, "This time you shall not flee,
But pay the price for all your great deceit!"

On hearing this, the villain felt such fear
That, falling down at once upon his knees, 3210
He cried for grace, his face upon the field.
He rendered up his sword, which Hugh received.
He did not strike or touch him in the least,
 But led him off to prison.

When Savaris had rendered up his blade,
The rest of them showed little will to stay.
Like folk bereft they fled in every way
And left behind the tents that they had raised.
Count Aymeri pursued them in his rage
And all his men joined swiftly in the chase. 3220
Without delay the nine who had remained
Within the tower forsook their hiding-place
In hot pursuit of all those rogues the same!
The man they struck was smitten to his grave.
How dear a wage those German knaves were paid —
Their hands were full with what our Frenchmen gave.
Who made away could bless his lucky day —
But who did not, he lost the lot straightway,
Save Savaris, who'd pleaded to be saved.
The noble Hugh, whose face with valor blazed, 3230
Released him to the vavasor whose grace
Had made his tower and all that it contained
Our envoys' own and so had kept them safe.
He locked him up inside his tower's jail
Till he was paid a ransom-fee so great
 It made him rich for ever!

❦ CHANT 12 ❦

HOW AYMERI AND HERMENJART MET AT LAST,
AND HOW THEY PROCLAIMED THEIR LOVE

Their foe was put to flight or to the sword,
And Savaris flung deep inside a vault!
Hugh dealt with him like one most nobly born,
Not taking from his purse two Paris coins, 3240
But giving him to that good vavasor
Who in his tower had saved our envoy–lords.
What wealth he gained for Savaris henceforth,
Whose ransom-fee was set and met in short.
And Aymeri himself was filled with joy
To find his knights alive and safe once more.
Among themselves how much they all rejoiced
Before the count and his fine nobles all
Remounted horse and with no further pause
Rode off to reach Pavia's city walls 3250
And greet the maid so fair of face and form!
I have no wish to chronicle their course —
Through night and day they rode till on the morn
Of Thursday next, before the noonday's warmth,
They entered through the city gates in force.
While noble squires sought lodgings for them all,
King Boniface, well-bred and rich, came forth
To welcome them as any worthy ought.
Count Aymeri, for him, leapt from his horse,
As one well-bred and raised in noble courts. 3260
In high content the envoy-band re-formed
And by the steps of dark-hued marble wrought
They climbed once more inside the royal hall.
Then from a room the lovely maiden walked,
Most nobly dressed and cloaked in miniver.
Upon her head the noble princess wore
A coronet of finest golden gauze.

Her eyes were green, her face was bright with joy.
A fairer maid was never seen before,
And none could look and not be struck with awe. 3270
And when she saw our nobles in the court
She hailed them in a most obliging voice:
"May Lord our God, in paradise adored,
Who always was and will be evermore,
Keep each of you in His strong watch and ward!
I see so many miniver-clad lords
That I can't tell which one among you all
Is Aymeri, Narbonne's most famous lord,
Who for my sake has come so far abroad!
Count Aymeri, fine, noble lord, step forth 3280
Without delay and take and make me yours!"
The count heard this and, laughing, cast to floor
His cloak, uncaring who should pick it up henceforth.
He placed his arms upon her shoulders, for
He was well-bred, and said with ringing voice,
"I swear to you in faith, you can be sure
That I am Aymeri, who would be called
Your husband and your worthy wedded lord;
Within my realm two thousand knights and more
Will serve your wish in any way at all, 3290
As soon as I may lead you to my hall."
"Much thanks for this," said fair-faced Hermenjart,
"So help me God, you can alike be sure
I love you more than any mortal born.
I've never said as much as this before —
But do not judge my openness a fault."
"By St. Denis," he answered, "rest assured,
I love you more and always will henceforth."
When this was said the two withdrew to talk
Of this and that upon a bed adorned 3300
 With dark-hued, silken covers.

In word and deed Count Aymeri was wise.
He took the maid and sat down by her side.
In his right hand, with tender, loving pride,
She placed her own, its fingers long and fine.
Her face was white, her cheeks incarnadine;
Her many charms I'd cheerfully describe
But half the day might run its course ere I
Could praise her grace as much as it required.
With sense and wit the count of her inquired, 3310
"My lovely maid, reveal your inmost mind!
What truly do you think of me and mine?
I have come far to seek you for my bride,
So in all truth, if you have no desire
To marry me, then tell me now outright
Ere one more word be spent in wasted time.
And rest assured, if you are not inclined
To marry me, I'll not proceed in spite,
For all the gold ten cities might supply.
It's better far to tell me now no lies 3320
Than bear henceforth with Lombard scorn and jibes."
"My lord," she said, "don't doubt of my desire.
I love you more than any man alive.
I'll thank the Lord each day of my new life
That it pleased you to want me as your wife.
Now I bid you, fine count and honored knight,
For love of Christ, Who bore the Cross's spite,
That when you go, you won't leave me behind,
But take me back at once to Narbonne shire,
Lest either prince or landed lord arrive 3330
To hale me forth in his frustrated pride.
For if one did, such hatred might arise,
Which could destroy too many Frenchmen's lives."
"Fair one, fear not," Count Aymeri replied,
"For I swear this, upon my father's life,
Who was Hernaut, of fame and honor high,

That when I go, you'll be there at my side
To ride for Narbonne's palace."

<center>❦ CHANT 13 ❦</center>

HOW COUNT AYMERI AND KING BONIFACE DISCUSSED
THE WEDDING AND THE RETURN TO NARBONNE

Inside the hall the noise was great indeed,
For many knights had come inside to meet 3340
With Lombard lords, some fifty score or near,
And talk of this and that, each man with each.
Count Aymeri, himself, was keen to leave
And summoned Miles, the son of Duke Garnier:
"My friend," he said, "I charge you to proceed
On my behalf in conference and speech.
I have proposed, now they must take or leave.
I must return to my own land and fief
And be on guard against the pagan breed,
For I know well they hold me far from dear! 3350
If they can see the smallest chance appear
To waste my realm and take that castle-keep
With which King Charles the Great entrusted me,
Then they will seize that chance most willingly.
If I lost all in dalliance, then he
Might truly claim and rightfully believe
That he had picked a poor lord for his lease."
"My lord," said Miles, "I'll do as you decree."
Good Garnier's son, at this, got to his feet.
A knight he was of noble brow and breed, 3360
Well-formed and fair, and very wise in speech.
He went at once to Boniface, to speak
With him and all his counselors convened:
"My lords," he said, "you should not be displeased
With Aymeri's desire and fearsome zeal,

And why he stands in this great palace here.
On his behalf I ask you to agree
To give him Hermenjart, whose hand he seeks.
If they are wed, your honor will increase.
In foreign lands you will be more esteemed 3370
And in your own be held in greater fear.
If you refuse, then what will be will be;
He will return to his own land and fief
And choose elsewhere before this month has ceased
Another wife whom God will bid him meet.
But there's one thing that I shall not conceal:
If you refuse, I swear, before we leave,
Five hundred wives will mourn in Lombardy!"
On hearing this, the Lombards filled with fear.
Among themselves they talked and all agreed: 3380
"How fierce a threat this vassal makes indeed!
A curse on him who for a woman's needs
Would let himself be split apart by steel!
He wants her — let him have her by all means!
And let us pack on fifteen hacks in brief
Enough fine gold and silver so his peers
And noble knights have also all they please,
With plenty more to please the Narbonnese!"
The princess laughed to hear their harried speech
And then she said, "My lords, much thanks, indeed! 3390
By all the faith I owe our Heavenly Liege,
Since such a count has sought to marry me,
I shall not choose to change this destiny!"
On hearing this, the Lombards all agreed:
"Our lady has a lord both rich and fierce.
No better knight serves Charlemagne than he.
We would to God, Who judges all and each,
That they were gone already, he and she,
And newly wed in Narbonne's castle-keep!"
King Boniface himself began to speak 3400

With Aymeri, whose heart with valor beat:
"My noble Count, is this your wish indeed?"
The count replied: "No more than this I seek."
With his right hand the king took Aymeri,
Who offered his with goodwill plain to see.
The noble knights, at this, were greatly cheered
And turned at once to find their rooms and sleep
Until the morn, whose dawn was bright and clear.
Then straightaway they dressed themselves to leave
And loaded up the sumpters with their gear. 3410
Then they themselves bestrode their rapid steeds
And rode along, then left the city's streets
With Aymeri and his fair wife-to-be,
And Boniface, thus far, in company.
"By good St. Richier's bones, Sir Aymeri,
To reach Narbonne you must ride on between
Such tribes of men whose hate for you runs deep.
My noble count, I bid you take from me
One thousand knights of my own Lombardy.
Each one shall have a steed and sword of steel 3420
To serve your need if any threat appears.
But heed this well in reference to these:
If fight you must, then just as you proceed,
Make sure these men are placed right in the lead!"
Said Aymeri, "I'll take them willingly!
To have more men will not dishearten me!
By St. Denis, whom noble knights beseech,
The more I have, the happier I'll feel!"
On hearing this, the Lombards' spite was keen.
Among themselves they grumbled, all aggrieved: 3430
"Just cause we have to groan, by St. Rémy!
King Boniface cares naught for us, it seems,
Who gives us up to such a man as he,
Who loves to fight more than to drink or eat!
If we in truth must keep him company,

Not one of us will live to come back here!"
When Boniface heard their complaints, he leaned
Towards the count and thus began to speak:
"My noble count, this much I must concede:
These Lombard lords I've given you to lead, 3440
When fighting starts, are cowardly and weak.
If fight you must, then just before the field
Make sure they ride in front to deal and feel
The first attack of steel on sturdy shields.
Then watch them grow in courage and in zeal!
Before they're killed or caught, believe you me,
Each one of them will sell his valor dear!"
On hearing this, the Lombards' joy was bleak.
"What gain is there," they cried, "in bitter grief?
If fight we must before we earn reprieve, 3450
Then shame on him who acts so cowardly
As to be killed or maimed or made to bleed
When he may live by striking with his steel!"
When this was said the party took its leave.
The count rode off beside his bride-to-be.
King Boniface turned back, while Aymeri
Set all his thoughts upon Narbonne, his fief.
His ranks were formed, his knights were brave and fierce.
God help them all, Who judges all and each —
 For awful strife was waiting! 3460

THE THIRD GESTE

THE RETURN OF THE PAGANS

⚜ CHANT 1 ⚜

HOW THE EMIR WAS INFORMED OF AYMERI'S ABSENCE
AND HOW HIS ARMIES LAID SIEGE TO NARBONNE

When Aymeri, whose face with valor shone,
Had set off for Pavia in courtship of
Fair Hermenjart, of slender limb and long,
A Saracen — may he be cursed by God —
Set off as well and went straight to Orange,
Not stopping till he reached the palace strong.
Within its hall of vaulted walls were lodged
King Desramé and his companion
King Baufumez, who through the tunneled rock
Had fled their throne that day in rich Narbonne 3470
When Charlemagne attacked them in his wrath.
They'd fled beneath the floor and sped along
To seek support and help in their great loss
From the emir of all the Persian throng.
Since then they'd lodged and lingered at Orange,
But now the spy had news to spur them on!
He hailed them both by their religion's gods:
"My lords," he said, "good fortune, by Mahom!
With many knights Count Aymeri has gone
Forth to Pavia to seek the wife he wants! 3480
Narbonne is left with very few on watch.

The force inside is much less than it was.
If you've the will, you may regain your loss!"
On hearing this, the two kings sprang aloft
 With joy and great rejoicing.

When both had heard the message he'd delivered,
That Aymeri, to seek a bride, had ridden
Straight to Pavia to woo her and to win her,
They mounted horse, not waiting for a minute.
To Babylon they turned and spurred as swiftly 3490
Upon that course as horse could gallop thither.
I'll not spin out the journey that they did there:
They came one night to Babylon and quickly
Dismounted steeds and climbed the steps to bring them
Within the hall of the emir's main building.
They found him there, about to eat his dinner,
With four more kings of fearsome mood and visage.
I cannot name the other pagans with him,
For hordes of Moors had all been summoned in there
To celebrate a feast of their religion 3500
In honor of Mahomet, whose own image
Had been transferred to Mecca on a litter
To lie within the shrine built in that city.
The feast was high and kept in highest spirits
By the emir, who'd called them all to witness
Upon this day a wondrous new exhibit:
Within the hall of the emir's main building
There stood a tree that had been crafted in there
Of copper mixed with gold boiled to a liquid,
Poured in a mold and cooled till it was rigid. 3510
No man alive, however wise or skilful,
Could look upon this tree and see within it
The birds it bore so that he could distinguish
Which one was which, in face and form or figure —
And yet each bird had one that was its twin there.

The man who made this tree was a magician.
He made the birds from jewels brought from a river
Called Paradise — when they were all delivered
He set them fast in fine enamel fittings.
By trickery, each passing breeze was filtered 3520
Through trunk and tree, which acted like a chimney.
Each passing breeze set all the songbirds singing.
So sweet and clear, so lovely was their trilling
That none on earth would ever tire to listen.
If any man with rage or anger in him
Heard just one note, it calmed him in an instant.
Their song could last as long as any wished it
And when required, or as desired, could finish.
The great emir was fêted by his minions,
And how he loved the lavish praises given! 3530
But very soon he'd have a change of spirits —
For those two kings were running up to bring him
 The news about Narbonne.

The exiled pair, who'd fled Narbonne before,
In their despair rushed up inside the hall.
There Desramé and Baufumez both saw
Their mighty liege and at his feet implored
And begged for grace in Mahom's name and cause.
The great emir raised both men from the floor
And then he said, in his most fearsome voice, 3540
"What is amiss, my dismal-looking lords?"
"My liege," they cried, "in truth, we'll tell you all.
The knights of France, cursed hour that they were born,
King Charlemagne and all his Christian force,
Have seized Narbonne from our control and law,
And all the land around from shire to shore,
And given it to one of Charles's choice —
Called Aymeri, a proud and haughty lord.
But now his knights and he have ridden forth

To seek a bride, for so our guide reports.
They'll not return for thirty days or more." 3550
On hearing this, the great emir was wrought,
Distraught with rage, and cried across the hall:
"A hundred fiends! That Charles should still endure,
With Roland dead, cut down by Spanish Moors,
And Oliver alike, so fierce in war,
And all the Peers of France's land and court!
Charles should have died with sorrow and remorse!"
The envoys said, "You are mistaken, lord.
Though Charles is old, he still is bold and sure. 3560
He bears his arms as nobly as before
And mounts as fast upon his fleetest horse.
There is no lord more worthy in his court.
But if you'll be persuaded by our thoughts,
Call forth your hosts from every land abroad,
And when they're here in all their strength and force,
Then let us move to take Narbonne once more!
When this is done by force of our assault
Then let us take the whole of France by storm!
Seize Paris, sire, and make it serve your cause, 3570
Then Troyes, then Meaux, till we have taken all
Old Charles's realm, for who shall call us halt?
At Aix in France, among his royal court,
You will be crowned its ruler and their lord!
And then, before six months have run their course,
Ride on to Rome, that noble town of yore,
And with assault that city too will fall!
The wondrous wealth amassed inside its walls
Can, if you wish, each whit and bit be yours,
Enough to arm some twenty thousand Moors!" 3580
Said the emir, "You've spoken well, my lords,
And counseled me with loving words and loyal.
By my long beard, I'll not be stopped or stalled
From doing that which you have said I ought!"

At once he bade instructions to be drawn
Up straightaway in letters sealed, then borne
By messengers to lands beneath his law;
And so they were, with no delay at all.
His envoys rode to kingdoms south and north,
From Rochebrune as far as Durestant, 3590
Where sunlight's ray is first each day at dawn.
So many Moors obeyed their master's call
That, side by side, their ranks were one league broad:
From Babylon to Mecca they marched forth
Until they reached Mahomet's shrine once more.
They railed against King Charles there and deplored
Count Aymeri as rich and haughty lords
Who'd robbed them of their rightful land Narbonne.
They blessed the shrine with gifts of gold and coin,
Then sounded out their olifants and horns; 3600
Their pack-mules brayed, their horses neighed and called,
And they themselves set up a mighty noise
And sparred with spears and with the point of swords.
No larger force was ever seen before,
For fourteen kings, who all were Spanish-born,
Had brought with them their total fighting force:
King Athanas was there with King Janbor,
King Forré and his brother King Maubraun,
King Codroé and Egypt's king and lord,
King Aceré and Anfelis the royal, 3610
King Mautriblé and King Cornabador,
King Giboé and one King Lucifer!
All boarded ship and brought their men on board,
Who, curse them all, bore food enough and stores
To feed their strength for one whole year and more.
They left the port and sailed upon their course.
The Living Fiend supplied such winds and storms
That in two weeks they reached their plotted shore
And saw the land that lives by Christian law.

Like summer flowers fair Tarragona's walls, 3620
That lovely realm, shone white in summer's warmth.
On seeing this, ten thousand of them mourned
The loss of it that their own race had borne;
They left their ships, they neither stopped nor stalled
But straightaway bestrode their steeds of war.
Most richly armed they rode their horses forth
And made their way as far as Avalence.
Each town they passed and field they scarred and scorched
And herded men in chains and haled them forth.
They birched their sides and flogged them with
 such force 3630
That bodies bled as flaying laid them raw.
The summer-feast of good St. John it was,
When wheat is scythed and laid up into store,
That they arrived upon the plain before
Narbonne again and set up tents galore.
The great emir, his princes and his lords,
Set lodges up around the city walls.
Alas indeed, by God our hope and joy,
That Aymeri knew nothing of it all,
 Who brought his bride towards them! 3640

♠ CHANT 2 ♠

HOW AYMERI RECEIVED NEWS OF THE INVASION
AND HOW HERMENJART RODE TO GIRART OF VIENNE

The great emir had all their lodges raised
Outside the walls at one longbowman's range.
Then he deployed two thousand Moors to wait
Inside a copse, well armed from top to tail —
God curse them all! Before they left they laced
Steel helmets on and coats of shining mail
And seized stout shields and pikes with cutting blades

And then turned loose their sumpter-mules to stray
Across the fields, with camels packed the same.
God curse them all, Who judges all, for they 3650
Had let them go to lure our men away:
Those soldiers left to guard the count's domain,
Who, when they saw the siege that had been laid,
Were sick at heart — no wonder too, I'd say.
Said Elinans, of courage fierce and great,
Duke Naimon's nephew, beloved of Charlemagne:
"My lords and men, I'll make my meaning plain:
Count Aymeri, who left us in his place,
May well have left his journey home too late!
To seek his bride he left Narbonne in haste, 3660
Pavia-bound, to marry this fair maid.
He'll not be back before some thirty days!
But since he left us here to guard his gates,
Let each of us be worth our knighthood's name!
A coward's curse on any who would stay
Cooped up in here like hawks within a cage!
So let us ride, each on his destrier
And fully armed, with all the haste we may,
And take inside this mule and camel-train,
Which they have packed and stacked with wheat
 and grain, 3670
And so restock this mighty hall of state!
When Aymeri, to whom I've pledged my faith,
Returns at length, he'll not find empty plates!"
The rest replied, "Most gladly we'll obey!
Who fails you now betrays his knighthood's name!"
They armed themselves without one moment's waste.
Stout helms of steel they laced and coats of mail,
And at their hips they clipped good, burnished blades,
Then mounted up, each one, their destriers.
Around their necks strong, quartered-shields
 they draped 3680

115

And in their palms strong cutting pikes they placed.
Through Water-Gate they left the town and raced
Towards the tents those Saracens had raised.
The great emir was at his meal when they
Attacked the Moors with all their heart and hate
And slew at once one thousand with their blades,
Then, turning back towards Narbonne again,
They caught those mules and camels on their way
And thought to lead this booty through their gates —
But then it was that those two thousand knaves, 3690
All fully armed astride their destriers,
Leapt out at them — God curse them and their fate!
And when our men beheld the trap they'd laid,
You can be sure they filled with deep dismay.
All thought they had of getting back again
Inside Narbonne's great fortress fell away.
They had no choice, they left behind their gains:
They led away no mule or camel-train,
Nor any wealth worth any denier.
No talk was made of jousting just for fame, 3700
But for their lives, just so they might escape.
If you had seen how fierce a fight they gave —
How many shields and spears they split in twain,
How many Moors they tumbled to their graves,
How dear they sold the honor of their names —
They struck to ground one thousand Moors, I'd say!
But on our side the losses too were great:
Of fifty score who started, scarce remained
Five hundred men to ride back home again —
And of these men one half again were maimed. 3710
Towards the hall they turned their horses' reins,
With great desire to be inside and safe;
They spurred their steeds straight though the castle gate
And, once inside, they raised the bridge's chains.
But one of them, the son of Duke Garnier,

Sir Fulk his name, rode off again in haste!
Of all his shield not half a foot remained —
The devil's breed had broken it away
And cleft his coat of so much of its mail
That it would serve no good man's use again. 3720
Sir Fulk himself bore awful wounds and pain
From where a spear they'd cast had found its aim:
Above his belt the iron had struck his waist
And from the wound the crimson blood escaped
And wet his spurs with every turn he made,
The saddle-cloth, the horse's neck the same.
His good spear, made of apple-wood, he raised,
Though it had lost its steel and iron blade.
His battered look no better could betray
That here was one who'd fought a bitter fray. 3730
The pagans yelled: "Pursue him straightaway!
By great Mahom, he's ridden off again
To carry news of us to Charlemagne
And summon here the king's fierce baronage!"
Ten thousand Moors set off to give him chase,
But when they saw they could not match his pace
They cast at him their spears both strong and straight.
But God, the Judge of all men, kept him safe.
He nor his horse took any scar or scathe.
No stag or doe springs through the woodland-glade 3740
Nor runs as fast when charged at in the chase,
As brave Sir Fulk spurred on his steed that day
To tell the news to Aymeri's own face,
With naught to lose, unless his horse went lame!
The worthy man, at last, met on his way
With Aymeri, his bride and all the brave
And gallant knights their bridal-train contained.
Jongleurs were there to cheer and entertain
On their *vièles* with tricks and merry tales.
From such a pair they hoped to be well paid — 3750

117

But very soon a different tune they'd play
As Fulk spurred up upon his destrier.
With ringing voice he hailed the count this way:
"Lord Aymeri, fine knight of noble race!
You have, I see, the wife you went to claim.
But lord, one thing may spoil this happy day:
You may not have a home in which to stay!
Those evil kings, the haughty Desramé
And Baufumez, God curse the heathen knaves,
Who fled your siege through Narbonne's
 tunneled cave, 3760
Have filled the ears of their emir with hate!
Now both are back and with a force so great
That none can count the thousands it contains.
Around your hall so large a siege they've laid
That not one foot of empty ground remains
Without a tent or great pavilion raised.
Just yesterday a great assault was made
Upon our walls, but little was their gain.
Thank God above, the Father of our fate,
We slaughtered more than fifty score, I'd say, 3770
But our own force did not escape unscathed:
Our injuries are many and most grave.
We charged, but ere we made it back again
One half of all the knights our force contained
Lay on the plain, cut down by heathen blades —
May God the Lord reward their souls with grace!
Sire, look at me and you can see straightway
That I don't lie — I've fought a bitter fray."
Said Aymeri, "In truth, I see the same;
You are indeed a knight of highest praise. 3780
I could not wish to find a knight more brave."
To Hermenjart he turned and spoke this way:
"My lovely maid, can you advise me, pray?
So help me God, my need is very great."

"My lord," she said, "most willingly, in faith;
It seems to me, it's easy in this case:
Do you not have four thousand men who stayed,
At Charles's wish, to help you guard your state?
And have you not one thousand Lombards placed
Within your ranks, well-armed by Boniface? 3790
If you should meet with pagans in their rage,
Then use this force to reinforce your claim!
With all these knights proceed upon your way,
And I will go, if you agree I may,
Straight to Vienne and stay where I am safe,
With Duke Girart, your uncle bold and brave!
I'll ask him then, for you and your love's sake,
To summon men and hasten to your aid.
He is your uncle, he will not hesitate.
So let me be your messenger this day! 3800
You could not send a truer one, I'd say."
The count heard this and held her in embrace.
He kissed her eyes and all her lovely face,
Then said to her: "With all my heart, fair maid!
What loyalty and love your words proclaim!
Seek out Girart without one moment's waste!
In God's good watch and ward be on your way!"
"And you, my lord! May God in glory save
Your life from death, from peril and from pain!"
The count rode off, farewelling the fair maid. 3810
He sent with her four counts of highest praise
And half of all those knights of Boniface
To keep her safe each step along the way
Towards Vienne. With fierce intent and haste
They reached the Rhône and crossed without delay;
The count, meanwhile, came to Lunel and stayed
There overnight till dawn lit up the day,
Then he re-armed and donned his coat of mail
And swung once more on his swift destrier.

He galloped forth, then on a hill drew rein: 3820
Before him there, in summer's sunlight bathed,
He saw Narbonne, its walls and all its plain
 Beset with pagan lodges.

⚑ CHANT 3 ⚑

HOW GIRART WELCOMED HERMENJART
AND HOW HE MUSTERED HIS FORCES TO HELP

Count Aymeri climbed up a hillock's crest.
Before Narbonne he saw the pagan tents
And in God's name he cursed the lot of them.
Fair Hermenjart, meanwhile, pursued her quest.
I'll not spin out the way her journey went.
She did not halt until she saw Vienne;
She hailed Poinçon, whom one Guimart had bred, 3830
A youthful knight whom she had dubbed herself
And given horse and arms and armaments:
"My friend," she said, "pay heed to my request:
Proceed at once to Girart of Vienne,
The worthy duke, whose honor is his crest,
And greet him in God's name, Who made all flesh,
And in my own, who sends you on ahead,
And Aymeri's, the nephew he loves well.
Do not conceal from him our present threat:
That Narbonne was besieged when Aymeri left 3840
To bring me from Pavia to be wed.
By pagan Moors the town is so beset
That none alive has seen the like of them.
With all his men the count has rushed ahead
And bade me come for safety to Vienne.
Request Girart to lodge me and my men."
"Most willingly I will," the youngster said.
With every haste he spurred his horse ahead,

Not slowing once before he reached Vienne.
He found the duke in his fine palace, where 3850
His dogs and he were baiting a great bear.
He greeted him with fair and fond address
In Jesu's name, the Father of all flesh,
And in her name who'd sent him in her stead;
Then he re-told, with nothing left unsaid,
The maiden's words as she had uttered them.
The duke heard all, then joyfully he said,
"God bless the hour, Who made all mortal flesh,
When that well-bred and brave and fine princess
Who sent you here shall enter here herself! 3860
It's many days since I've known such content
As now, to know my nephew so well wed!
Guibourc, good wife, hear this! If ever yet
You loved me well, now let me see and tell!
If any here would show their love's true depth,
Then show this maid great honor and respect!"
When this was said he hastened down the steps
And found the maid upon their bottom tread!
He held her close and kissed her cheek and then
He brought her back inside his hall again, 3870
Where she was served as each could serve her best.
I'll not describe the food they ate, except
To say that all the party was well fed!
For Aymeri's sake he showed them great largesse.
His wife Guibourc took Hermenjart herself
Within her rooms and to a splendid bed.
On guard till dawn stood Lombards while she slept,
Each with an axe or goad with cutting edge.
Now hear, my friends, what Duke Girart did next —
And know you're rich if you have such a friend! 3880
He mustered forth ten thousand of his men,
All fully armed upon fine thoroughbreds,
And spoke his will to bring his nephew help

And bring him back his worthy bride as well
And all the gold and silver in the chests
Brought by the maid from rich Pavia's realm,
And his own wife would ride with them, he said.
If Aymeri, by chance, should need his help
In any fight, he'd lend him his prowess.
In any feast he'd help him out as well, 3890
 In Narbonne at his wedding!

⚜ CHANT 4 ⚜

HOW AYMERI FOUGHT FOR HIS LAND AND FOR HIS LIFE

Girart set off, unwilling now to pause.
He took with him a very fearsome force
Of noble knights all highly praised in war
And with him was the maiden Hermenjart
And all the silks and gold and silver coins
That she had brought from rich Pavia's court
On sumpters' backs well loaded and well borne.
He took alike his own good wife Guibourc.
I'll not spin out their journey or its course — 3900
To reach Narbonne they rode without a halt.
Now I must sing of Aymeri once more,
Who'd ridden up a hillock's crest at dawn,
Well-armed astride his iron-armored horse,
To view Narbonne and all the fields before.
Erected there he saw marquees galore,
Pavilions and tents, each fifty score,
Their kitchens too and cooking-fires a-roar
And Moors themselves as back they went and forth
Or sparred with swords and exercised in sport. 3910
He saw them shoe and water steeds of war,
And in God's name, Who holds the world in ward,
The noble count laid curses on them all:

"God humble you, you haughty pagan horde!
Accursed the wombs that brought so many forth,
And curse the rogues who sired you of their loins!"
I do not think that anywhere abroad
Held half the Moors camped then on Narbonne's shores!
It would have stopped another man, I'm sure,
But Aymeri, with ringing voice, rejoiced 3920
And said, "True God, I praise and thank You, Lord,
For bringing me such wealth in goods and coin
As all these Moors have piled before my walls!
If You decree, Who guard and save us all,
That I may win this wealth the Moors have brought,
Then all my life I'll nevermore be poor!
And by the saint in Rome I swear, what's more,
That if I live to wed my wife henceforth,
I'll use this wealth to raise the marriage-boards
Within these tents pitched for me by the Moors! 3930
I shall not ride or bide inside my hall
To wed my bride or celebrate our joy."
When this was said he spurred without a halt
From Narbonne's heights to join his fighting-force.
His knights and peers came forth to meet their lord,
All keen to know the strength of the assault.
Brave Aymeri spoke forth: "My worthy lords,
Since God above made man in His own form,
Then let His Son of Virgin birth be born
Upon this earth to serve and save us all, 3940
No man has seen so vast a pagan swarm
As you may view from yonder hillock's point!
My worthy knights, lose neither heart nor voice!
For if we must hack through this heathen horde,
Cry out 'Mountjoy!' and strike with all your force!
If you do this, the Saracens and Moors
Will think that Charles, the mighty emperor,
Has come from France with all his fighting force —

They fear him more than lightning-strike or storm.
If our small band can break their vanguard's wall, 3950
Then all the rest will soon give way, I'm sure.
The wealth they've brought can very soon be yours,
For I'll not claim or take two denier coins.
You and your friends may gladly take it all!
Whoever fights this day and sees the dawn
Will straightaway be rich for evermore."
He knew indeed how to inspire his force
And filled their hearts with courage so assured
That all were keen to face the fearsome Moors.
The Lombards, though, still trembled at the thought! 3960
Each said to each, "We have no chance or choice!
This very day our last breath will be drawn!
King Boniface, who forced us on this course
To banish us, could not have wished for more!
Now he may give our wives to richer lords
And our great lands to others he supports!
Not one of us shall see his face henceforth!"
Count Aymeri, on hearing their remorse,
Called in his knights and said, with ringing voice,
"I will not hide from you, my worthy lords, 3970
These Lombard knights are cowards to the core!
And yet there is one means that I recall
King Boniface advised me to employ
Upon these men, when leaving from his court:
He urged me then that when our ranks were formed,
I ought to place these Lombards to the fore.
So I intend to do that now, my lords;
And when it comes to battle in due course,
If you should see them flee or flinch at all,
I urge you all and order you, in short, 3980
To smite their heads clean off with your own swords,
As if they too were Saracens and Moors!"
The Lombard knights, on hearing this, rejoined

Among themselves: "We have no other choice
But face our deaths, if we would live at all!
We cannot flee this day from fray or war!
May God the Lord shame each of us henceforth
Who lets himself lose life and limb before
He makes the Moor pay dearly for his corpse!"
With such resolve they girded up their loins 3990
That all the French esteemed their people more.
Brave Aymeri called out: "My worthy lords,
I'll ride ahead to strike them first of all
Upon my steed well-clad in iron for war.
I'll go alone, with no companions, for
If I can slip unhindered through their force
To the emir himself, so we may talk,
Then with this spear I shall make clear my thoughts:
I'll drive them home with its sharp, shining point!
If I can slay the pagans' overlord, 4000
Then all the rest won't last for long, I'm sure!
Men, you yourselves must be well armed for war,
And if you hear the calling of my horn
And see me there encircled by the Moors,
Then come to me and clutch me from their claws.
The way is short — one little hill is all!"
His men replied: "We'll do as well we ought.
God curse the cur who fails you or your cause."
When this was said the count sped bravely forth
Upon his steed well-clad in iron for war, 4010
With God for guard, Who bore the Cross's gall.
He passed the hill, then through the host towards
A golden hawk that marked, he knew before,
The great emir's own tent and entrance-door.
He spurred in haste straight underneath its claws
And saw the rogue with three kings of his court.
No other Moor was present but these four:
They'd met inside to plot and plan a course

Whereby they hoped to take the town by storm
And with Greek fire to put it to the torch — 4020
But very soon they'd have a change of thought!
If you had seen how Aymeri strode forth,
His spear in hand, whose shaft was strong and broad,
Its shining point aimed straight towards them all!
Three started up, each one with panic fraught,
But Aymeri called out: "Sit down, you frauds!
You will, perhaps, fare better than you ought —
Or worse, perhaps, if you do not take thought —
I will not swear to anything at all!
I am a messenger, of this be sure, 4030
From Charlemagne, the best and bravest lord
And noblest king that history records.
He sends me here to speak this message forth
To the emir, whose wisdom is so small
That he has dared to challenge us in war!
I have come here to find out and report
If he will leave or stay here as a corpse!
So show me now your leader and your lord!"
The fierce emir was quick to find his voice:
"I do not hide from vassals of your sort! 4040
I am the lord with whom you wish to talk;
By great Mahom, to whom my faith is sworn,
I swear to you the greater folly's yours,
Who dare to come in here attired for war!
My door-keeper was very much at fault
To let you in to me with spear and sword,
And he shall pay — my own hand shall not baulk
At cutting off the foot or fist that paused
Or plucking out the eyes that witnessed naught!"
Said Aymeri, "This all is senseless talk! 4050
You answer me with no regard or thought.
Though others here may save their skin henceforth,
Since you have brought this host to Narbonne's walls,

I challenge you, let me pretend no more,
In Lord God's name, the Savior of us all!"
He raised his spear and with its shining point
He ran him through with all his fearsome force.
From ribs to rear he speared the blackamoor
And flung him dead from folding-stool to floor.
His pagan slaves, when they beheld him fall 4060
And roll around until he writhed no more,
All turned in flight without the slightest pause.
Those other kings, alike, raced for the door,
But Aymeri was there to greet them all
And smote their heads clean off with his steel sword,
Then fought his way outside to find his horse.
All round, the Moors, at first, were dumb with awe.
Two hundred then cried out their combat-call,
Then all at once they struck him like a storm.
Around the count they came in such a horde 4070
He had no means to get away at all.
On seeing this, he only raged the more
And drew again the bright blade of his sword.
The man he struck was finished, that's for sure,
For none of them had yet been told or warned
To arm themselves, so every blow he scored
Laid one man dead, another, and one more.
Then Aymeri raised up and blew his horn
With four great breaths to make four mighty calls
Heard well enough by all the knights and lords 4080
He'd left behind upon the hill before.
Without delay they broke the ranks they'd formed
And spurred at once, as fast as each could force
His horse downhill, to help their liege and lord.
They struck the Moors as fiercely as wild boars,
And, closing ranks, they cried aloud: "Mountjoy!"
On hearing this, the pagans all recoiled,
In shock to think that Charles the emperor

Had come from France with all his fearsome force —
They feared him more than any mortal born — 4090
And still their knights were ill-equipped for war!
On seeing this, those Lombard lords rejoiced
And struck great blows more boldly with their swords —
Towards the count they cut a swathe of Moors!
And yet, those knaves, God curse their evil course,
Did what they could and struck to ground his horse
And raised the hem of his good coat to gore
Their goads in him and mighty spears to bore
Upon his breast and slay him once for all.
But just in time Count Geoffrey, Valcler's lord, 4100
And Fouquerez and Fulk, he who before
Had brought the news of the emir's assault,
Sped up and led a band of loyal lords
 To Aymeri's protection.

To save their lord, the brave Count Aymeri,
Came hardy knights, with all their might and means,
And led him forth a fresh Arabian steed.
He mounted up, as swiftly as could be,
And in his hand he swung his blade of steel.
How fierce a fight began again in brief! 4110
The pagan cries were so widespread and fierce
That folk around could hear them for one league.
The pagans dressed for war with every speed
And armed themselves, and when this was achieved,
Rode back in force to fight with mighty zeal.
Yet ere they all had donned their battle-gear
Our noble knights slew all their slower peers
And on the field their corpses lay in heaps.
But when the Moors had seized their swords and spears,
Friends, what a fight! How fierce the spite and deep! 4120
So many shafts they cracked, so many shields,
So many coats they slit from seam to seam,

So many helms they crushed of burnished green!
Whoever fell was in a fearful need,
For he'd not rise without a comrade near.
The pagan cries were so widespread and fierce
Each Lombard knight was filled with fright and fear.
They would have fled, each one, but all were seized
With greater fear of brave Count Aymeri!
Not one of them turned back or tried to flee. 4130
Then, when they saw the brave count in the lead,
Who cleft the press in front of them with ease,
Fresh courage filled their weakest and most meek,
And each one struck with his bright sword of steel
 Upon the heathen pagans.

When they beheld their leader forging forward,
Fresh courage spread among the Lombard lords there.
Their weakest hearts beat bolder when recalling
That their own maid, fair Hermenjart, was shortly
To wed this man whose daring was so dauntless. 4140
Each spurred along his good, gray-dappled war-horse,
Some wielding pikes, some axes sharply pointed,
All fretting at their slowness to employ them!
Like leopards then they struck the pagan forces
And on that day they put them through such torment
That none could tell the half of it or quarter!
Count Aymeri beheld their bold performance
And said, "In truth, how well these men support me!
A fool alone could say that they fought poorly.
Towards the Moors their valor is remorseless! 4150
 They've won back all my love."

The Lombard lords took up the challenge keenly;
From first to last they never failed or weakened
But sold their rage against the Moors most dearly.
Across the way there rode in ranks convened there

The count's good friends, his loyal knights and liegemen,
And these backed up the Lombard charge most fiercely,
As in great strength they spurred their steeds to meet them.
Opposing them, those pagan disbelievers,
With piercing shouts and yelling out and screaming, 4160
All surged as one upon the Frenchmen, wielding
Great goads galore and darts as sharp as needles.
They struck our men, they thrust at them, they beat them
Till many died or lay there badly bleeding.
The count may well have been rebuffed or beaten,
When, rushing up, his envoy-band relieved him,
The very ones who'd journeyed to Pavia!
Three score they were and very brave their breeding,
All friends of his and peers whom he loved dearly.
On long-maned steeds their spurs had sent
 them speeding 4170
To help him out — and how their help was needed,
As fighting flared once more with fiercer feeling!
How many shafts and shields were split to pieces,
How many coats were ripped and rent completely!
How many arms and hands and legs and feet there
Our Frenchmen hacked from trunks of helpless heathens!
Yet, as they fell, so many more succeeded
That if Lord God had not looked down and seen it,
Girart the duke, his comrades and his liegemen,
Would all have come to bolster and relieve him — 4180
 And left Vienne in vain!

⚔ CHANT 5 ⚔

HOW FIRST THE ENVOYS AND THEN GIRART OF VIENNE
ARRIVED, AND HOW THE PAGANS WERE FINALLY ROUTED

The battle raged and long it waged and great.
The pagans put our men in direst straits

When from all sides, now fully armed, they raced
To fling themselves upon the French in waves
Of countless strength — so many of them came!
Five kings there were, of fiercest rank and rate,
Who sounded out their horns, each one, and raised
Their battle-cries aloft with ringing rage.
Around them all their ranks and runaways 4190
Who'd taken flight re-formed upon the plain,
And then, what blows upon our men they laid,
And many fell and never rose again.
Our Christian force would all have died that day,
When, once again, brave Hugh arrived in haste,
With Gui and Aliaume, of honored fame,
And bold Sanses and Aymon fierce of face,
And strong Spoleto's king, Othon the brave,
And wise Girart of Roussillon the same,
And Geoffrey of Anjou, with his bright blade, 4200
And Duke Hernaut, of great prowess and grace,
And Savari on his prized destrier —
All sixty lords and counts and peers of state
Who'd ridden forth for Aymeri's own sake
As envoys to Pavia and to the maid!
Not waiting now, they all broke rank and raced
To throw themselves, once more, among the fray.
Each held aloft his blade of steel engraved
And took the head of many knights and knaves.
The men they struck were finished straightaway, 4210
And with the shock the pagans rocked and swayed,
But came again with fiercer heart and hate!
So many shafts were cleft and shields the same,
And hauberks ripped and reft of saffroned mail,
And feet and fists and arms cleft clean away,
And countless Moors unhorsed upon the plain!
Across the fields their saddled steeds escaped;
Bereft of lord upon the sward they strayed.

Whoever there desired swift destriers
Could pick at will and lead their choice away. 4220
The pagan crowd all whelped aloud and wailed
And urged Mahom to pity them their fate.
On hearing this, their kings were filled with rage —
Each one blared forth his olifant again
And beat his drum and bade his horn-call raised,
Which, once again, stopped short their fleeing knaves.
Two hundred score fell into ranks again,
Who'd yet to fight where fighting was most grave.
So fierce a din their shrieks and shouting made
That all around the ground began to shake 4230
As on they came with vigor to the fray.
Upon our men such fearsome blows they rained
They beat them back more than an arrow's range —
This almost sent Count Aymeri insane!
With all his pride he pricked his destrier
And struck the press, his worthy sword upraised,
With twenty counts behind, of high estate,
Who held, each one, a town or fortress great.
Yet had the Lord been loath to lend them aid,
They'd more to lose before they loosened rein. 4240
Each one was so surrounded and waylaid
That I can't see how others' help availed,
Kept as they were from one another's aid —
For none of them knew where his friend was placed.
The count was struck and badly hurt that day,
When Moors brought down and slew his destrier;
But up he leapt and, swinging his steel blade,
He called aloud on our Lord Jesu's name,
And mowed them down with all his heart and hate!
Around him then the pagans massed and aimed 4250
Their great nielloed spears from safety's range.
But God the Lord, Whose name he had proclaimed,
Defended him from death and from the grave.

Across the field those other counts who came
To help their liege encircled in the fray,
Stood unaware of his or others' fate.
Not one there was whose hauberk did not gape
With mighty rents, which went right through the mail.
And all their steeds had been brought down and slain,
So that they stood, but gallantly all stayed. 4260
Each held aloft his blade of steel and aimed
It helmet-high and drove it neck to nape.
Yet even then our men made little way,
Beset, each one, by pagan sums so great
That if the Lord, with His majestic grace,
Had not been nigh, they'd all have died that day.
So many thrusts the heathen pagans made
They captured ten, worn out with pain and strain,
And tied their hands and hustled them away.
The captives called on God the Lord to save 4270
Them all from death, through His majestic grace.
So loud they cried that those inside the gates
Of old Narbonne could hear their pleas and plaints,
And from their cries they recognized their names.
Said Elinant, "Too long we have delayed!
Count Aymeri, our liege-lord ever brave,
With all his knights has hurried to our aid!
Fine, gallant knights, let us make haste the same
And help our peers out there upon the plain!"
His men replied, "We welcome what you say! 4280
God curse the cur whose courage falls or fails!"
They armed themselves, each one, without delay,
And those with wounds that they'd already gained
Wound bandages bound tightly round their waist
And swung astride their war-steeds straightway.
The gates swung wide, the draw-bridge dropped and they
Rode forth in ranks most closely banked and straight
To strike the Moors, their horses at full pace.

133

Each one of them sent sprawling on the plain
The blackamoor who first should block his way! 4290
But even so they too would soon have failed,
When Girart came with all the men he'd raised,
Vienne's great lord, of strength and temper famed!
What welcome help this hero's forces gave!
Ten thousand men, well armed and clad in mail,
Fresh-limbed and keen, they stormed among the fray,
Which flared anew, and soon its fortune changed.
They smote the Moors with all their heart and hate
And slew their lords in numbers hard to state.
On seeing this, the pagan soldiers paled; 4300
And if they did, that's no surprise, I'd say,
For you all know what happens without fail
To any crowd, however proud or great:
If once they lose their leader in the fray,
Then their own force begins to fall and fade.
So when the Moors beheld the noble face
Of old Girart and all the men he'd raised,
They sheathed their arms and shot off in escape.
They fled away, not looking back, I'd say.
Girart the duke spurred on across the plain. 4310
He turned his mount this way and that again
Until he saw his well-loved nephew's face,
As Aymeri stood there among the slain!
So many strokes his blade of steel had made
That both his arms were swollen with the strain;
So many wounds he had himself sustained
That blood ran down and through his saffroned mail
And both his spurs were covered with the stains.
Girart saw this and almost went insane.
He seized a horse, and handing him the reins, 4320
Dismounted his and spoke his nephew's name:
"Fair Aymeri, will you survive this day?"
"Fine uncle, yes, with Lord God's loving aid!

But had you not arrived here when you came,
I know in truth I would have met my fate!
But do not wait! Fine uncle, ride in chase
Of every Moor so none of them escape!
We may, I fear, already be too late!"
When this was said, remounting straightaway,
They spurred in haste and chased those runaways, 4330
And all their men sped after them the same.
Those fearless ten the Moors had hauled away
In captives' bonds, they found upon their way,
And cut the ropes that held them fast as chains.
They too, when freed, took steeds and joined the chase.
The Moors, meanwhile, made off in close array;
In hot pursuit Girart was on their tail
Relentlessly, his graven blade upraised!
How well that knight displayed his might that day:
The man he caught was slaughtered straightaway. 4340
The chase went on until the daylight waned
And fields were filled with all the pagan slain.
The living hid among the dead and feigned
Their death alike — they fell as in a faint
And smeared themselves with comrades' blood, so they
Might not be seen and suffer such a fate.
What use was that? Not one of them escaped —
Except King Desramé and Baufumez:
They fled to live and fight another day.
With thirty Moors they sped and fought their way 4350
Towards their boats and boarded in the bay
A pagan barge and straightaway set sail
 For Cordova directly.

THE FOURTH GESTE

AYMERI'S TRIUMPH

❀ CHANT 1 ❀

COUNT AYMERI'S FAMOUS WEDDING

Count Aymeri pursued them to his utmost
With Duke Girart and all of those who loved him.
If all Vienne had not set off when summoned,
It would have been the count who would have suffered:
He would have died and all his men been humbled,
If they had not been aided in that struggle.
The French returned when all was done and
 won there, 4360
And Aymeri, at once, ran to his uncle.
Each raised his helm and with their heads uncovered
They hugged and kissed, then greeted one another.
Girart spoke first, both wise and gallant-blooded:
"Fine nephew mine, will your wounds soon recover?"
"Fine uncle, yes, thanks be to God above us,
And you who came to rescue us from trouble.
We've had to fight so hard to overcome them,
And for so long have shown our Christian courage,
That we all ache in every limb and muscle! 4370
If you had not arrived, it is my judgment
That by this time my knights would have succumbed here
And none survived, the old ones nor the younger;
But come you did, and with such help and hurry

137

That, thanks to God, we've won back all our country,
And what is more have gained the goods and money
The heathen breed brought with them for their comfort.
Those poor before shall lack henceforth for nothing,
And we shall feast upon it in abundance,
 In mighty joy and triumph." 4380

Girart at once dismounted on the meadow,
As did the knights and noble lords he'd led there.
At their free will they chose a lodge or shelter.
Girart the duke did not forget but said then
To Aymeri, his gallant-visaged nephew:
"Sir Aymeri, I must speak forth a message
My own dear wife and love Guibourc has sent you.
She urges you and urges me to tell you,
That no great hall should hold your noble wedding,
No fortress fine, nor wealthy city dwelling, 4390
When you wed Hermenjart, Pavia's treasure,
But these great tents and lodges here erected
By pagan hands upon these very meadows
Should host the day in triumph and resplendence!
Hold such a feast and let there be such revels
So richly made and lavishly attended
That news of it shall reach all France's Frenchmen!
King Charlemagne, our emperor white-headed,
Who left this land to you and your protection,
On hearing this, will love you more forever." 4400
Said Aymeri, of gallant face and temper:
"Fine uncle, lord, by God and with His blessing,
I'd planned to do what you have said already —
 Though it seem mad to some!"

Count Aymeri asked then to see his bride;
His uncle left, then brought her to his side.
Embracing her, he kissed her face three times:

"God bless the hour that gave you birth!" he cried,
"This mighty realm is yours as much as mine!"
On hearing this, she bowed and then retired. 4410
Within Narbonne what joy there was that night!
Count Aymeri, whose face was brave and bright,
Sent quickly for a doctor, who arrived,
A pagan Moor from far across the tide.
He made a brew and cut a cloth to bind
The wicked wound the count took in the fight,
Then bade him drain a goblet's potion dry.
Count Aymeri, my friends, ere day grew light,
Was healthier than apples freshly sliced!
At early morn, as soon as dawn arrived, 4420
Fair Hermenjart was splendidly attired,
Then raised upon a mule with padded sides.
They led her to Narbonne and there, in Christ,
As many clerks and clergymen stood by,
The archbishop pronounced them man and wife.
When this was done Guibourc arose, the wife
Of Duke Girart, whose face was brave and bright.
With ringing voice she spoke aloud her mind:
"Count Aymeri, pay heed to my advice!
For love of God, Who made the dew and sky, 4430
Behold this maid of birth and breeding high!
Within this land she has no kith or kind,
No sibling close on whom she may rely.
Endow her, lord, against the day you die,
And do it now, if you respect her rights!
Her love of you will only grow thereby,
And her respect and loyalty alike."
"It shall be done!" Count Aymeri replied.
"She first shall have Narbonne and all its shires.
Then all Biaulande upon its shoreline wide, 4440
Which was my mother's dowry before she died,
Shall, as it should, be Hermenjart's in kind,

Who shall command its homage all her life."
His words were cheered by each and every knight.
How joyfully, by God, he wed his wife.
Midday it was ere Mass was sung and signed;
Without delay they left the church to ride
Outside, the bride most lavishly attired,
With Duke Girart upon her right hand side.
Across the plain the bachelors and squires 4450
Of name and fame engaged in jousting-trials,
And many a lance they split and splintered wide.
The jongleurs too, for everyone's delight,
Tuned their *vièles* till every string was right
And then they played and plucked their harps alike.
The wedding-group rode on till they arrived
Where friends and foe in fields below had died.
Then ladies-maids led off the lovely bride
Inside a tent, the largest they could find,
To honor her and serve her as they might, 4460
While all Narbonne prepared the feast outside:
Both salted meat and fresh, clear wine and spiced,
And sundry fowl they brought, then every kind
Of food to eat in wagons loaded high
With everything that everybody likes.
So much arrived from each and every side
That its amount could only be surmised!
And when it all was cooked and carved aright,
Girart the duke, not wasting any time,
Had water brought to wash with ere they dined. 4470
In thirty tents the water was supplied
By noble youths, who bore it as required
To all the lords of greatest praise and pride.
What tableware the tables there supplied!
What golden bowls and napkins patterned fine,
And goblets too and beakers golden-bright!
You never saw, in all, so fine a sight!

All down the field they rolled out cloths of white,
Which, end to end, my friends, without a lie,
Went further than a crossbow arrow's flight! 4480
All those who wished could eat whate'er they liked —
No stint was made and nothing was denied,
But all laid out for everyone's delight!
I'll not describe each food and every wine,
Except to say no folk were ever plied
With such a feast as in that field outside
 The walls of old Narbonne.

❀ CHANT 2 ❀

COUNT AYMERI'S SONS AND DAUGHTERS

The wedding-feast went on for one whole week —
Both rich and poor each day were served a feast
As fine and full as I have told you here, 4490
And I've not heard of any feast its peer.
The next week came and folk began to leave.
Not stopping more, Girart spurred forth his steed
Towards Vienne with all his men of liege,
And his good wife Guibourc, the fair and sweet.
Count Raymond went — he rode home to Saint-Gilles —
Ors to Valence, his native land and fief,
And to their realms the other gallant peers.
In Narbonne's hall they left Lord Aymeri
With Hermenjart, for whom his love was deep. 4500
I've never heard men speak of such as she,
Who was his wife throughout one hundred years
And bore in the first score and ten of these
Seven noble sons to brave Count Aymeri,
Who all were counts of greatest chivalry
And conquered through their fierce and gallant deeds
 The mighty Spanish marches.

The first-born son of Aymeri the brave
Was called Bernart the Brabantine by name.
He sired Bertrand, the palace-count, whose days 4510
Were filled with deeds of great prowess against
The heathen hordes of Antichrists in Spain.
His second son was William, whose fame
As William Bent-Nose became so great,
Whose every day was filled with so much pain
No bard alive could tell it all, I'd say.
He conquered Nîmes by means of wagon-trains,
And slew the lords that ruled that noble place —
King Harpin and King Otran were their names —
And then he took Orange, that fine domain, 4520
And raised Guibourc, its queen, to Christian faith,
Then married her, as is well known, the same
As how he slew at Rome Corsolt the knave.
Each day he lived he so upheld the Faith
That when he died, we read time and again,
He'd earned God's love, this much was very plain,
And well deserved eternal rest and grace
 For such a life of honor.

This second son I speak of, William,
Endured so much in service of the Cross 4530
That when he died he'd truly earned God's love.
The third son that Count Aymeri begot,
We know this well, was Garin of Anseune,
Who was the father of gallant Vivien,
That fearless knight you've heard of in the songs,
Whose noble heart was so sincere and strong.
Throughout his life he pledged the Lord our God
To never flee more than a lance-length from
The ground he stood against the pagan throng.
Throughout his life he never broke this bond 4540
And took such pain for it at Aliscans

He died for it, this vow I've told you of.
Count William interred him at that spot
 And still today he lies there.

The fourth-born son of Aymeri the fine
Was called Hernaut, you all know this is right;
He ruled Gironde with great prowess and pride
And boasted things, which proved to be unwise,
As all his boasts turned later into lies!
For once he said before his band of knights 4550
That he'd not wed or bed a red-haired wife!
But then he did, not long beyond that time,
And in his town there was no uglier bride.
She had a limp, and in one eye was blind,
And she was red — and he was red alike!
Then after that he bragged a second time
That he would not be run from any fight,
But then he was — the heathen Antichrists
For four whole leagues pursued him till he dived
Across a ford where he was forced to hide! 4560
Before he'd reached the other bank and side
The flow had reached his jeweled helmet's height!
Once more he made a boast that went awry:
To never eat coarse bread in all his life!
He boasted this, but in a little while
He gulped it down and thought it fair and fine.
A crumb or crust he ate with great delight
Of bitter wheat or roughest barley-rind,
Not parting with the smallest bit or bite,
When in his town he was besieged in might 4570
By all twelve sons Borrel the Pagan sired.
But nonetheless his heart was true and kind,
And he himself was strong and bold in strife,
 And of a noble temper.

The fifth-born son of Hermenjart the praised
Was called Beuvon, whose face with valor blazed;
It was to him that Aymeri gave the blade
Whose blows were feared and that was called Grisbay.
With this in hand how many times he aimed
At heathen heads with heavy blows of hate! 4580
How many wives he widowed in this way,
How many maids he changed to orphaned waifs!
Two sons he had of great renown and fame,
Who did or thought no evil all their days:
One was Girart, whose face was bright and brave,
The other Gui, whose destiny was great:
Against the Moors how many fights and frays
 At Barbastro they fought in!

The sixth-born son of Aymeri the wise
Was Aïmer called "The Captive" all his life; 4590
How wise, well-bred and brave was this great knight
Who slaughtered Moors each day until he died.
He made a pledge to never rest or lie
Within old towers or vaulted halls on high,
But in the field to fight Moors all his life!
He conquered Venice and all the land nearby,
And took by force the king of Persia's bride,
Called Soramonde, of face and figure fine —
A noble maid, he bade her be baptized
To serve the Faith of our Lord Jesus Christ, 4600
Then he himself took her to be his wife
 And ruled all of that country.

The seventh son of Hermenjart the lovely
And Aymeri, the paladin who loved her,
Was called by them, and all, Guibert the Youngster.
How noble was his heart, how firm his courage!
How fierce he was to Moors around that country!

How many times his sword-blade left them bloodied!
But then, one day, they captured him and hung him
Upon a cross, where he was made to suffer 4610
Great agony in their barbarian clutches,
Till rescued by his father and his brothers.
To him at last Count Aymeri entrusted
His marble hall and all the land it governed,
 As heir of old Narbonne.

Between these youths five sisters too were born,
More beautiful than sirens, one and all.
When each of them had been well raised and taught,
Count Aymeri, whose care had wanted naught,
Found each of them a rich and noble lord 4620
Who wed them and by whom they were adored.
The Grace of God so blessed them all henceforth
And raised their name and fame, that in due course
They soon held sway in many lands and courts.
 Through them the count's line flourished.

The eldest daughter born to them became
The wife of one whose deeds were so well praised:
His name was Drew, his town Mondidier.
Four sons they had, who all were fierce and brave:
Gaudin was one, then there was Richier, 4630
The other two Sanson and Angelier.
They all did much to raise the Christian faith.
Brave William gained greatly from their aid,
And his own love for each of them was great,
 Who were his noble nephews.

How brave a knight they gave their second daughter:
Sir Raoul of Le Mans, whose heart was dauntless.
One son they had, who won such fame and fortune,
And he was known as Anchetin the Norman.

As many know, he was most skilled in warfare, 4640
A doughty knight, redoubtable in all things,
His courage plain in each campaign he fought in
Against the Moors, whom every day he thwarted.
How many Moors his cutting sword-blade slaughtered!
He hated them and theirs each day and always.
Brave William gained much from his support, as
 Did all his noble line.

Their third-born daughter wed in love and faith
An English lord of high renown and rate
Who, in his land, they say, became a saint 4650
And well deserved the joy of heaven's grace.
Ere that he had five sons who all were brave:
One was Rabel, another Estormay,
The third Mularz — both bold and fierce of face —
The fourth was called Soef of Le Plaissay,
And St. Meurand was their fifth son, whose days,
As you have heard, were filled with heaven's praise.
At Douai lie that noble saint's remains,
 Of lineage most saintly.

The fourth daughter whom Hermenjart conceived 4660
They wed to Hugh, of visage bold and fierce,
Who was the lord and liege of Floreinville.
From him was born Sir Fulk, who won Cadiz.
You all have heard the song of his brave deeds,
And how he won that town with sword and spear
And took the slim and lovely Anfelise
From pagan hands by force of his own zeal
Then married her when she renounced her creed
And in the blessed Virgin's Son believed.
Her brother was that heathen Slav emir 4670
Called King Tiebaut, who fought for Spanish fiefs,
 His face with valor gleaming.

The youngest child and youngest daughter born
To Aymeri the brave was Blancheflor.
How fine she was, how fair of face and form!
She earned more fame than all the other four;
A mighty gift she gained from God the Lord,
When Charles's son himself led her to court:
King Louis, who was high of deed and thought,
Who ruled the land with every force of law, 4680
And with his hand slew countless Moors henceforth.
You all have heard the song of deeds record
How on the field he slew Gormont the Moor;
My friends, this same King Louis, in due course
Wed Blancheflor, so fair of face and form:
 She was the queen of France!

EPILOGUE

As richly as I've told you in this *geste*,
Brave Aymeri saw all his daughters wed.
As county-knight his might outdid the rest,
And everywhere he gained support and friends. 4690
His seven sons, as I have sung and said,
The count retained within Narbonne itself.
He brought them up so well until at length
They all became the finest of young men,
With fiercer hearts than any now or then,
And greater strength and pride in their prowess!
Count Aymeri, I'd say, well needed them,
For his own lands so often were beset
That two weeks never passed without new threats.
So many raids the Moors and Persians led 4700
That often he would not have come off best
Without the help those noble youngsters lent:
They threw them back so fiercely that he kept
His foes at bay each day until his death.
With them in hand, he planned another step:
To send his sons, each one, upon a quest
To other lands, to kings and marquises,
 To fight for their own fortune!

❈ ❈ ❈

GLOSSARY

acton A quilted jacket worn under a knight's chain-mail armor.

bezant A gold coin of Byzantine origin.

boss A round metal knob or stud at the centre of a shield.

buckler A small round shield.

byrnie A long knee-length garment of leather, upon which metal rings were sewn in various patterns; for the protection of the body and the thighs in battle.

castellan A governor of a castle.

coif A close cap worn under the helmet.

crenel An open space in an embattled parapet, for shooting arrows through, etc.

denier A coin of little value; a penny.

destrier A war-horse; a charger.

emir A Saracen prince or governor.

fealty A feudal tenant's fidelity to his lord.

fief An estate held in fee by a vassal (q.v.) from a superior.

geste 1. A military exploit; 2. An epic narrative; 3. A family or race.

gonfalon A banner with streamers.

hauberk A long knee-length garment of chain-mail (q.v.); for the protection of the body and the thighs in battle.

jongleur An itinerant musician.

liege lord A feudal superior.

liegeman A sworn vassal (q.v); a faithful follower.

mail Armor composed of metal rings or chain-work.

Nero's field Site of the *circus Neronis* in Rome; the traditional place of St. Peter's martyrdom and the present-day site of the Vatican.

Olifant An ivory horn.

Oriflamme The sacred red banner of the abbey of St. Denis; traditionally handed to French kings upon the start of any war.

paladin 1. One of the Twelve Peers of Charlemagne's court; 2. A knight errant; a champion.

quintain A jousting-post, often provided with a shield as a mark to tilt at, and a sandbag to swing round and strike the unskillful tilter.

seneschal A steward in a noble household.

squire A knight's attendant.

sumpter A beast of burden.

vassal A holder of land by feudal tenure.

vavasour A vassal (q.v.) holding of a great lord and having other vassals under him.

vièle A five-stringed, lute-shaped instrument played with a bow.

APPENDIX I

EXTRACTS FROM THE ORIGINAL POEM

GESTE 1, CHANT 2

KING CHARLES BEHOLDS NARBONNE

Nostre emperere a un pui devaler,
Si com il dut .j. haut tertre monter,
Par devers destre se prist a regarder;
Entre .ij. roches, près d'un regort de mer,
Desus un pui vit une vile ester
Que Sarrazin i orent fet fermer.
Molt bien fu close de mur et de piler;
Onques plus fort ne vit hom conpasser.
Virent l'arbroie contre le vent brenler
D'is et d'aubors q'an i ot fet planter.
Plus biau deduit ne pot nus regarder;
.XX. tors i ot fetes de liois cler,
Et une en mi qui molt fist a loer.
N'a home el mont tant sache deviser,
N'i covenist .j. jor d'esté user,
S'il voloit bien tote l'uevre aconter
Que paien firent en cele tor fonder.
Les creniax firent tout a plon seeler;
Jusqu'as batailles ot .j. ars que giter.
Sus as estages del palès principer
Ot .j. pomel de fin or d'outremer;
Un escharbocle i orent fet fermer

Qui flanbeoit et reluisoit molt cler,
Com li solauz qui au main doit lever;
Par nuit oscure, sanz mençonge conter,
De .iiij. liues le puet en esgarder.
D'autre part est la greve de la mer;
D'autre part Aude qui molt puet raviner,
Qui lor amoine qanqu'il sevent penser.
A granz dromonz que la font arriver,
Font marcheant les granz avoirs porter,
Dont la cité font si bien rasazer
Que riens n'i faut q'an sache deviser
Qui mestier ait a cors d'ome ennorer.
La cité prent li rois a esgarder,
Dedanz son cuer forment a goloser;
Son dru Naimon en prist a apeler:
"Biaus sire Naimes," ce dist Charles li ber,
"Dites moi tost, nel me devez celer,
Qui est tele vile qui tant fet a loer?
Cil qui la tient se puet trés bien venter
Q'an tot le mont, ce cuit je, n'a sa per,
Ne crient voisin qui le puise grever.
Mès, par l'apostre que l'en doit aorer,
Cil qui en France s'en vodront retorner,
Parmi ces portes les covendra paser,
Car ge vos di tout por voir, sanz fauser,
Que la cité vodré ge conquester,
 Ainz que m'en aille en France." (ll. 156–204)

GESTE 1, CHANT 4

CHARLES'S ANGER AT HIS KNIGHTS' RELUCTANCE

En Charlemaine nen ot que airier,
Qant si li faillent si baron chevalier.
Il en apele de Danemarche Ogier:

"Venez avant," dist Charles au vis fier.
"Tenez Nerbone, vos la veil ge lessier;
Ne la puis mieuz a nului enploier.
De moi avroiz la terre a jostissier."
Qant cil l'antant, le sans cuide changier.
"Sire," fet il, "mie ne vos en quier.
Assez ai terre, je ne la veil changier.
Traveilliez sui, si me veil aessier
En Danemarche, se g'i puis reperier.
Ja de Nerbone ne me quier enchargier;
Donez la autre a cui ele ait mestier,
 Car ge n'i puis entendre."

Molt fu li rois corrociez et pansis,
Qant de Nerbone li est chascuns eschis.
Il en apele Salemon le marchis:
"Venez avant, frans chevaliers gentis.
Tenez Nerbone et le palès votis;
De moi tandroiz la terre et le pais."
Qant cil l'antant, si enbronche le vis,
Puis li respont com hom mautalantis:
"Droiz enperere, par le cors saint Denis,
Ce ne sera jusqu'au jor del jois
Que ci demeure en Nerbone entrepris.
Ainz m'en irai arrier en mon pais;
S'en remenrai mes chevaliers de pris.
Mès molt petit m'en est, ce vos plevis;
Ce poise moi de ceus qui sont ocis,
Les ames d'eus soient en paradis!
Car recovrer nes puis, ce m'est avis.
Mès d'une rien poez estre toz fis,
Que ja Nerbone ne tendrai .xv. dis.
Donez la autre, enperere gentis,
 Car ja ne sera moie."

Plains fu li rois de molt fier mautalant,
Qant si li faillent si home plus puisant.
Il en apele Gondelbuef l'Alemant:
'Venez avant, franc chevalier vaillant.
Tenez Nerbone, recevez en le gant."
Qant cil l'oi, n'ot de chanter talant;
Il li respont hautement en oiant:
"Droiz enperere, merveille dites grant.
Plus a d'un an, par le mien escient,
Que ge ne vi ne fame ne anfant;
Del retorner sui forment desirant,
Car en Espangne ai sofert poine grant,
Ne me puis mès aidier ne tant ne qant.
De toz mes homes n'ai pas de remenant
La tierce part, s'en ai le cuer dolant;
Toz les ont morz Sarrazin et Persant.
Si n'en remeng palefroi n'auferrant
Qui tuit ne soient lassé et recreant.
Or m'alez ci Nerbone presentant,
Dont vos encore n'avez vaillant .j. gant!
Mès, par l'apostre que quierent peneant,
Ja ne l'avrai nul jor de mon vivant.
Donez la autre, au maufé la conment!
Je la claim tote quite." (ll. 435–94)

GESTE 2, CHANT 3

THE DEPARTURE OF AYMERI'S ENVOYS

Cil mesagier que ge vos ai nommé
Furent .lx. esleu et nonbré,
Prince et baron, duc et conte chassé.
Lor oirre aprestent, n'i ont plus demoré;
Congié demendent, es chevax sont monté,
Et Aymeris si les commende a Dé,

Le glorieus, le roi de majesté,
Qui les conduie trestoz a sauveté.
Et li baron s'en sont a tant torné,
Mès ne vont pas com vilain esgaré:
Richement sont vestu et acesmé;
Robe de soie, mantel de gris forré,
Avoit chascuns a son col afublé;
Lor chauces furent de paile et de cendé,
Et lor soler de cordouan ovré.
Chascuns chevauche bon mulet sejorné,
Ou palefroi richement enselé;
Seul li lorain qui estoient doré
Valoient bien tot l'or d'une cité.
.V. escuiers a chascuns d'aus mené,
Qui bien estoient garni et conreé;
En destre moinent maint destrier abrivé,
Or et argent, et armes a plenté,
Maint bon hauberc et maint hiaume jemé,
Et maint espié, et maint escu listé,
Dont lor seignor seront tost adobé,
S'il voient chose qui ne lor soit a gré,
Car molt estoient chevalier aduré
Et si n'estoient pas trestuit d'un aé:
En .iij. aages estoient devisé.
Li .xx. en furent viel et chanu barbé,
Et li .xx. autre furent assez puisné,
Li autre .xx. jovencel alosé.
Li .xx. plus viel que ge vos ai nommé
Portoit chascuns .j. bon ostoir mué;
Et li puisné qui sont de grant barné,
Chascuns de ceus porte .j. faucon ramé;
Et li .xx. juenne bacheler redouté,
Chascuns d'aus a .j. esprevier porté.
Mès tuit sont sage et bien enlatimé;
N'a cort el monde n'en la crestienté

Ou il ne fussent par reson escouté.
Se Boniface n'a or le cuer sené,
Que par conseil ou par sa grant fierté
Ne veille fere riens de lor volenté,
Tost li movront tel plet en sa cité,
Dont .c. Lonbart seront a mort livré,
 Por l'amor la pucele (ll. 1561–1608)

GESTE 2, CHANT 8

FAIR HERMENJART DISCUSSES MEN AND MARRIAGE

En une chanbre qui estoit peinte a flor,
Se sist li rois en son palès hauçor,
Lés lui sa suer a la fresche color.
Il li a dit belement par amor:
"Ma bele suer, ancui avroiz seignor:
Doner vos veil .j. conte pongneor;
N'a plus vaillant jusqu'en Inde major.
.LX. per de la terre Francor
Vos vienent querre, tuit sont duc et contor;
En ceste vile ont ja fet tel sejor,
Qui a couté .v. cents mars puis cart jor."
Hermenjart l'ot, si li dist par amor:
"Frere," fet ele, "nel tenez a folor,
Foi que doi Deu le verai criator,
Je n'avrai ja ne mari ne seignor,
Se .j. n'en ai qui est de grant valor,
C'est Aymeris, le noble pongneor,
Qui tient Nerbone et le pais d'entor,
Que refuserent li grant et li menor,
Tant redotoient la gent Sarrazinor,
Et cil la tient par force et par vigor,
Et desfant si contre gent paiennor
Q'ainz n'en perdi demi pié ne plain dor.

Et por ice q'an le tient au meillor,
Ai ge vers lui si tornée m'amor,
Se ge ne l'ai, n'avrai mari nul jor,
Car de celui me puet venir ennor.
Antan me quist Herchenbaus de Monflor;
Vieuz est li rois, si tret mès a foiblor;
Mès nel preisse, par Deu le criator,
Por le tresor Charlon l'enpereor,
Qu'il an poist bien venir desennor,
Que ja n'eusse a lui pès ne amor;
 S'en venist tost hontage."

"Frere," ce dit la pucele eschevie,
"Por amor Deu, qui tot a en baillie,
"N'aiez vos ja de grant avoir envie;
Trop avez vos avoir et menentie.
Or vos ennuie la moie conpangnie;
Ce poise moi, tant sui ge plus marrie
Ne m'en queisse a piece movoir mie.
Antan me vint querre dedanz Pavie
Cil d'Apolice a molt grant baronnie,
Ce est rois Otes qui tant a seignorie,
Et Savaris a la barbe florie,
Li Alemanz qui cuidoit grant folie,
Car mieuz vosisse estre vive enfoie,
Que tex viellarz eust ma druerie.
Et li dus Aces c'a Venice en baillie,
Plus a d'un an me requiert molt et prie.
Si me requiert rois Andreus de Hongrie;
Riches hom est, ce ne desdi ge mie;
.X. citez a dedanz sa seignorie,
Mès il n'avra ja a moi conpangnie,
Car il est vieuz, s'a la barbe florie,
Et si est rox et la char a blesmie.
Par cele foi que doi sainte Marie,

Ne le prendroie por a perdre la vie.
Mieuz vodroie estre enz en .j. feu broie,
Que ja jeusse lez sa pance flestrie.
Si m'eist Dex qui tot a en baillie.
 Je n'avrai ja viel home."

Dist Hermenjart au gent cors seignori:
"Biaus sire frere, par foi le vos afi,
Que ja n'avrai en ma vie mari,
Se ge nen ai le preu conte Aymeri,
Le fil Hernaut au coraje hardi,
Que Charlemaine de Nerbone sessi,
Qant tuit li autre en furent esbahi,
Et tuit en furent del prendre au roi failli,
Qant li danziaus en gré la recoilli.
Biaus sire frere, tot mon pansé vos di,
Si m'eist Dex qui onques ne menti,
Je ne desir nul home fors que li."
Dist Boniface: "Jesu Crist en merci!
Je ne vos veil doner fors Aymeri.
.LX. per a envoiez ici,
Qui sont haut home, corajeus et hardi;
Dedanz Pavie sont passé a cart di."
Dist la pucele: "Deu en aor et pri!
Or puis bien dire, de bone eure nasqui,
Puis que c'est voirs que j'avrai Aymeri,
 Le seignor de Nerbone." (ll. 2420–2502)

GESTE 2, CHANT 10

THE RALLYING SPEECH OF HUGH OF BARCELONA

"Seignor," ce dist Hugues li gentis hom,
"De bon conseil ne vient il se bien non.
Bien poez ore veoir a ma reson

Que vos donai leal conseil et bon,
Car ci nos vienent pongnant de grant randon,
Ce m'est avis, li Alemant felon
Que l'autre jor desconfit avion.
Por amor Deu, seignor, et por son non,
Or gardez bien que chascuns soit preudon,
Et conbatant et fier comme lion.
Se somes poi, tant mieuz les requerron!
Vos veez bien qu'eschaper ne poon,
Ne d'autre part nul secors n'atendon,
Ne nule aide, se de Damedeu non;
Et bien sachiez, se nos desconforton,
Ja encontr'eus n'avrons plus de foison,
Ne que l'aloe contre l'esmerillon.
Hé! verai Dex, quel soufrete hui avon
Del bon vassal Girart de Rosillon,
D'Hernaut de Mez et d'Ors de Valbeton,
Gautier del Mans, de Garin de Loon,
Et de Geufroi, de Hunaut le Breton,
De Jocerant et del vassal Guion,
Et des .L. que arrieres lesson!
S'or fussent ci li chevalier baron,
Petit durassent envers nos cil gloton;
Mès puis que voi que avoir nes poon,
Par ce Seignor qui Longis fist pardon,
Chier me cuit vendre, ainçois que pris soion!
Ne vos puis fere, seignor, autre sermon:
Toz nos comant a Deu et a son non.
Ja i ferrai, qui q'an poist ne qui non!"
A ce mot broche le destrier arragon
Et desploia le vermeil confanon. (ll. 2761–94)

GESTE 3, CHANT 1

THE RETURN OF THE PAGAN HOST

Lors a tantost l'amirant commandé
Que si brief soient maintenant seelé,
Et as corlius soient molt tost livré;
Et il si font, n'i ont plus demoré.
Tant ont li mès esploitié et erré,
De Rochebrune de si c'an Duresté,
Ou li soleuz giete premiers clarté,
Sont tant paien venu et asenblé
Que l'ost en dure une liue de lé.
De ci a Mesques ne se sont aresté;
Ileques ont Mahomet enserré;
De Charlemaine se sont a lui clamé,
Et d'Aymeri, cel orgueillex chasé,
Qui de Nerbone les a desherité.
Grant fu l'ofrande que il li ont doné;
Après i ot maint olifant soné;
Destrier henissent et mur ont rechané;
Cil Sarrazin ont glati et jupé,
Li uns a l'autre escremi et josté.
Plus grant enpire ne vit nus auné,
Car ilec fu Athenas et Janbé,
Et rois Maubrun, et son frere Forré,
Li rois d'Egipte et li rois Codroé,
Et Anfelis, et li rois Aceré,
Cornabadas et li rois Mautriblé,
Et Lucifer, et li rois Giboé,
.XIIII. roi qui d'Espengne sont né.
A tout l'enpire qu'il orent amené,
Sont maintenant en lor navie entré;
Vitaille portent li gloton deffaé
Por aus guerir jusq' a un an passé,

Boutent de rive, en mer sont esquipé.
Li vif deable lor donent tel oré
Q'an .xv. jorz sont deça arivé.
Voient la terre de la crestienté;
De Terrasconne, le bon pais loé,
Li mur blanchoient comme flor en esté.
Plus de .x. mille ont de pitié ploré,
Por lor lignaje qu'en iert desherité.
Des nés issirent, n'i ont plus demoré,
Sor les destriers sont maintenant monté.
Qant il se furent molt richement armé,
Par Avalence se sont acheminé,
Tote ont la terre et le pais gasté;
Tant chetif ont pris et enchaenné,
Batu les ont et feru et fusté,
Que de lor char en est li sans volé.
 Ce fu a feste saint Jehan en esté,
Que soié sont et recoilli li blé;
Sarrazin vindrent a la bone cité,
Devant Nerbone ont fet tendre maint tref.
Li amirant, li prince et li chasé,
Maint paveillon ont tot entor fermé,
Dex, quel domaje, voirs rois de majesté,
Que or nel set Aymeris l'aduré,
 Qui amoine sa fame! (ll. 3585–3640)

GESTE 3, CHANT 4

THE FINAL BATTLE RAGES

Lors veissiez fier estor esbaudi,
Tant hante frete et tant escu croissi,
Et tant hauberc desrout et desarti,
Et detranchié tant vert hiaume bruni!
Mal fu baillis qui a terre chai,

Que n'en leva, se il n'ot bon ami.
Paien demoient et tel noise et tel cri
Que tuit en furent li Lonbart esbahi.
Molt volentiers s'en fussent tuit foi,
Mès tant redoutent le preu conte Aymeri
C'onques .j. seus de l'estor ne parti,
Car qant il voient le preu conte hardi
Qui devant eus la presse departi,
Li plus coarz hardement recoilli;
Si fiert chascuns del branc d'acier forbi
 Sor la gent Sarrazine.

Grant hardement recoillent li Lonbart,
Por Aymeri qui les granz cox depart
Sont devenu hardi li plus coart.
Qant lor remenbre de lor dame Hermenjart,
Qui tel baron doit avoir a sa part,
Chascuns d'aus broche le bon destrier liart.
L'un porte hache et li autres faussart;
As cox doner cuident venir a tart;
Sor paiens fierent ansi comme liepart,
Des glotons font le jor si grant essart
Que n'en diroie la moitié ne le cart.
Cuens Aymeris s'en est donez regart:
"Voir," dist li cuens, "bien le font li Lonbart!
Ques blameroit, jel tandroie a musart,
Car vers paiens sont felon et gangnart.
 M'amor ont recovrée!"

Trés bien se sont li Lonbart maintenu;
As premiers cox ont fort estor rendu;
Bien ont as Turs lor mautalent vendu.
D'autre part sont asenblé et venu
Li chevalier Aymeri et si dru;
Les Lonbarz ont fierement secoru,

A l'estor vienent a force et a vertu.
Et d'autre part Sarrazin mescreu
Grant cri demoinent et grant noise et grant hu,
Entre François se sont tuit enbatu,
Portent maint dart et maint espié molu,
Sor crestiens ont chaplé et feru,
Assez en ont navré et abatu.
A grant meschief cuens Aymeris i fu,
Qant li mesage i sont tuit acoru,
Cil qui estoient de Pavie venu.
.LX. estoient baron de grant vertu
Qui Aymeri furent ami et dru.
Chascuns a point le bon destrier crenu;
Cil ont le conte vaillament secoru.
La veissiez fier estor maintenu,
Tant hante frete et percié tant escu,
Et tant hauberc desmaillié et ronpu,
Tant braz tranchié, tant pong, tant pié, tant bu,
Et tant paien trebuchié et cheu!
Mès tant estoient li gloton mescreu,
Se Dex n'en panse par la seue vertu,
Cil de Vienne seront a tart venu,
Li dus Girarz, si ami et si dru,
 Qui secors lor ameinne. (ll. 4120–81)

APPENDIX II

THE HOUSE OF NARBONNE
IN THE EPIC TALES OF MEDIEVAL FRANCE

GARIN OF MONGLANE = MABILLE

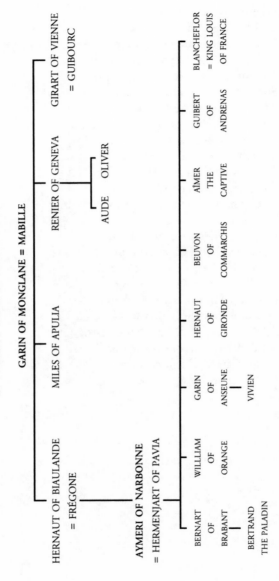

HERNAUT OF BIAULANDE = FRÉGONE

MILES OF APULIA

RENIER OF GENEVA

GIRART OF VIENNE = GUIBOURC

AUDE OLIVER

AYMERI OF NARBONNE = HERMENJART OF PAVIA

BERNART OF BRABANT

BERTRAND THE PALADIN

WILLIAM OF ORANGE

GARIN OF ANSEUNE

VIVIEN

HERNAUT OF GIRONDE

BEUVON OF COMMARCHIS

AIMER THE CAPTIVE

GUIBERT OF ANDRENAS

BLANCHEFLOR = KING LOUIS OF FRANCE

SELECT BIBLIOGRAPHY

AYMERI DE NARBONNE

1. Edition

Aymeri de Narbonne: Chanson de geste. Edited by Louis Demaison.
2 vols. Paris: Société des Anciens Textes Français, 1887; rpt.,
New York: Johnson Reprint Corporation, 1968.

2. Secondary Material

General

Becker, Philipp August. *Das Werden der Wilhelm- und der Aimerigeste.*
Abhandlungen der Sächsischen Akademie der Wissenschaften,
Philol.-Hist. Klasse, 44.1. Leipzig, 1939.

Blanks, David R. and Michael Frassetto, eds. *Western Views of Islam
in Medieval and Early Modern Europe.* New York: St. Martin's
Press, 1999.

Calin, William C. "Aspects of Realism in the Old French Epic:
Aymeri de Narbonne." *Neophilologus* 50 (1966): 33–43.

————. *The Epic Quest: Studies in Four Old French Chansons de Geste.* 1,
"The Quest for the Woman and the City: *Aymeri de Narbonne.*"
Baltimore: John Hopkins Press, 1966.

————. "The Woman and the City. Observations on the Structure
of *Aymeri de Narbonne.*" *Romance Notes* 8.1 (Autumn 1966):
116–20.

Combarieu (du Gres), Micheline de. "Une ville du sud vue du nord:
Narbonne dans le cycle d'Aymeri." *Perspectives médiévales* 22
(1996): 59–77.

Emden, Wolfgang van, ed. *Girart de Vienne.* Paris: Société des An-
ciens Textes Français, 1977.

Grisward, Joël-Henri. "*Naissance d'Aymerides. L'idéologie des trois fonctions dans le cycle des Narbonnais.*" Thesis, Université de Paris – Sorbonne, 1980.

——. "*Aymeri de Narbonne* ou la loyauté masquée." In *Hommage à Jean-Charles Payen: Farai chansoneta novele. Essais sur la liberté créatrice au Moyen Age,* 199–210. Caen: Université de Caen, 1989.

Heer, Friedrich. *The Medieval World.* New York: Mentor, 1963.

Kibler, William W. "Bertrand de Bar-sur-Aube, Author of *Aymeri de Narbonne?*" *Speculum* 48 (1973): 277–92.

Krappe, Alexander H. "Bertrand de Bar-sur-Aube and *Aymeri de Narbonne.*" *Modern Philology* 16 (1918–19): 151–58.

Lejeune, Rita. "La question de l'historicité du héros épique Aimeri de Narbonne." In *Economies et sociétés au Moyen Age: Mélanges offerts à Edouard Perroy,* 50–62. Paris: Publications of the Sorbonne, 1973.

Lewis, Charles Bertram. *Classsical Mythology and Arthurian Romance.* London: Oxford University Press, 1932.

Moore, R. I. *The Formation of a Persecuting Society; Power and Deviance in Western Europe, 950–1250.* Oxford: Blackwell, 1987.

Nirenberg, David. *Communities of Violence: Persecution of Minorities in the Middle Ages.* Princeton: Princeton University Press, 1996.

Paris, Gaston. "Sur un épisode *d'Aimeri de Narbonne.*" *Romania* 9 (1880): 515.

Scherping, Walther. *Die Prosafassungen des "Aymeri de Narbonne" und der "Narbonnais."* Halle: a. S. Hohmann, 1911.

Schlauch, Margaret. "The Palace of Hugon de Constantinople." *Speculum* 7 (1932): 500–514.

Strickland, Debra Higgs. *Saracens, Demons, and Jews: Making Monsters in Medieval Art.* Princeton: Princeton University Press, 2003.

Tolan, John V. *Medieval Christian Perceptions of Islam.* New York and London: Garland Publishing, 1996.

——. *Saracens: Islam in the Medieval European Imagination.* New York: Columbia University Press, 2002.

Tyssens, Madeleine and Jeanne Wathelet-Willem. *La "Geste des Narbonnais" (Cycle de Guillaume d'Orange).* Heidelberg: Carl Winter-Universitätsverlag, 2001.

Weiske, Hans. "Quellengeschichtliches zu Aimeri de Narbonne." *Archiv für das Studium der neueren Sprachen* 107 (1901): 129–34.

The Chanson de Geste Genre

Bédier, Joseph. *Les légendes épiques.* Third ed., 4 vols. Paris: H. Champion, 1926–29.

Boutet, Dominique. *La chanson de geste. Forme et signification d'une écriture épique au Moyen Age.* Paris: PUF, 1993.

Brault, Gerard J. *The Song of Roland: An Analytical Edition.* University Park, PA: Pennsylvania State University Press, 1978.

Burns, E. Jane. *Bodytalk: When Women Speak in Old French Literature.* Philadelphia: University of Pennsylvania Press, 1993.

Calin, William C. *The Epic Quest: Studies in Four Old French Chansons de Geste.* Baltimore: John Hopkins Press, 1966.

Cheyette, Frederic L. *Ermengard of Narbonne and the World of the Troubadours.* Ithaca, NY: Cornell University Press, 2001.

Comfort, William W. "The Character Types in the Old French *Chansons de Geste.*" *PMLA* 21 (1906): 279–434.

———. "The Literary Role of the Saracens in the French Epic." *PMLA* 55 (1940): 628–59.

Crosland, Jessie. *The Old French Epic.* Oxford: Blackwell, 1951.

Daniel, Norman. *Heroes and Saracens: An Interpretation of the Chansons de Geste.* Edinburgh: Edinburgh University Press, 1984.

De Weever, Jacqueline. *Sheba's Daughters: Whitening and Demonizing the Saracen Woman in Medieval French Epic.* New York: Garland, 1998.

Doutrepont, Georges. *Les Mises en Proses des Épopées et des Romans Chevalresques du XIVe au XVIe siècle.* Brussels: Palais des académies, 1939; rpt., Geneva: Slatkine, 1969.

Duggan, Joseph J. *The Song of Roland: Formulaic Style and Poetic Craft.* Berkeley: University of California Press, 1973.

Gautier, Léon. *Les épopées françaises.* 4 vols. Paris: Palmé, 1879; rpt., Osnabrück: Zeller, 1966.

Gildea, Marianna, Sister. *Expressions of Religious Thought and Feeling in the* Chansons de Geste. Washington, DC: Catholic University of America Press, 1943.

Haidu, Peter. *The Subject of Violence: The Song of Roland and the Birth of the State.* Bloomington: Indiana University Press, 1993.

Harden, Robert A. "The Element of Love in the *Chansons de Geste.*" *Annuale Medievale* 5 (1964).

Hatem, Anouar. *Les Poèmes épiques des Croisades.* Paris: P. Geuthner, 1932.

Heinemann, Edward A. *L'art métrique de la chanson de geste.* Geneva: Droz, 1993.

Heng, Geraldine. *Empire of Magic: Medieval Romance and the Politics of Cultural Fantasy.* New York: Columbia University Press, 2003.

Herman, Gerald. "Aspects of the Comic in the Old French Epic." Ph.D. Dissertation, Stanford University, 1967 (Ann Arbor, MI: University Microfilms Inc., 1968).

Hindley, Alan and Brian J. Levy. *The Old French Epic: Texts, Commentaries, Notes.* Louvain: Peeters, 1983.

Jones, George F. *The Ethos of the Song of Roland.* Baltimore: John Hopkins Press, 1963.

Kahf, Mohja. *Western Representations of the Muslim Woman. From Termagant to Odalisque.* Austin: University of Texas Press, 1999.

Kay, Sarah. *The Chansons de Geste in the Age of Romance.* Oxford: Clarendon Press, 1995.

Keller, Hans-Erich, ed. *Romance Epic: Essays on a Medieval Literary Genre.* Kalamazoo, MI: Medieval Institute Publications, 1987.

Krause, Kathy M., ed. *Reassessing the Heroine in Medieval French Literature.* Gainesville: University Press of Florida, 2001.

Krueger, Roberta J., ed. *Women Readers and the Ideology of Gender in Old French Verse Romance.* Cambridge: Cambridge University Press, 1993.

———. "Questions of Gender in Old French Courtly Romance." In *The Cambridge Companion to Medieval Romance,* ed. by Roberta L. Krueger, 132–49. Cambridge: Cambridge University Press, 2000.

———. "Beyond Debate: Gender in Play in Old French Courtly Literature." In *Gender in Debate from the Early Middle Ages to the Renaissance,* ed by Thelma Fenster and Clare A. Lees, 79–96. New York: Palgrave, 2002.

Langlois, Ernest. *Table des noms propres de toute nature compris dans les chansons de geste imprimées.* Paris: É. Bouillon, 1904; rpt., New York: Burt Franklin, 1971.

Martin, Jean-Pierre. *Les motifs dans la chanson de geste.* Thesis, Université de Paris III, 1984.

Menéndez Pidal, Ramón. *La Chanson de Roland et la tradition épique des Francs.* Trans. I.-M. Cluzel, second ed. Paris: Picard, 1960.

Moisan, André. *Répertoire des noms propres de personnes et de lieux cités dans les chansons de geste françaises et les oeuvres étrangères dérivées.* 5 vols. Geneva: Droz, 1986.

Nichols, Stephen G. *Formulaic Diction and Thematic Composition in the* Chanson de Roland. Chapel Hill: University of North Carolina Press, 1961.

Paris, Gaston. *Histoire poétique de Charlemagne.* Paris: Franck, 1865; second ed., Paris: É. Bouillon, 1905.

———. "La Chanson du *Pèlerinage de Charlemagne.*" *Romania* 9 (1880): 1–50.

Ramey, Lynn T. *Christian, Saracen and Genre in Medieval French Literature.* New York: Routledge, 2001.

Riquer, Martin de. *Les chansons de geste françaises.* Trans. by Irénée Cluzel, second ed. Paris: Librairie Nizet, 1968.

Rossell, Antoni. "Pour une reconstruction musicale de la chanson de geste." In *Charlemagne in the North: Proceedings of the 12th International Conference of the Société Rencesvals.* Ed. by Philip E. Bennett *et al.* Edinburgh: Société Rencesvals British Branch, 1993.

Rychner, Jean. *La chanson de geste: Essai sur l'art épique des jongleurs.* Geneva: Droz, 1955.

Schilperoort, G. *Le Commerçant dans la littérature française du moyen âge.* Gröningen: J. B. Wolters, 1933.

Suard, François. *Chanson de geste et tradition épique en France au Moyen Age.* Caen: Paradigme, 1994.

———. *La chanson de geste.* Collection *Que sais-je?* Paris: P.U.F., 1993.

Subrenat, Jean, ed. *La Technique Littéraire des chansons de geste: Actes du Colloque de Liège, Sept. 1957.* Paris, Société d'édition "Les Belles Lettres," 1959.

Taylor, Karen J. *Gender Transgressions: Crossing the Normative Barrier in Old French Literature.* New York: Garland, 1998.

Trotter, D.A. *Medieval French Literature and the Crusades (1100-1300).* Geneva: Droz, 1988.

This Book Was Completed on February 21, 2005 at
Italica Press, New York, New York. It was
set in Garamond and Charlemagne
and It Was Printed on 60-lb
Natural, Acid-Free Paper
by LightningSource,
U. S. A./
E.U.